There's night and day, brother, both sweet things;
sun, moon, and stars, brother, all sweet things;
there's likewise a wind on the heath. Life is very
sweet, brother; who would wish to die?

GEORGE BORROW (1803-1881), *LAVENGRO*

Who walks with Beauty has no need of fear;
The sun and moon and stars keep pace with him;
Invisible hands restore the ruined year,
And time, itself, grows beautifully dim.

DAVID MORTON (1886-1957), *WHO WALKS WITH BEAUTY*

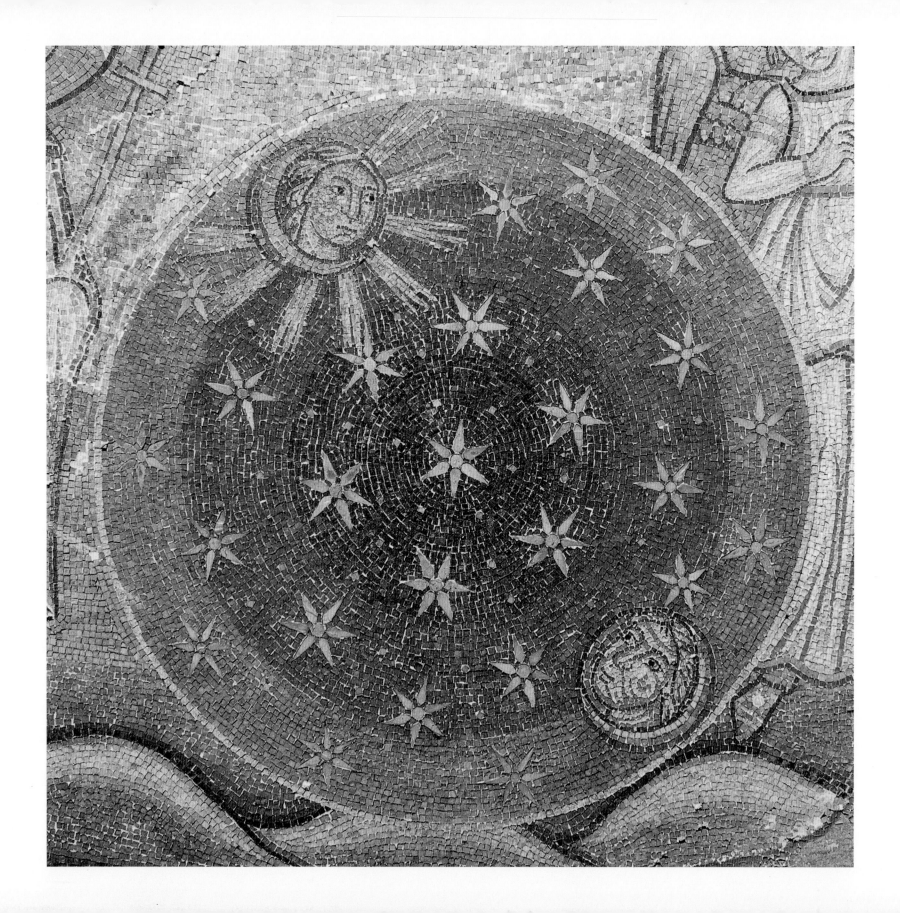

The Sun the Moon and the Stars

by Richard Whelan designed by Arnold Skolnick

FIRST GLANCE BOOKS, COBB, CALIFORNIA

© 1998 O. G. Publishing Corp.
Text © 1998 Richard Whelan

Published in the United States of America
by First Glance Books

Distributed by First Glance Books
P.O. Box 960
Cobb, CA 95426
Phone: (707) 928-1994
Fax: (707) 928-1995

This edition was produced by
Chameleon Books, Inc.
31 Smith Road
Chesterfield, MA 01012

ISBN 1-885440-35-9

Printed in Hong Kong

President: Neil Panico
Vice President: Rodney Grisso
Designer: Arnold Skolnick
Design Associate: KC Scott

Frontispiece:

THE CREATION OF THE HEAVENLY BODIES,
13TH CENTURY (detail of page 139)
Mosaic
Basilica of San Marco, Venice

ACKNOWLEDGMENTS

We wish to thank the following very warmly for their help:
Janet Borden, Inc., New York; Mary Sluskonis at the Museum
of Fine Arts, Boston; Jacklyn Burns at the J. Paul Getty
Museum, Los Angeles; Joanne Charlton at the Wallace
Collection, London; Deanna Cross at the Metropolitan Museum
of Art, New York; Anita Duquette at the Whitney Museum of
American Art, New York; Beth Garfield at the Detroit Institute
of Arts; Christina S. Geiger at Christie's Images, New York;
Thomas Grischkowsky at the Museum of Modern Art, New
York; Ruth Janson at the Brooklyn Museum of Art; Alison
Jasonides at Art Resource, New York; Maxine Maindonald at
the Birmingham Museums & Art Gallery, England; C. Thomas
May, Jr.; Duane Michals; Greg Mort; Davide Mosconi; Dona
Nelson; Julie Saul, Julie Saul Gallery, New York; KC Scott;
Chuck Searls; Stacey L. Sherman at the Nelson-Atkins
Museum of Art, Kansas City; Tomiyasu Shiraiwa; Julia Van
Haaften; John Wallace; Suzanne Warner at the Yale University
Art Gallery, New Haven; Marion Wheeler; Horoshi Yamazaki;
and Richard York, Richard York Gallery, New York.

R.W. & A.S.

Since the dawn of human consciousness the Sun, the Moon, and the stars have inspired awe, curiosity, fear, and delight. In virtually every culture great works of art have conveyed the sense of wonder and magic that attend these cosmic presences, while myths and legends have attempted to organize the celestial phenomena into familial patterns based on human relationships.

Many pre-modern cultures all over the world worshipped the Sun as a supreme god, the giver and sustainer of life. In other pantheons the Sun was revered as a son or daughter of the omnipotent ruler of Heaven. The Moon was generally characterized as the Sun's sibling or spouse, and together they often played the role of the parents of the world. Sexist stereotyping tended to prevail, with the "active," Sun regarded as male and the "passive," sunlight-reflecting Moon as female. Although there were numerous isolated exceptions to this generalization among the tribal peoples of North America and northern Eurasia, the most important is in Japanese mythology, where the Sun goddess Amaterasu is worshipped as the ancestress of the emperor

The Sun has naturally played a special role in many religions as the marker of time, for the calendar had life-and-death importance in agricultural and hunting societies. Four thousand years ago the massive pillars of Stonehenge were set up to provide sight lines for predicting solstices, eclipses, and other celestial phenomena. The ability to predict eclipses must have bestowed great power upon the astronomer-priests of cults widely scattered throughout the prehistoric world. A priest, having secret knowledge of the time of an eclipse, could threaten to make the Sun disappear from the sky if his wishes were not obeyed. Who would dare to defy a man who could make the Moon swallow the Sun?

In many cultures the winter solstice, on or about December 21, has been one of the most important celebrations of the year—for it is at that solstice that the days cease getting shorter and begin to get longer again. We can hardly imagine the joy that primitive peoples must have felt at their annual release from the terrifying fate of watching the days grow ever shorter until the Sun would permanently disappear. It is no mere coincidence that Christmas is timed so close to the winter solstice and its promise of renewal and rebirth.

Perhaps the most influential solar cult in history was that of Mithra, originally the Persian god of the Sun, justice, and war. As in many other cultures, the Sun was revered by the Persians as the all-illuminating, all-beholding light that guarantees justice, oaths, and contracts, as well as victory to the righteous and the loyalty of soldiers to their king.

Persian myth told of Mithra's reluctant sacrifice of a white bull that then metamorphosed into the Moon, while Mithra's cloak became the vault of the heavens, the bull's tail became the first grains of wheat, and the drops of his blood were transformed into grapes. Roman legionaries invading Persia adopted the versatile god of the Sun and of war, whom they called Mithras, as their own and worshipped him as the Unconquerable Sun. In Mithraic sanctuaries Roman soldiers stood under grates so that the blood from the cut throats of sacrificed bulls could drip upon them and give them invincible strength. During the second century A.D., Mithraism became so powerful that it was early Christianity's most serious rival.

On untold numbers of Roman plaques depicting Mithras sacrificially cutting a bull's throat the faces of the Sun and Moon are represented in the sky. This iconography of sacrifice was carried over directly into depictions of Christ's crucifixion. Until the early sixteenth century a Sun face was often shown above the right shoulder of the crucified Christ, and a Moon face above his left. (See, for instance, the Raphael *Crucifixion*, c. 1503, in the National Gallery, London.) The synoptic gospels relate that during the Crucifixion, an eclipse of the Sun lasting three hours signaled Heaven's mourning for the Savior. According to Saint Augustine, the Sun and Moon symbolized the Old and New Testaments, the former (the Moon) to be understood only in the light shed upon it by the latter (the Sun).

One of the great legends of ancient Greece concerning the

Sun is the story of Daedalus, a mythical Athenian architect and sculptor of unparalleled skill, and his son Icarus. To enable them to escape from the island of Crete, where they had been imprisoned, Daedalus fashioned two pairs of wings from feathers and wax. He then instructed his son to follow him closely and to fly neither too high nor too low. Alas, Icarus became intoxicated with the freedom of flight and soared so high that the Sun melted the wax of his wings. He plummeted from the sky and was drowned in the sea. While moralists have held Icarus up as an example of what happens to those who fail to practice moderation, others have revered him as a symbol of human willingness to risk everything to acquire knowledge and experience. The greatest depiction of this story is surely that by Pieter Brueghel the Elder (Musèe des Beaux-Arts, Brussels).

The Moon is the most beautiful of nocturnal presences, from the exquisite first sliver of a crescent to the bold full Moon that governs madmen and werewolves as well as tides.

In Egyptian mythology, the gods Horus and Seth represented Lower and Upper Egypt, respectively. Seth murdered Horus's father, Osiris, and then challenged Horus for the throne of Egypt. Horus emerged victorious, but in the fight his left eye—the Moon—was injured. That wound and its healing under the care of the Moon-god Thoth (who was also the god of learning, as well as the representative of the Sun-god, Ra, on earth) were said to account for the phases of the Moon.

The lunar month has been a unit of time for many peoples, and each culture has had its own explanation for the phases of the Moon that occur during that period. Some have said that the Moon is first overfed and then starved by his two planetary wives. For other cultures the phases have represented pregnancy and delivery.

Many cultures have feared the three days during which the Moon is not visible, and they have warned against embarking upon new enterprises on those days, during which the Moon is said to have been killed by its celestial rivals, though the first appearance of the crescent marks its revival. Incidentally, both the beginning and the end of the month-long Muslim fast of Ramadan are declared upon the first sighting of the new crescent.

All cultures have imagined gods, heroes, and beasts delineated among configurations of stars in the night sky. Vast numbers of people around the world, since the beginning of civilization, have believed that the positions of the planets relative to certain constellations have a direct bearing on human behavior. The locus of astrology is the Zodiac, the circular belt of twelve constellations within which, when viewed from Earth, the Sun. the Moon, and the planets all appear to move.

The name is derived from the ancient Greek *zodiakos kyklios*, meaning "circle of animals." Modern astrology seems to have originated in Greece and in Hellenistic Egypt, from which it spread to the Sudan and to India, Indonesia, China, and Polynesia.

The stars have been studied more frequently than they have been worshipped. The most important and widely disseminated stellar texts have generally been almanacs, either astrological or navigational. The directional reliability of Polaris, the North Star, was recognized very early, and this speck of light that has guided many a hunter and many a sailor toward home has been variously called "the nail of the world" or "the pillar of heaven."

The Milky Way, the swath of stars that arcs across part of the night sky, has been viewed as the footsteps of God, the road to Zeus's palace, the path along which souls travel to Heaven, or the seam of the heavenly tent.

Human beings have always gazed into the heavens and believed that out there, somewhere, could be found the answers to the big questions: What is the nature of God? What is our role in the universe? How and when was the universe created, What was there before the universe existed? Does the universe have an outer limit? If so, what is beyond it? Will the universe ever come to an end? If so, when? Gathered together in this book are some of humankind's finest artistic and literary attempts to come to terms with such questions.

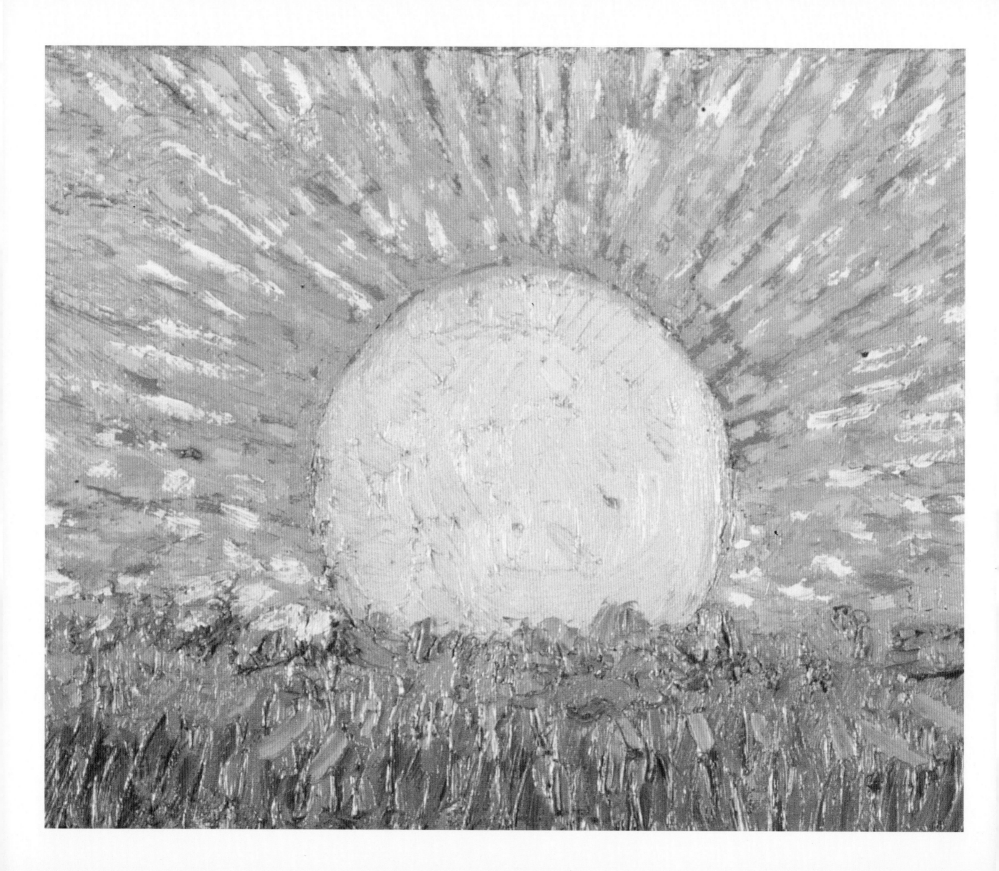

The Sun
&
the Solar System

*Give me the splendid silent sun
with all his beams full-dazzling.*

—WALT WHITMAN

*t*he Sun is a thoroughly unexceptional star—of average age, medium size, and medium temperature. It is classified as a G2 yellow dwarf about 4.5 billion years old, with a diameter 109.3 times greater than that of Earth, and a surface temperature of about 10,000°F.

The Sun's extremely dense core has a diameter of about 250,000 miles. Within that core, at temperatures around 27,000,000°F and under hundreds of millions of tons of pressure, rages the nuclear fusion of hydrogen into helium (named for a Greek sun god). The released energy takes about one million years to make its way from the core to the surface. The energy passes outward first through the radiative zone (about 200,000 miles thick), then through the convective zone (about 125,000 miles thick), to the surface layer, known as the photosphere (about 300 miles thick). Beyond the photosphere lies the corona, emitting the solar wind, which extends outward for many millions of miles.

The Sun has used up about 65 percent of its nuclear fuel. About five billion years from now the Sun will develop into a red giant, hundreds of times its present size, with its entire mass engaged in nuclear fusion. After vaporizing everything in the solar system, it will collapse into a white dwarf of extreme intensity, until it completely burns itself out.

The average distance of Earth from the Sun is approximately 93,000,000 miles. Sunlight, traveling at 186,000 miles per second, takes about 8.3 minutes to reach Earth, which receives only one part in 2.2 billion of the Sun's total output. During periods of bright sunlight, the energy reaching a single square mile of Earth's surface equals about four million horsepower.

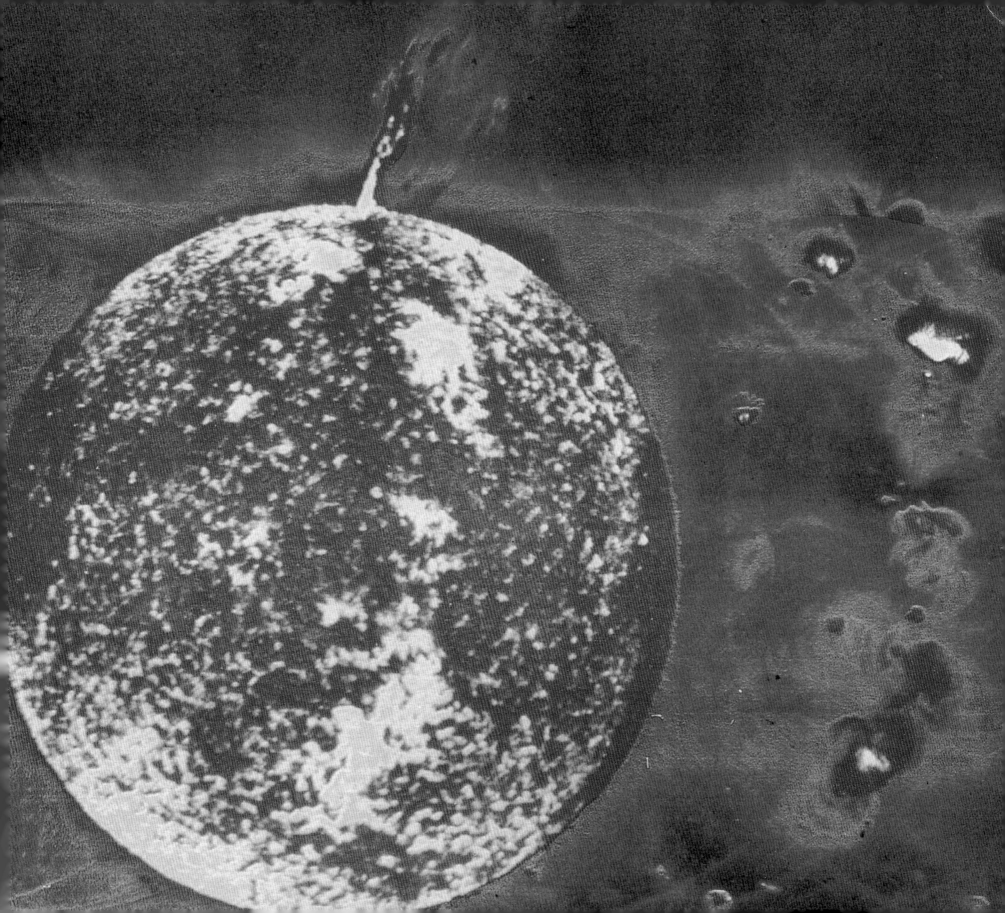

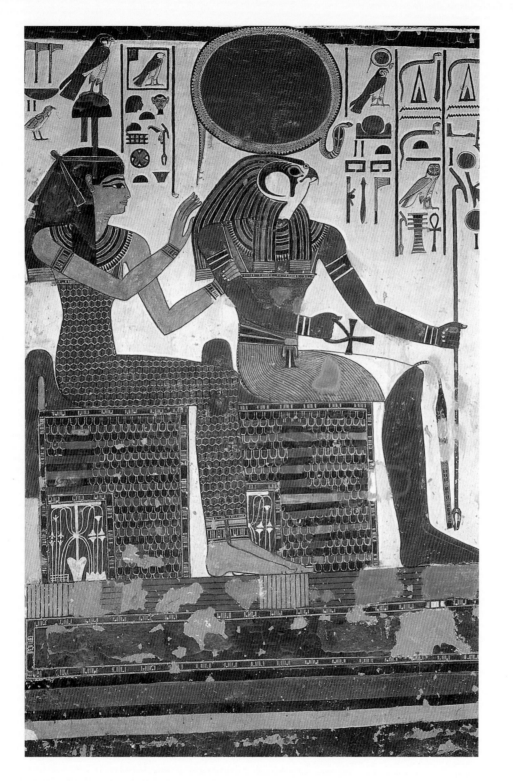

The principal god in the Egyptian pantheon was Ra (or Re), god of the Sun as the giver of light and warmth, often depicted as a disk encircled by a snake. The Egyptians had several gods who represented various aspects of the Sun, and Ra himself often formed hybrids with other gods, such as the falcon-headed sky god Horus, one of whose eyes was said to be the Sun, the other the Moon. Sometimes Horus balances the Sun disk on his head; alternately, Horus is shown as a winged Sun disk. Many pharoahs claimed to be embodiments of Horus; others styled themselves sons of Ra.

Egyptian
RA-HORAKHTY, THE SUN-SKY GOD, c. 1215 B.C.
Fresco. University of Basel, Switzerland

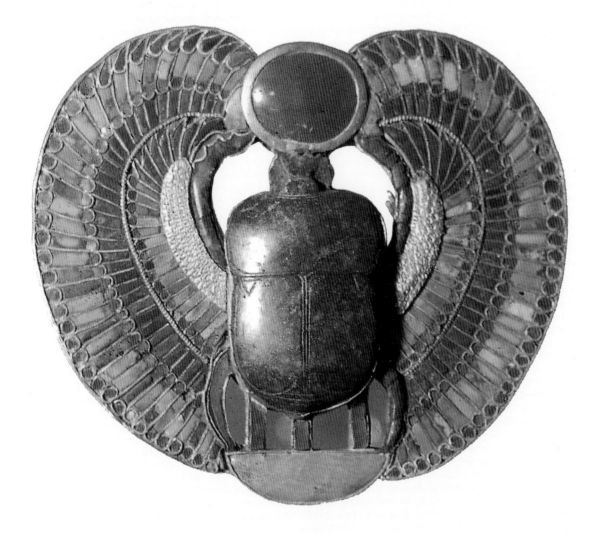

SCARAB PECTORAL, c. 1332–1322 B.C.
Found in the tomb of Tutankhamun
Gold and semi-precious stones
Egyptian Museum, Cairo

To the ancient Egyptians the dung beetle, known as a scarab, was an important symbol of the Sun. The ball of dung that such a beetle pushes along the ground came to represent the Sun being rolled through the sky, and the scarab thus became the god Khepri, the divinity of the morning Sun. Furthermore, the Egyptians believed that when the scarab burrows underground with its ball of dung the beetle lays its eggs and then dies; the newborn scarab was thought to feed on the dung before emerging to repeat the cycle, in which the Egyptians naturally saw an analogy to the daily solar cycle. Because of this cycle of death and rebirth, the scarab was associated with immortality.

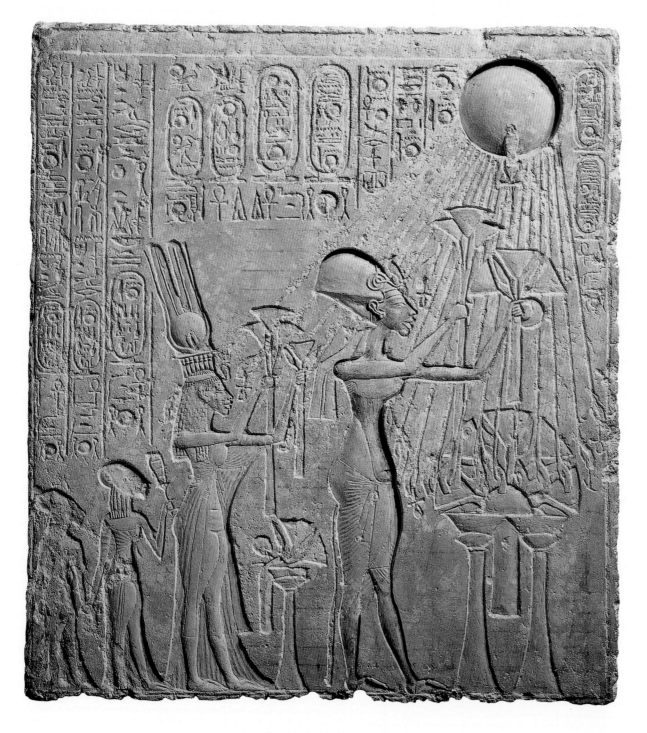

The Sun disk as one of the heavenly bodies was worshipped as Aton or Aten. The pharoah Amenhotep IV (ruled 1379–1362 BC) established a monotheistic religion devoted to Aton and changed his own name to Akhenaton (He Who Represents Aton). The new cult, perhaps the first monotheistic religion in history, died with the pharoah.

Beautiful is your shining forth on the horizon, O living Aton, beginning of life! When you arise on the eastern horizon, you fill every land with your beauty.

—HYMN TO ATON, REIGN OF AKHENATON

THE PHAROAH AKHENATON WORSHIPPING THE SUN, c. 1353 B.C.
Limestone
Egyptian Museum, Cairo

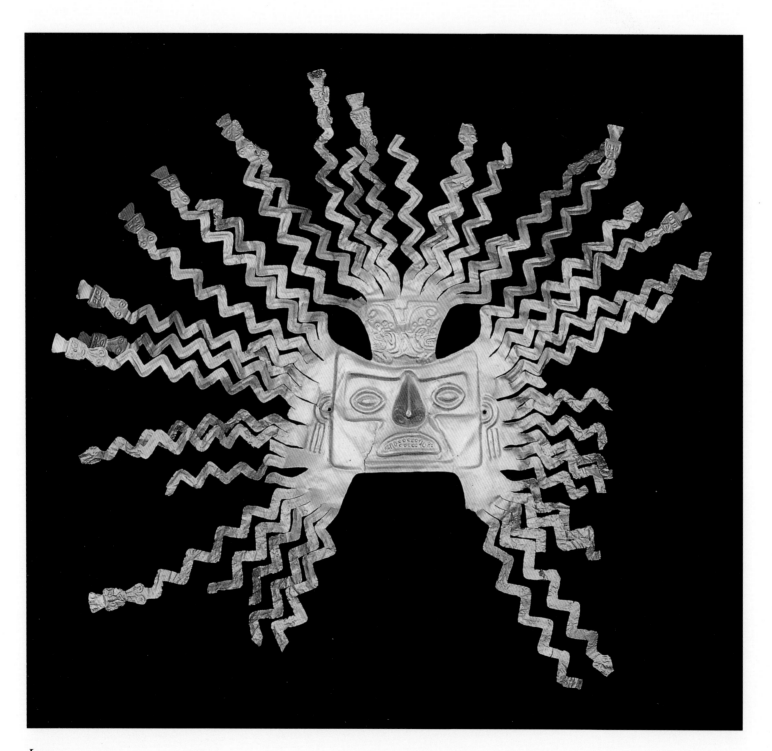

Inca
INTI, THE SUN GOD, 15TH CENTURY
Gold. Museo Arqueologico y Galerias de Arte
del Banco Central, Quito, Ecuador

15

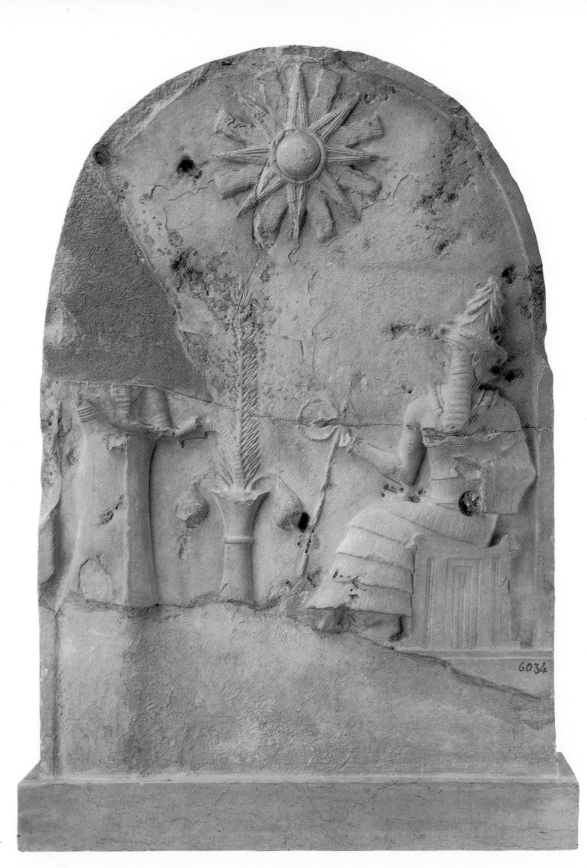

From the city of Susa, Mesopotamia
A BABYLONIAN KING SEATED BEFORE THE SUN
GOD SHAMASH, 20TH-19TH CENTURY, B.C.
Limestone
Musée du Louvre, Paris

6034

16

Afghanistan
MEDALLION OF CYBELE, 4TH CENTURY B.C.
Bronze and gilt, diameter approx. 6 inches
National Museum, Kabul

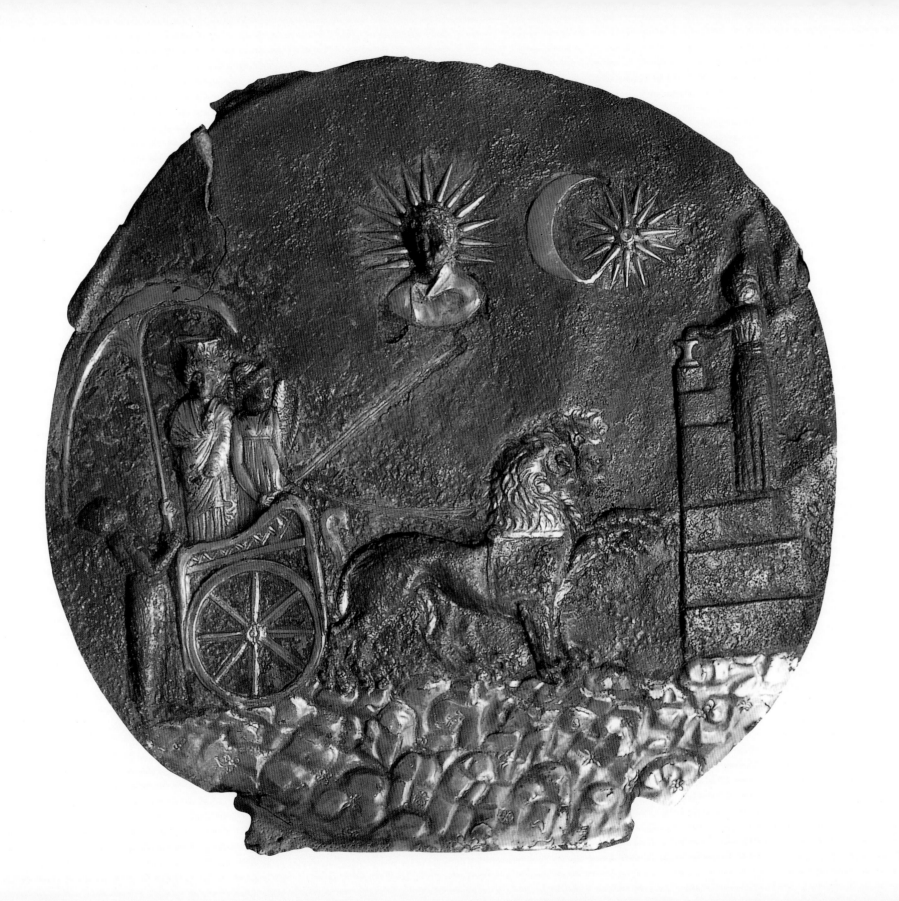

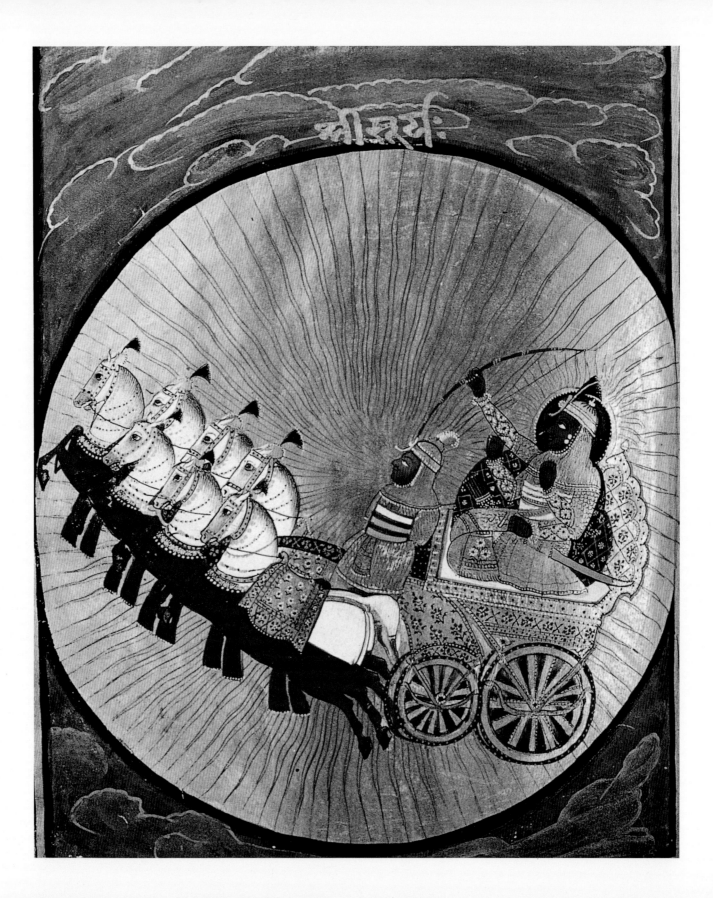

18

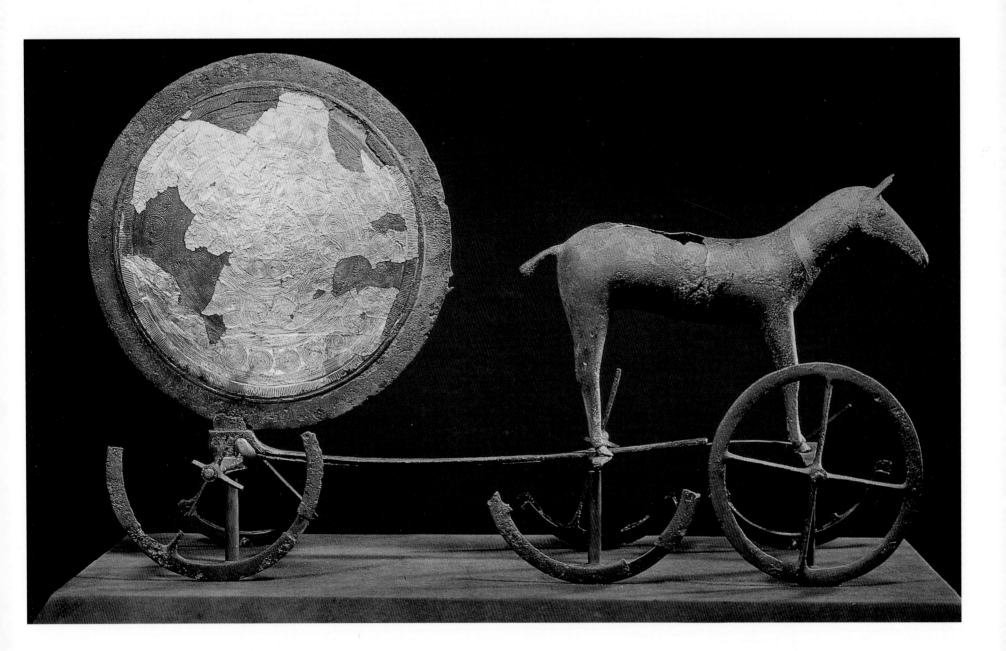

Mewar School , India
THE SUN CHARIOT OF SURYA, 18TH CENTURY
Tempera and gilt on paper, 9 1/2 x 8 inches
Private collection

THE TRUNDHOLM CHARIOT,
WITH THE SUN DISK, BRONZE AGE
Bronze and gilt
Nationalmuseet, Copenhagen

19

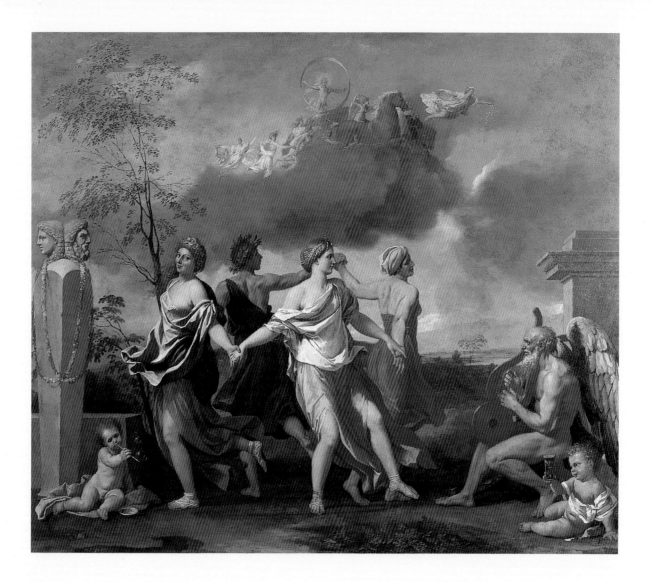

The four dancing figures in the painting above represent, from left to right, Pleasure (crowned with roses), Poverty (a male youth with a laurel wreath), Wealth (with pearls in her hair), and Labor. Father Time plays the lyre, while a putto beside him holds an hourglass. In the sky Apollo drives the chariot of the Sun, preceded by Aurora strewing her rose petals of the dawn, and surrounded by her attendants, the Hours. The golden band around Apollo is the ring of the Zodiac.

The illustration on page 22 shows the top half of a highly finished oil sketch for a fresco executed in the royal palace in Madrid by Corrado Giaquinto. Apollo appears in all his glory as god of the sun, a role that he began to acquire during the fifth century B.C. To the earlier Greeks, who revered him above all other deities, Apollo was the god of reason, law, and purification. The son of Zeus and the brother of Diana, he was associated with music and prophecy. Helios, a secondary deity quite distinct from Apollo, was the god of the Sun, and his sister Selene was the goddess of the Moon. Gradually, however, Apollo took on Helios's role, while Diana took on Selene's. He became Phoebus (Radiant) Apollo, the ideal of male physical beauty, driving the sun-chariot with its team of four horses yoked abreast, and in that role he became the enemy of darkness as a symbol of ignorance and evil. His cult grew supreme in Roman times.

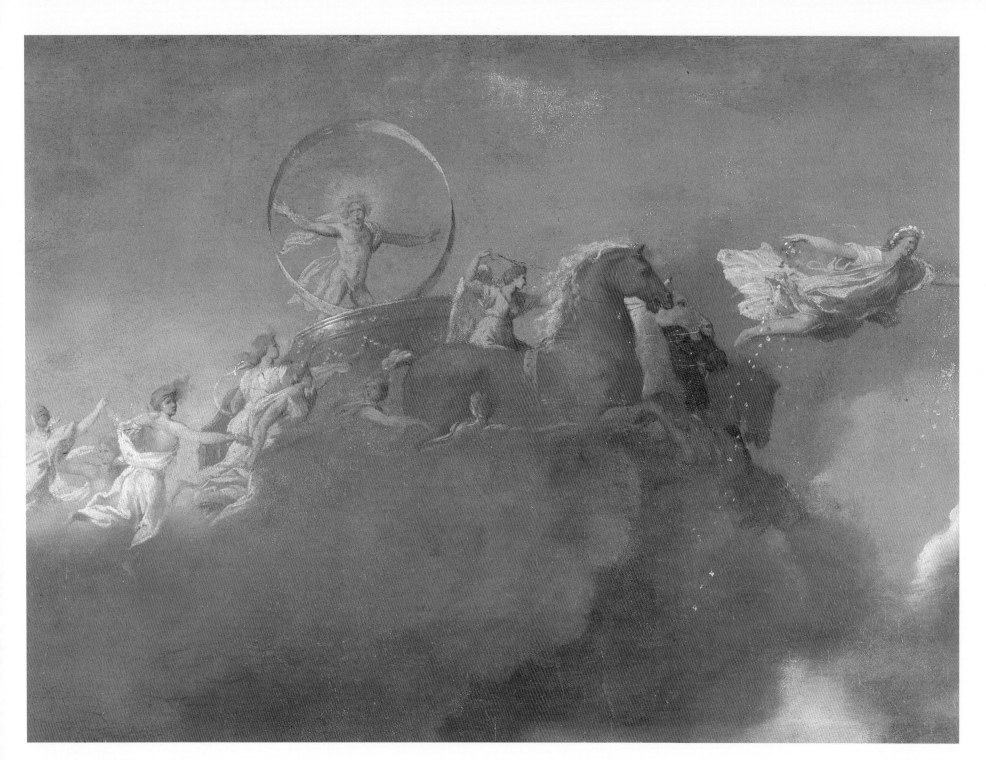

(opposite and above)
Nicolas Poussin
A DANCE TO THE MUSIC OF TIME, c. 1639
Oil on canvas, 33 1/2 x 41 3/8 inches
Wallace Collection, London

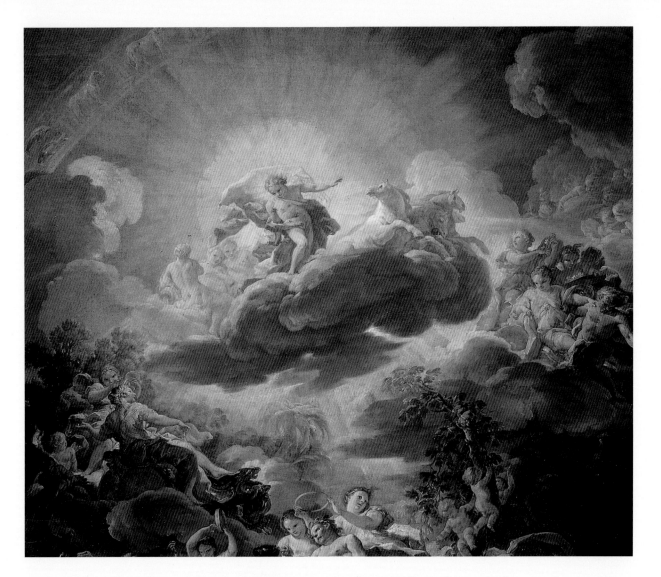

Corrado Giaquinto
THE BIRTH OF THE SUN AND THE
TRIUMPH OF BACCHUS (detail), *c. 1761*
Oil on canvas, 66 1/8 x 55 1/8 inches
Museo del Prado, Madrid

Gustave Moreau
THE FALL OF PHAETHON (detail), *1878*
Watercolor and crayon on paper,
39 x 25 5/8 inches
Musée d'Orsay, Paris

In the upper left corner of the above illustration can be seen four of the signs of the Zodiac: Pisces, Aries, Taurus, and part of Gemini. The subject of the lower half of the painting is the triumph of Bacchus, accompanied by the goddess Diana, wearing a crescent moon in her hair. The symbolism is clear: the licentious Bacchus may thrive in the darkness of ignorance and chaos, but his kingdom is swept away with the coming of Apollo, representing the Spanish king, who wished to be seen as the upholder of law, order, justice, and virtue.

In his *Metamorphoses* Ovid tells the story of Phaethon, the son of Helios (see illustration on facing page). Every day Helios drove across the sky in his splendid golden chariot pulled by four horses. Phaethon desired above all else to take his father's place, even if only for one day, and he entreated his father to grant him this wish. Finally Helios relented, against his better judgment. Early the next morning Phaethon set off in the shining chariot, but the horses soon realized that their driver did not have the strength to control them. They swerved from their appointed course until, frightened by the scorpion in the Zodiac (or by the lion, according to Moreau), they bolted and Phaethon dropped the reins. The chariot dipped so low that the earth began to catch fire, at which point Jupiter killed Phaethon with a thunderbolt—though Moreau shows him about to be bitten by the terrible serpent Python, who would be killed by Apollo. The boy's body plunged into a river, and the horses pulled the driverless sun-chariot home. Phaethon has become a symbol of aspirations that exceed one's capabilities.

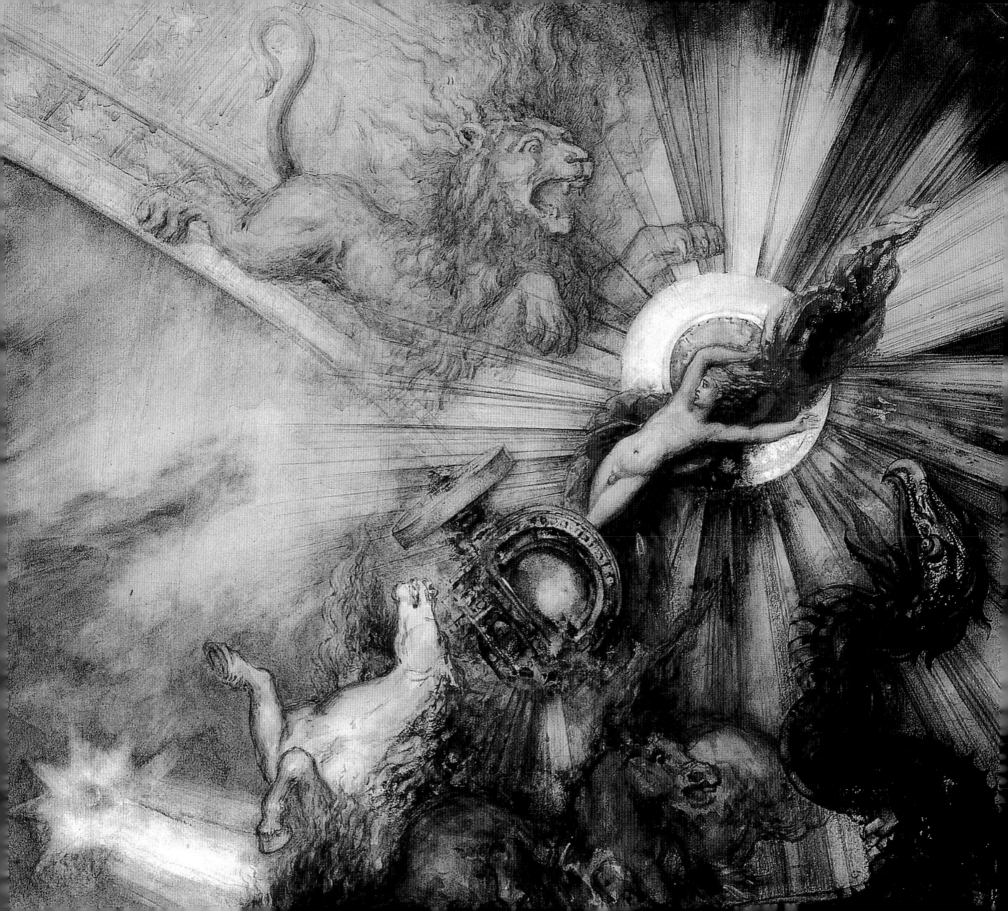

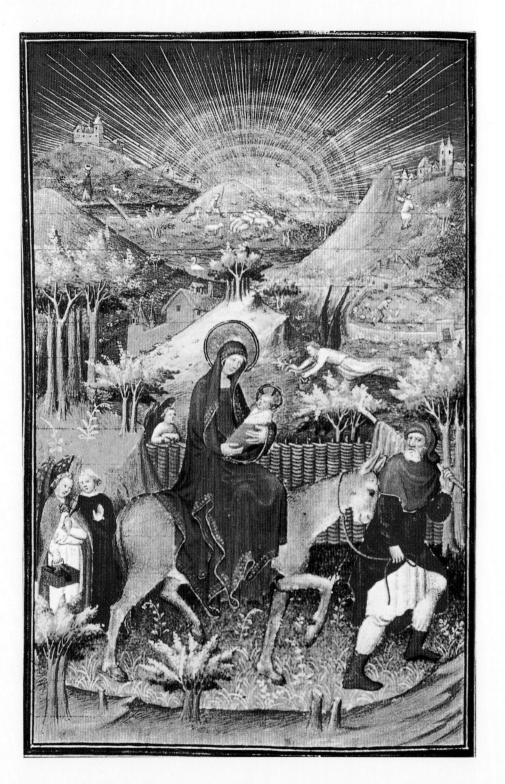

Limbourg brothers
THE MONTHS OF JANUARY (far right)
AND SEPTEMBER (near right)
TRÈS RICHES HEURES DU DUC DE BERRI, c. 1413–1416
Tempera and gold on vellum
Musée Condé, Chantilly

The book of hours known as the *Très Riches Heures du Duc de Berri,* one of the most magnificent of all illuminated manuscripts, was the work of Pol Limbourg and two of his brothers. They received their early training as apprentices to a Parisian goldsmith, and their experience in making intricate jewelry partly accounts for the exquisitely rendered detail of their paintings.

The finest pages in the *Très Riches Heures* are those of the calendar with which the book begins. The twelve paintings, one for each month, depict both aristocratic and peasant life with unprecedented realism, successfully integrating the figures with the landscape they inhabit. Above each painting is shown the chariot of the sun and the signs of the Zodiac that govern the month.

THE FLIGHT INTO EGYPT.
French Book of Hours, early 15th century
Tempera and gold on vellum
Collection unknown

24

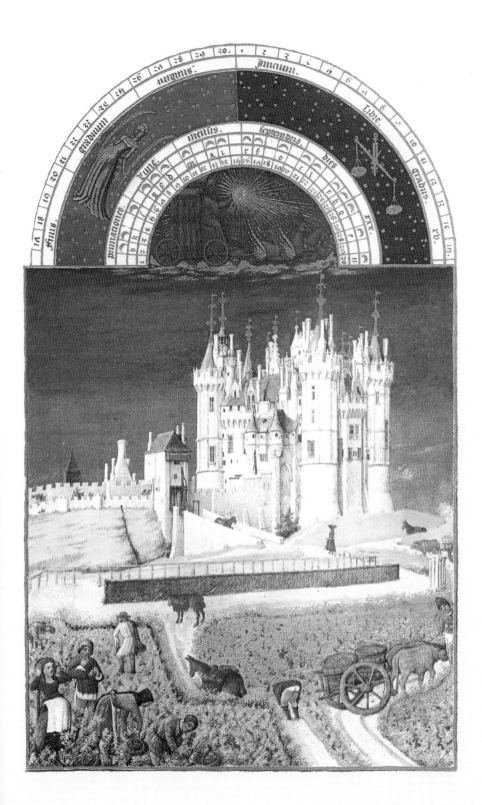

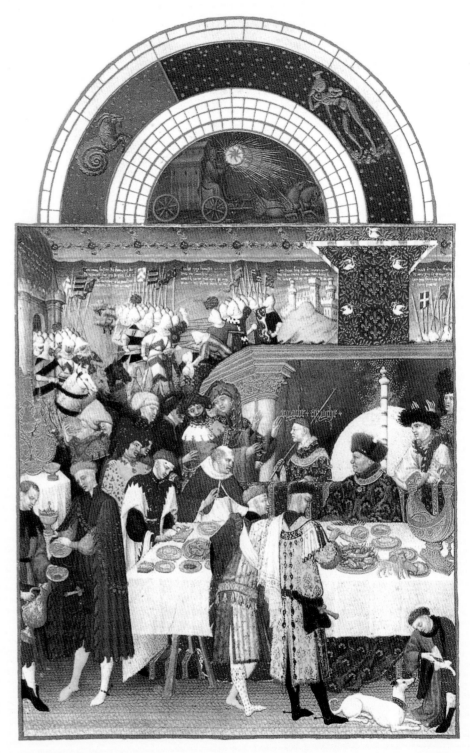

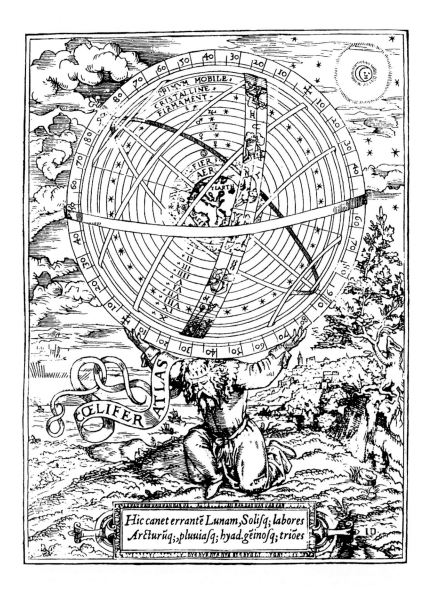

Claudius Ptolemæus, the most influential astronomer and geographer of the ancient world, lived in Alexandria during the second century after Christ. Ptolemy, as he is generally known, asserted that the Earth is an immovable sphere in the center of the universe; around it moved—in the following order of increasing distance from the Earth—the crystalline spheres to which were attached the Moon, Mercury, Venus, the Sun, Mars, Jupiter, Saturn, and the "fixed" stars. Outermost of the material spheres was the Primum Mobile (prime mover), beyond which were the three spheres of the Holy Trinity and then the fiery Empyrean, beyond time and space, the sphere of God as First Cause. In direct contact with the divine spheres, the Primum Mobile was said to spin at an infinite speed, providing the force that moved all the inner spheres at much slower speeds.

Ptolemy was a tireless observer of the sky and, because his theory was incorrect, he had to perform some mathematical acrobatics in order to reconcile his ideas with his observations. Believing that the planets, as perfect bodies, could move only in circles, he worked out a system of epicycles—small circles with their centers lying on the large circular orbit—to explain the discrepancies between fact and theory.

Ptolemy also compiled a catalog of more than one thousand stars, a work that remained without a rival until the fourteenth century. He was so certain of the value of his astronomical findings that he had them engraved upon two stone pillars that were then erected in Alexandria.

Ptolemy's conception of the universe remained dominant until the seventeenth century, by which time the evidence accumulated in support of the theory Copernicus had published in 1543 became so great that all serious astronomers had to accept it, despite the continued Ptolemaic dogma of the Roman Catholic Church.

THE PTOLEMAIC UNIVERSE SUPPORTED BY ATLAS, 1559
Library of Congress, Washington, DC

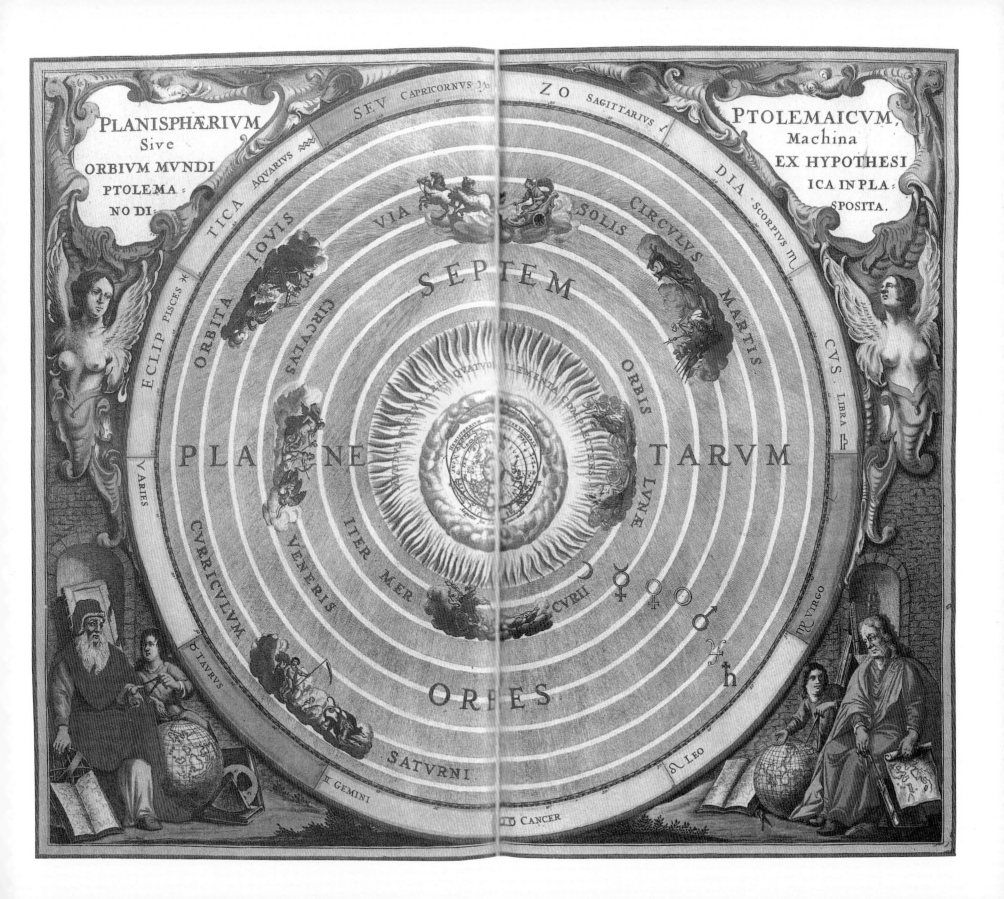

The astrolabe, invented by the Greeks in the 3rd century B.C. to measure the altitudes of celestial bodies, may have been the earliest of all true scientific instruments. During the Middle Ages, Islamic astronomers perfected the astrolabe as a navigational tool by means of which mariners could determine their latitude.

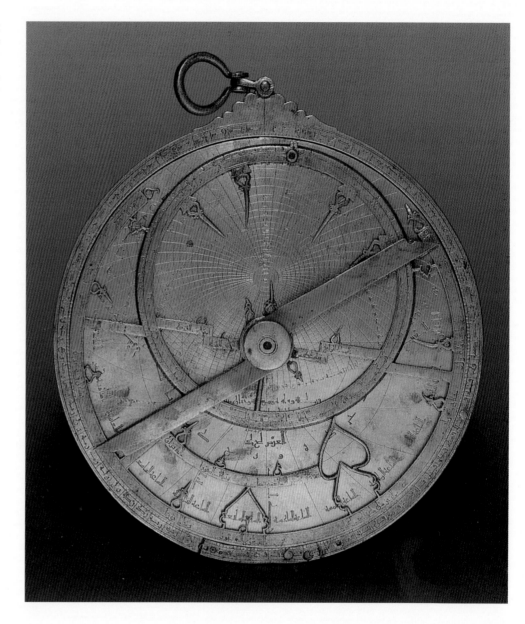

ASTRONOMERS ON MOUNT ATHOS, c. 1410–1420
from a volume of illustrations to Sir John Mandeville's TRAVELS
Pen and watercolor on vellum, 8 7/8 x 7 1/8 inches
The British Library, London. Add. Ms. 24189, fol. 15r

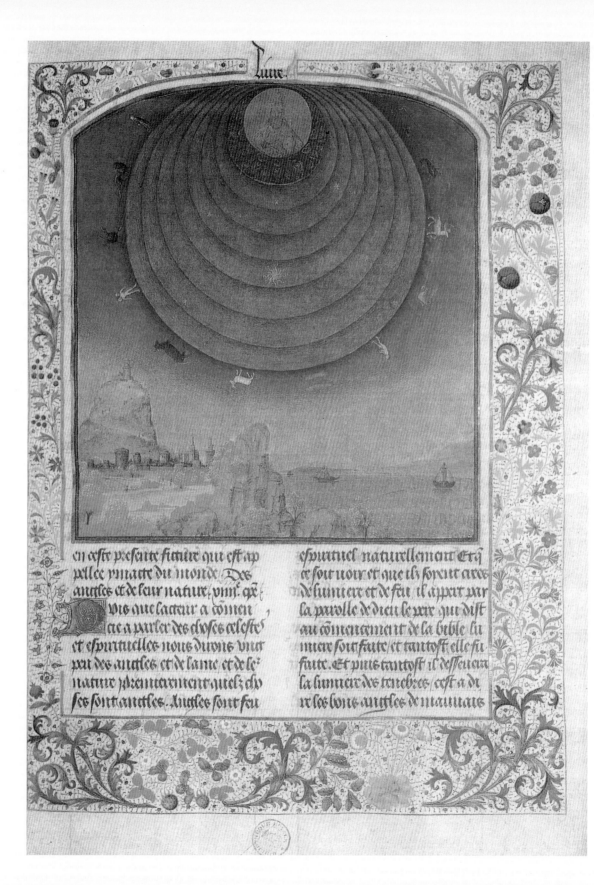

en ceste presente fieuur qui est ap
pellee vmaue du monde. Des
angeles et de leur nature. pruf. qz
uis que lacteur a comen
ce a parler des choses celestes
et espirituelles. nous dirons vnr
peu des angeles. et de lame et de le
natuure premierement quelz cho
ses sont angeles. Angeles sont feu

espurtuel naturellement Et q̃
ce soit noir et que ils sorent arex
de sumiere et de feu il apert par
la parolle de dieu le xxx qui dist
au comencement de la bible lu
miere sont faue et tantoft elle su
faite. Et puis tantost il desseuea
la sumier des tenebres cest a di
re ses bons angeles de mauuais

Simon Marmion
THE SPHERES OF THE FIRMAMENT, c. 1460
in *LE LIVRE DES SEPT AGES DU MONDE (The Book of the Seven Ages of the World)*, calligraphy and borders executed in the workshop of Jacquemart Pilavaine, Mons.
Tempera and gold on vellum, 17 5/16 11 13/16 inches
Bibliothèque Royale Albert I, Brussels, Ms. 9047

Simon Marmion, who became known during his lifetime as the "prince of illuminators," was a Burgundian artist who developed a style combining mystical and realistic elements. Here the cosmic spheres float above a landscape with a river, a town, and a mountaintop castle. Marmion's diagram makes sense only if we understand that we are looking down upon it (or perhaps looking upward into it), so that God is not in the central sphere but rather at the top of the heirarchical arrangement.

THE RED SUN
in Salomon Trismosin, SPLENDOR SOLIS
Gouache and gold on vellum, 1582
The British Library, London, Ms. Harley 3469, fol. 33v

The final and climactic painting in a series of twenty-two illustrations for the alchemical allegory Splendor Solis, the splendor of the sun, a saga in which the opposing principles of the sun and the moon merge into a harmonious entity. This is accomplished only after a series of sexual couplings, chemical transformations, and physical ordeals. The red sun shown here represents the last stage in the production of the coveted "philosopher's stone," whwould convert lead into gold, and which would restore youth and health to the elderly. Indeed, the narrator of the Splendor Solis claimed to have lived 150 years in youthful vigor since producing the stone, by means of which he enabled ninety-year-old women to give birth to many babies.

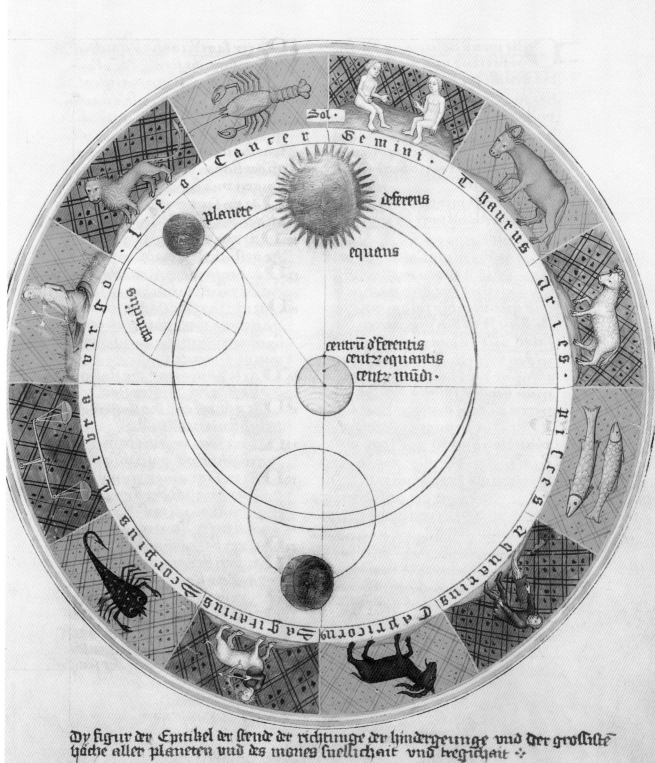

Dy figur der Epicikel der stende der richtunge der hindergeunge vnd der grossiste
höche aller planeten vnd des mones snellichait vnd tregichait ⁂

The diagram of the Zodiac and solar, lunar, and planetary orbits illustrates an early fifteenth-century Austrian manuscript that contains German translations of two important works on astronomy. The first is the *Sphaera Mundi* by John Holywood, an outstanding thirteenth-century English astronomer and mathematician who taught at the University of Paris and who was known by the literal Latinization of his name: Johannes de Sacrobosco.

The manuscript's second work is a treatise by the Arabic scholar Abd-al-Aziz, known in medieval Europe as Alchabitius. The diagram shows the variable orbits that the sun and planets appeared to follow when observed by astronomers who believed that Earth was the immovable center of the universe.

The woodcut of the Earth with the Sun and Moon illustrated an edition of Sacrobosco's wok printed in Venice in 1485, seven years before Columbus set off to discover a western route to the Indies. In reviving Ptolemy's assertion that the Earth is spherical, Sacrobosco provided the decisive inspiration for Columbus's voyage.

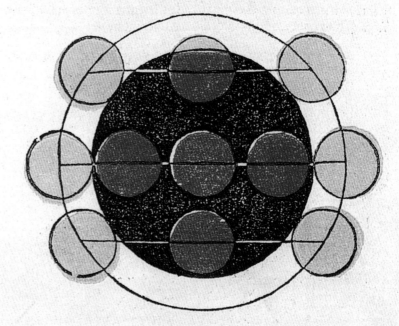

Minuta moræ dimidiæ funt minuta zodiaci quæ luna Solem fuperando a principio totalis obfcurationis ufcp ad mediũ eius perambulat.

THEORICA ECLIPSIS LVNARIS.

Minuta cafus in eclipfi folari funt minuta quæ luna a pricipio eclipfis ufcp ad mediũ fupatióe fua ultra Solem pficit. Quare fi minuta ifta p fu

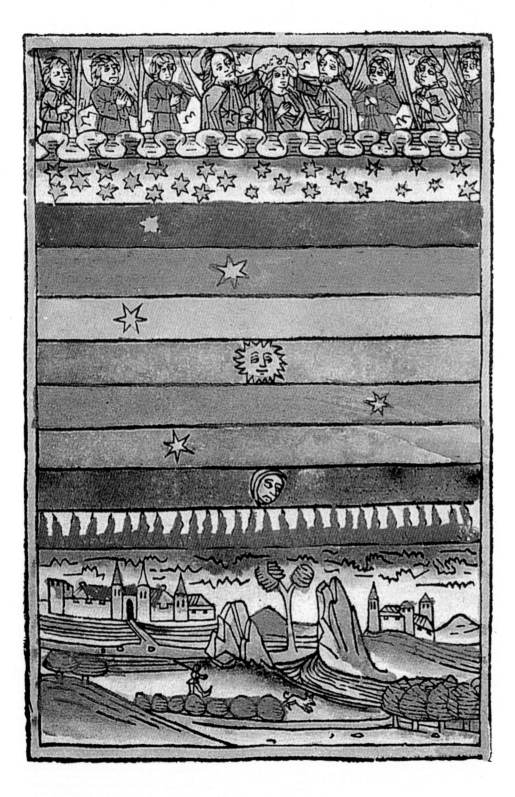

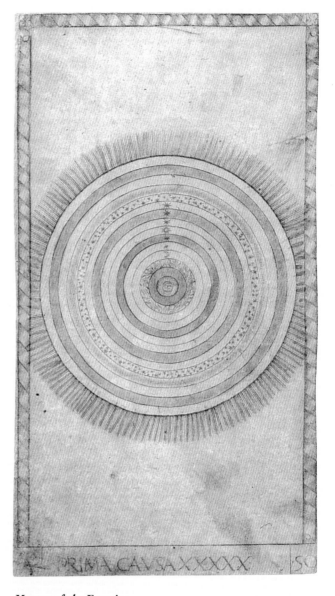

Master of the E-series
PRIMA CAUSA (FIRST CAUSE)
Engraving, 7 x 3 7/8 inches
National Gallery of Art, Washington, DC

DIAGRAM OF THE COSMOS,
from Konrad von Megenberg, BUCH DER NATUR.
(Augsburg, 1481), Hand-colored woodcut
Library of Congress, Washington, DC

(*opposite, left*) Konrad von Megenberg wrote his compendium of nature lore in Latin during the thirteenth century, and it was subsequently translated into a number of languages. One of the first printed editions was this German version, illustrated with woodcuts, which in some copies of the book were handcolored. At the bottom of the cosmic diagram reproduced here we see a terrestrial scene that includes three of the four basic elements: earth, water, and air. The fourth, fire, is in the band just above. The ascending bands represent, respectively, the moon, Mercury, Venus, the sun, Mars, Jupiter, Saturn, the fixed stars, and God with his saints and angels governing the whole system.

(*opposite, right*) Although the sets of fifty cards from which comes the one reproduced here have been traditionally called tarocchi (tarot cards), they were apparently used for some long-forgotten didactic game. Each set was made up of the following distribution of cards: the ten heirarchical conditions of man, Apollo and the nine muses, the ten liberal arts (Poetry, Philosophy, and Theology being added to the tradtional seven), the three cosmic powers (the Genius of the Sun, the Genius of Time, and the Genius of the World), the seven virtues, and the ten firmaments of the universe. The cards exist in two versions, the so-called E-series and the S-series.

(right) Mercury and Venus are shown to revolve around the Sun, which in turn revolves around the Earth. Mars, Jupiter, and Saturn are shown to orbit that inner semi-geocentric configuration.

DIAGRAM OF THE PLANETARY SYSTEM, 16TH CENTURY
from a manuscript of the works of Martianus Minneus Felix
Capella (active late 4th and early 5th centuries A.D.)
Biblioteca Nazionale Marciana, Venice. Ms. lat. XIV. 35, fol. 143r

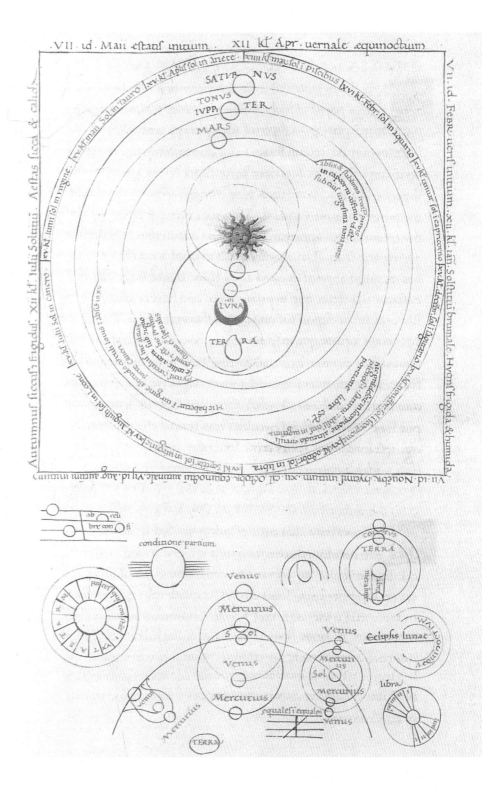

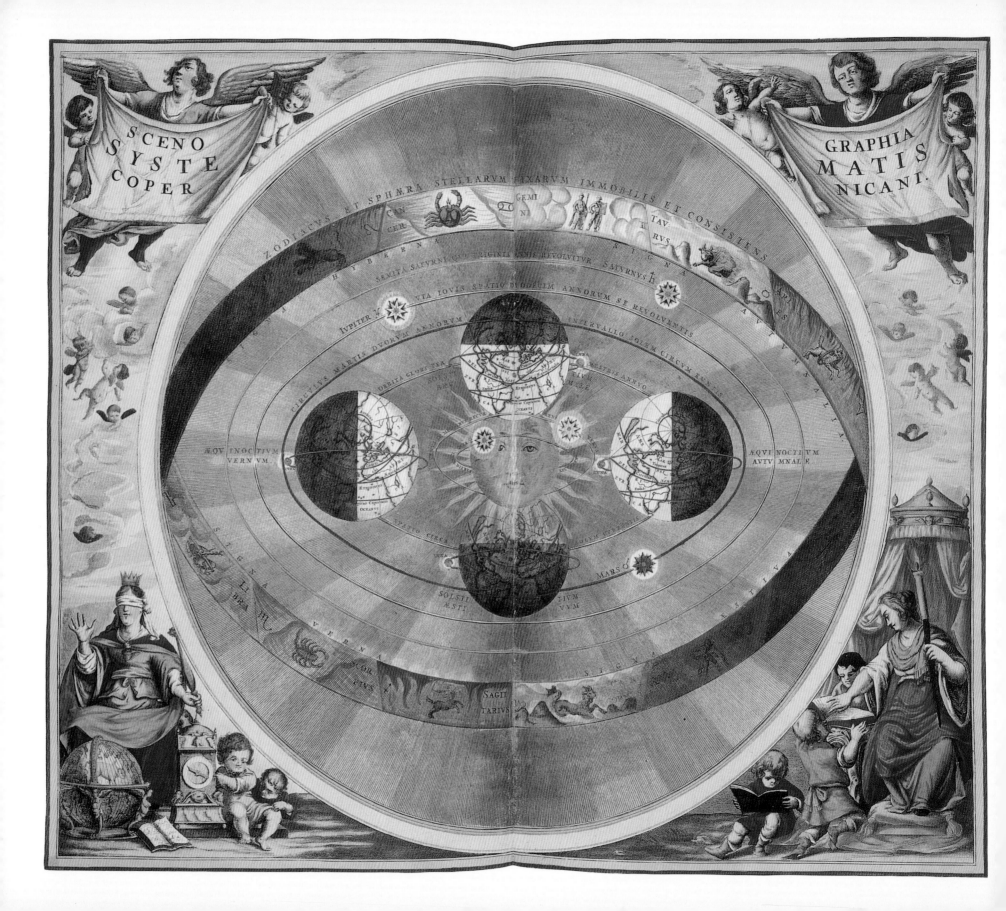

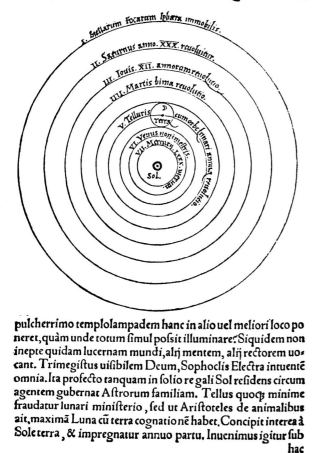

NICOLAI COPERNICI

net, in quo terram cum orbe lunari tanquam epicyclo contineri
diximus. Quinto loco Venus nono mense reducitur. Sextum
denicʒ locum Mercurius tenet, octuaginta dierum spacio circu
currens, In medio uero omnium residet Sol. Quis enim in hoc

pulcherrimo templo lampadem hanc in alio uel meliori loco po
neret, quàm unde totum simul possit illuminare? Siquidem non
inepte quidam lucernam mundi, alij mentem, alij rectorem uo:
cant. Trimegistus uisibilem Deum, Sophoclis Electra intuentē
omnia. Ita profecto tanquam in solio re gali Sol residens circum
agentem gubernat Astrorum familiam. Tellus quocʒ minime
fraudatur lunari ministerio, sed ut Aristoteles de animalibus
ait, maximā Luna cū terra cognatiōnē habet. Concipit interea à
Sole terra, & impregnatur annuo partu. Inuenimus igitur sub
hac

(left)

THE COSMOS ACCORDING TO COPERNICUS
from Andreus Cellarius (Andreas Keller), Atlas Coelestis (Amsterdam, 1660)
Biblioteca Comunale dell'Archiginnasio, Bologna

(above)

DIAGRAM OF THE SOLAR SYSTEM
*from Nicolaus Copernicus, DE REVOLUTIONIBUS ORBIUM COELESTIUM
(On the Revolutions of the Celestial Spheres), Nuremberg, 1543*

Born in Poland in 1473, Nicolaus Copernicus became interested in astronomy while studying at the University of Cracow. He subsequently spent three years at the University of Bologna, studying mathematics, learning Greek, and reading Plato. In 1497 an uncle who was a bishop obtained for him a post in the canonry of the Polish cathedral of Frauenburg, a sinecure that would give him lifelong financial independence. Copernicus then spent three years studying medicine, law, and astronomy at the University of Padua. Although he would practice medicine, using his skills to help the poor of Frauenburg, it was in astronomy that he made a truly revolutionary contribution. By about 1510 Copernicus had become convinced that the Sun, not the Earth, was at the center of the planetary system; only the Moon revolved around the Earth, which was now first recognized as being itself a planet, one of six revolving around the sun in circular orbits.

For more than twenty years, Copernicus worked out the mathematical calculations to support his claim. In 1533 he went to Rome to lecture on the subject to Pope Clement VII, who granted his permission to publish the new theory. Copernicus stalled until until 1540, when he allowed his manuscript to be taken to Nuremberg for publication, but then Martin Luther and his cohorts objected to the theological implications of a heliocentric universe. The work was not published until 1543, after the Lutheran theologian Andreas Osiander had added, without Copernicus's knowledge, a preface maintaining that heliocentricy was merely a convenient fiction to simplify calculations of planetary movements. Because of that disclaimer, the book was not placed on the Index of Prohibited Books until 1616, after the first Galilean crisis.

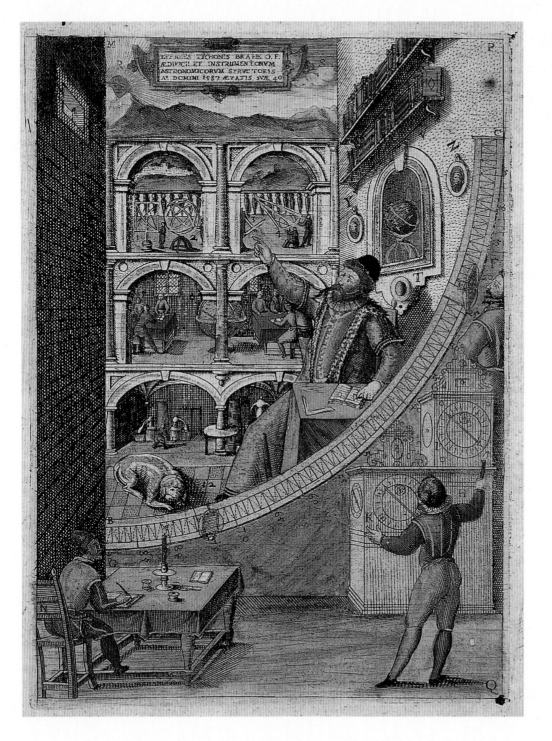

TYCHO BRAHE IN HIS OBSERVATORY, 1598
Hand-colored woodcut from Brahe's book
ASTRONOMIAE INSTAURATA MECHANICA
Library of Congress, Washington, DC

While studying law at the University of Copenhagen, Tycho Brahe (whose nose was cut off in a sword duel and replaced by a metal prosthesis) was astounded when the prediction that a solar eclipse was to take place on August 21, 1560, proved to be correct. From then on he devoted most of his life to astronomy.

A tireless observer of the heavens, Brahe corrected the positions of hundreds of stars on celestial maps. In 1572 he observed the appearence of a new star in the constellation of Casseopeia; this nova posed a serious challenge to the Aristotelian notion that the stars were perfect and unchanging.

Because his observations convinced him the planets revolve around the sun, Tycho proposed a modified version of the Copernican planetary system. He argued that the Earth is indeed the stationary center of the system; around it revolves the Sun, and the planets in turn orbit the Sun.

THE COSMOS ACCORDING TO TYCHO BRAHE
from Andreus Cellarius (Andreas Keller),
ATLAS COELESTIS (Amsterdam, 1660)
Biblioteca Comunale dell'Archiginnasio, Bologna

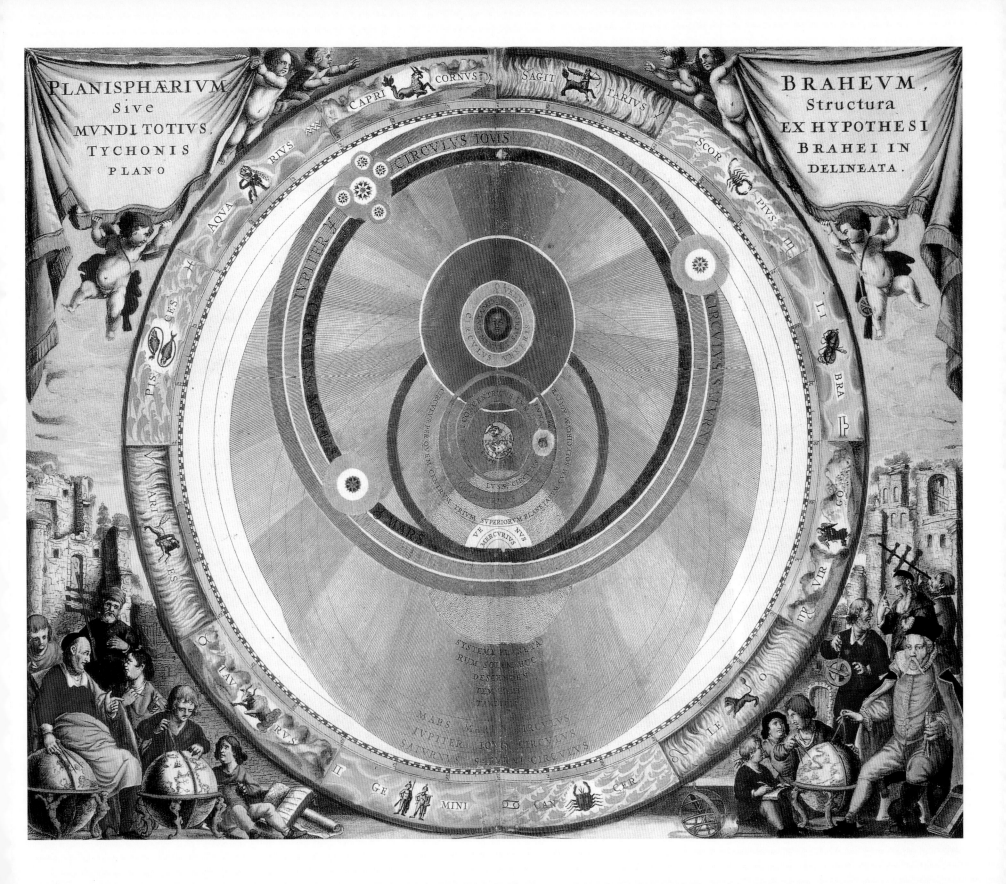

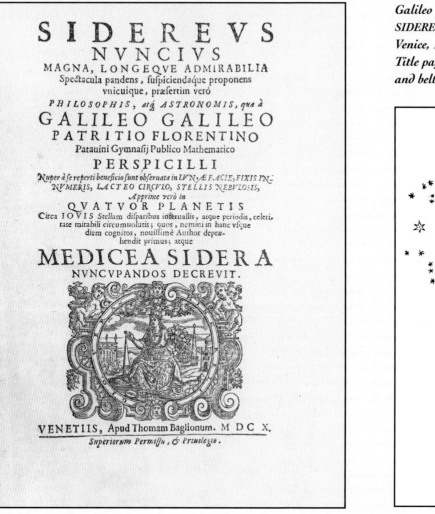

Galileo Galilei
SIDEREUS NUNCIUS (The Starry Messenger)
Venice, 1610
Title page and diagram of the stars in the sword
and belt of the constellation Orion.

In the summer of 1609 Galileo made the first telescope capable of astronomical observation. Using his invention, he made many discoveries, which he published in his 24-page book *The Starry Messenger*, the first edition of which appeared in Venice in 1610. In it Galileo reported his discovery of four "planets" orbiting around Jupiter; in honor of his Florentine patrons he called these satellites (the largest of Jupiter's sixteen now known) the Medicean stars. He was the first to describe lunar mountains and valleys. And he reported on his observations of the Milky Way, of innumerable fixed stars, of nebulae, and of earthshine.

In his book Galileo strongly endorsed Copernicus's revelation that the Sun, not the Earth, was at the center of the solar system. Galileo's Copernican position brought him into trouble with the Church. In 1615 he was officialy forbidden to publish anything further about astronomy. Eventually, in 1632, he defied the Inquisition and published a book in the form of a dialogue between the Ptolemaic and the Copernican systems, in which the latter, of course, emerges victorious. The following year Galileo was taken to Rome to stand trial before the Inquisition, which forced him to abjure his claim that the Earth moves around the Sun. Tradition has it that Galileo then muttered, "Nevertheless, it does move."

During the late 1580s Johannes Kepler studied astronomy at the University of Tübingen with one of the few professors of the time to accept Copernicus's heliocentric system. Kepler had planned to become a Lutheran minister, but when he was offered a job teaching mathematics at the Lutheran high school in Graz, Austria, he accepted the position. It was during his tenure that he published his first work, a Copernican dissertation on the "Cosmographic Mystery" that was part mathematical and part mystical. He sent a copy to Tycho Brahe, the imperial astronomer of the Holy Roman Empire. Although Brahe dismissed Copernicus's ideas as nonsense, he was impressed by Kepler's mathematical abilities and invited the young man to work at the imperial observatory, near Prague. After they had worked together for only one year, Brahe died and Kepler was promptly appointed the new imperial astronomer—and astrologer, with responsibility for casting the emperor's horoscopes.

In 1609, the year before Galileo's *Starry Messenger*, Kepler published a book entitled *Astronomia Nova* (The New Astronomy), in which he expounded two of his three revolutionary laws of planetary motion: (1) the planetary orbits are elliptical, not circular, and one focus of each ellipse is located at the Sun; (2) each planet travels at varying speeds, in such a way that for equal periods of time the areas inside the ellipse swept by an imaginary line from the planet to the Sun are equal. Ten years later, in 1619, Kepler published his third law in his book *Harmonices Mundi* (Harmonies of the World): the ratio between the square of the time a planet takes to complete one orbit and the cube of its mean distance from the Sun is the same for all of the planets. His laws laid the foundation for Isaac Newton's theory of universal gravitation.

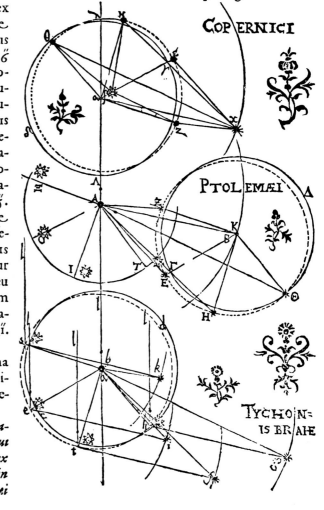

COMPARISON OF ORBITS ACCORDING TO COPERNICUS, PTOLEMY, AND TYCHO BRAHE, from Johannes Kepler's ASTRONOMIA NOVA (Heidelberg, 1609)

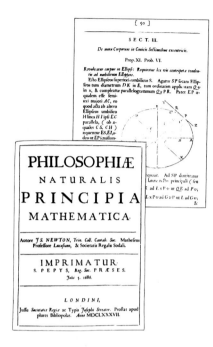

In August 1684 Edmond Halley, the discoverer of the comet that bears his name, went to Cambridge University to visit Isaac Newton. They discussed Kepler's third law and attempts by others to account for the phenomenon it describes by positing the existence of a force emanating from the Sun. Robert Hooke had suggested that Kepler's third law implies that the strength of such a force must diminish in proportion to the inverse square of the distance of a planet from the Sun, but Hooke was unable to work out the mathematics necessary to prove his insight. Newton had done many of these calculations nearly twenty years earlier but had mislaid them. At Halley's urging, he resumed work on them. The eventual result was one of the most important books in the history of science: *Philosophiae Naturalis Principia Mathematica* (The Mathematical Principles of Natural Philosphy), published for the Royal Society in 1687.

In the *Principia* Newton demonstrated that the movements of not only everything on Earth but also of all the bodies in the solar system could be explained in light of the law of universal gravitation and the basic laws of dynamics. With this stroke Newton, who was deeply religious, shattered the traditional notion of a universe that was kept in motion by the constant, active participation of the divine. In its stead, Newton revealed a clockwork universe running relentlessly according to strict scientific principles. God seemed relegated to the role of clockmaker, standing aside to admire the functioning of his perfect, harmonious system.

Newton's immensely influential conception of the universe remained unchallenged until Einstein published his theory of relativity. Newton became the first Englishman to be knighted for his contributions to science.

Joseph Wright, known as Wright of Derby, was a member of the famous Lunar Society, composed of industrialists, scientists, inventors, philosophers, artists, and medical doctors. The group, whose members lived in the British Midlands, around Derby and Birmingham, took its name from its custom of meeting monthly on the Monday nearest the full moon. From about 1764 until the early 1780s, the watershed years of the Industrial Revolution, the men met regularly to discuss scientific and technological questions.

Their hero was Newton, who had died in 1727. It was to make Newton's conception of the solar system comprehensible to laypeople that the Earl of Orrery had underwritten George Graham's invention of a clockwork machine, named for its patron, to move models of the planets through their relative orbits around the Sun, which was usually represented by a brass ball. Wright's painting shows a Newton-like "natural philosopher" (the term then current for "scientist") giving a private demonstration of an orrery to a group consisting of three men, a woman, and three children. The lecturer has placed an oil lamp in the center to represent the Sun, most likely in order to illustrate the phenomenon of a lunar eclipse.

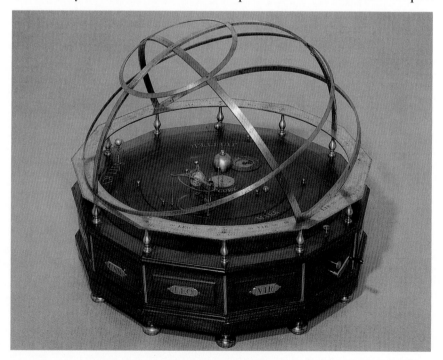

ORRERY, 18TH CENTURY. Science Museum, London

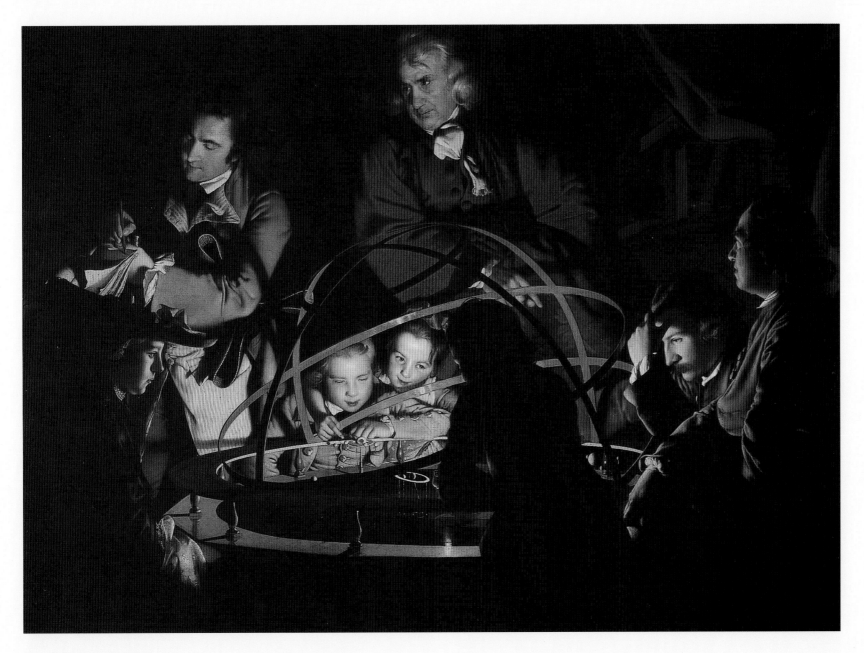

Joseph Wright of Derby
A PHILOSOPHER GIVING THAT LECTURE ON THE ORRERY, IN
WHICH A LAMP IS PUT IN THE PLACE OF THE SUN, 1766
Oil on canvas, 58 x 80 inches
Derby Art Gallery

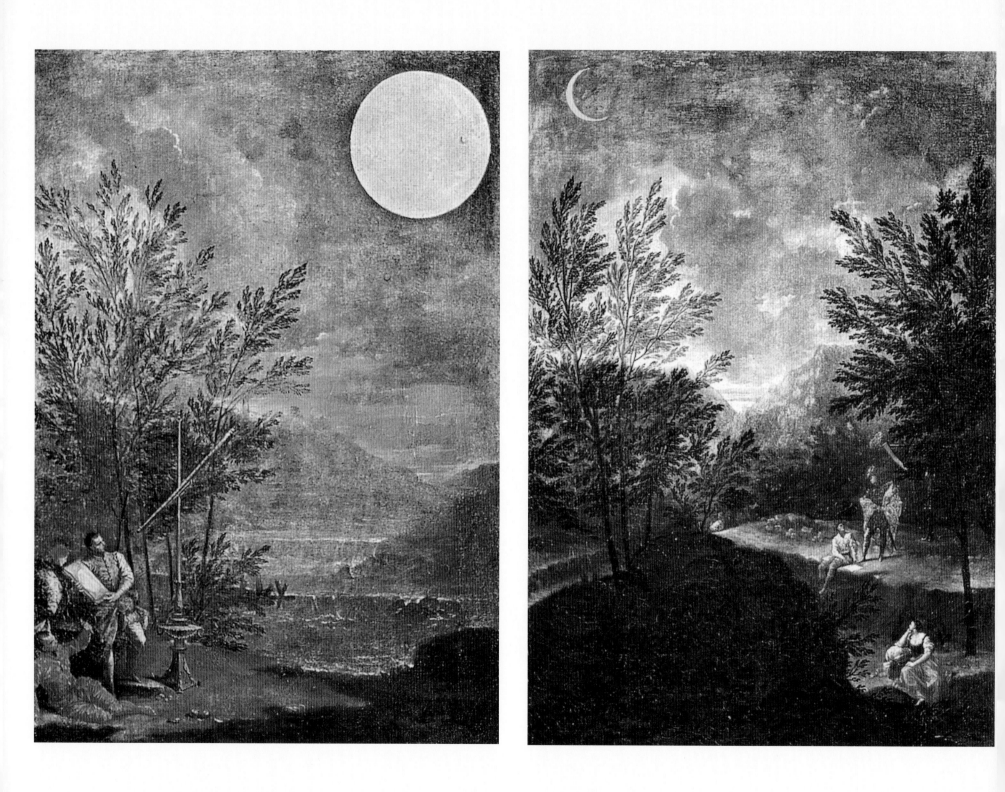

44

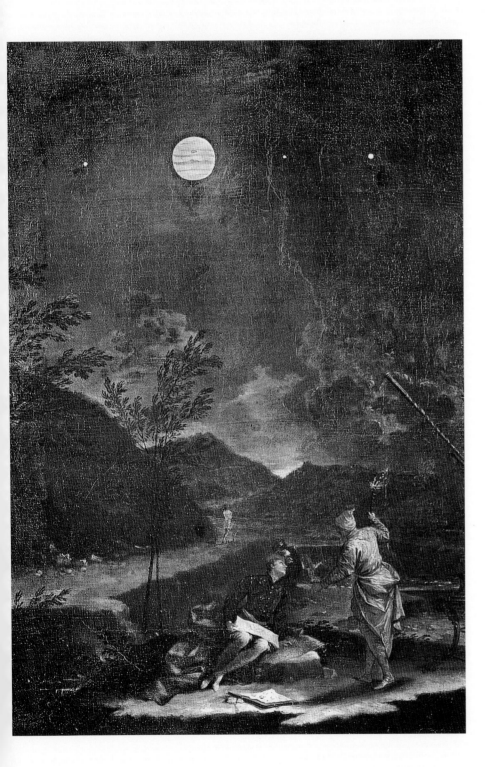

Eight paintings—of the Sun, the Moon, a comet, and the five planets then known, all as seen through a telescope and thus greatly out of proportion to the landscape—were commissioned in 1711 by Count Luigi Ferdinando Marsili, a military man who was an amateur astronomer. In 1703 Marsili had set up an observatory in his Bolognese palazzo. Eight years later he decided to donate all of his equipment to the city of Bologna if the civic government would build a suitable observatory. Because Bologna was under pontifical authority, this appeal was directed to the pope. To support the petition, Marsili commissioned Creti to make this series of paintings to charm the pope into assenting, as he did.

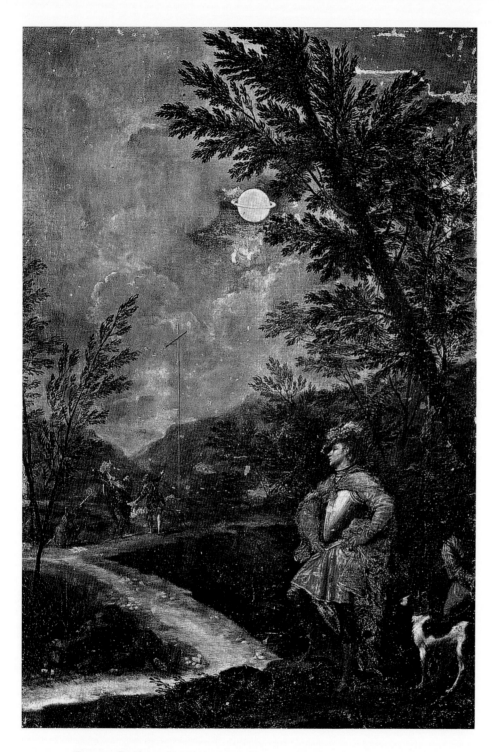

Donato Creti
ASTRONOMICAL OBSERVATIONS: SATURN, 1711
Oil on canvas, 20 1/4 x 13 3/4 inches
Vatican Museum, Rome

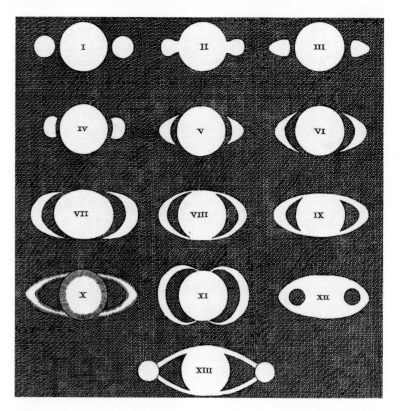

Fold-out page from Christiaan Huygens,
SYSTEMA SATURNIUM (The Hague, 1659)
Library of Congress, Washington, DC

Huygens was the first to understand that Saturn is surrounded by a flat band of rings. In his book he illustrates the incorrect conceptions that his predecessors—all of whom thought they were looking at the planet from the top rather than from the side—held about Saturn's strange appearance. Hevelius, for instance, postulated that the planet was bracketed by two crescent-shaped satellites. The misconceptions diagrammed by Huygens were held by the following:
I: Galileo, 1610
II: Scheiner, 1614
III: Riccioli, 1641 or 1643
IV-VII: Hevelius, 1640s
VIII-IX: Riccioli, 1648-1650
X: Divini, 1646-1648
XI: Fontana, 1636
XII: Biancani, 1616; Gassendi, 1638-1639
XIII: Fontana, 1644-1645

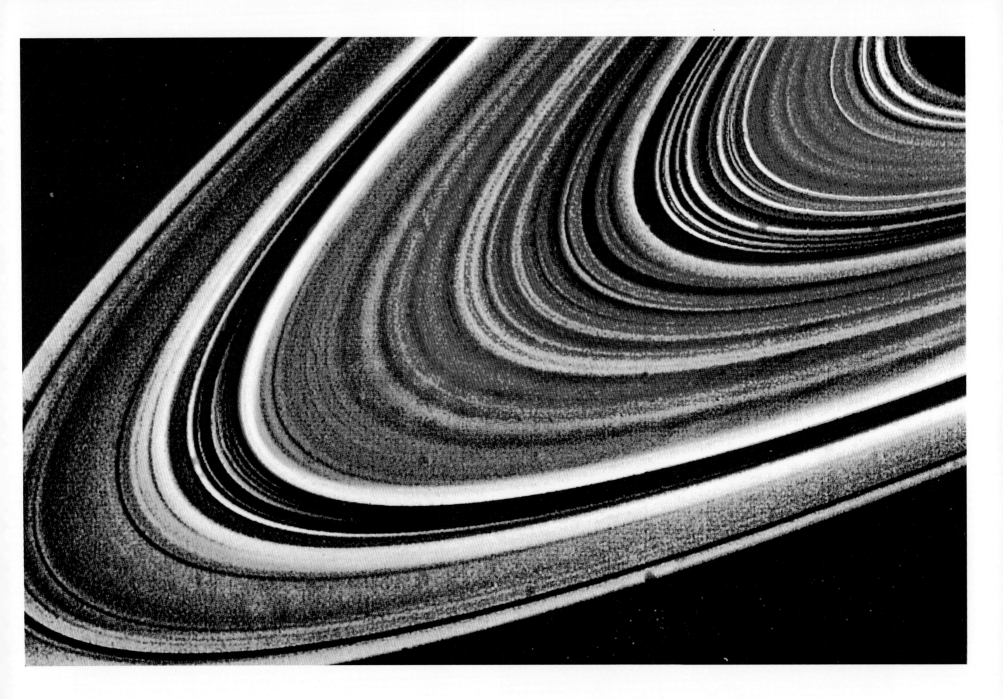

Voyager space probe
THE RINGS OF SATURN, 1981
Computer-enhanced photograph
Courtesy the National Aeronautics and Space Administration (NASA)

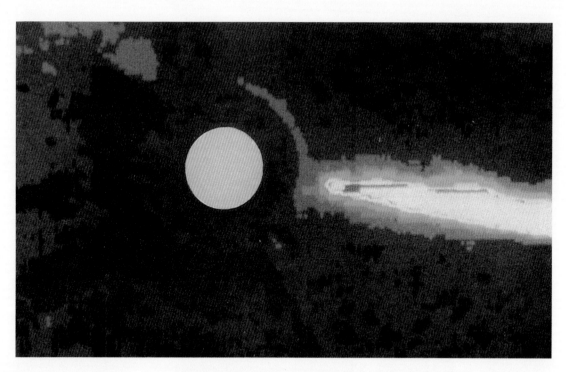

(right) **D. J. Michels, Naval Research Laboratory, Washington, DC**
COMPUTER-ENHANCED SOLWIND CORONA-GRAPH OF A COMET ABOUT TO COLLIDE WITH THE SUN, 1979

(below left) **Pioneer Venus Orbiter**
COMPUTER-ENHANCED COMPOSITE INFRARED PHOTOGRAPH OF VENUS FROM DATA GATHERED BETWEEN 4 DECEMBER 1978 AND 14 FEBRUARY 1979

(below right) **C. R. Lynds, S. P. Worden, and J.W. Harvey, Kitt Peak National Observatory, Arizona**
COMPUTER-ENHANCED PHOTOGRAPH OF THE SURFACE OF BETELGEUSE, 1974
The first photograph of the surface of a star other than the Sun.

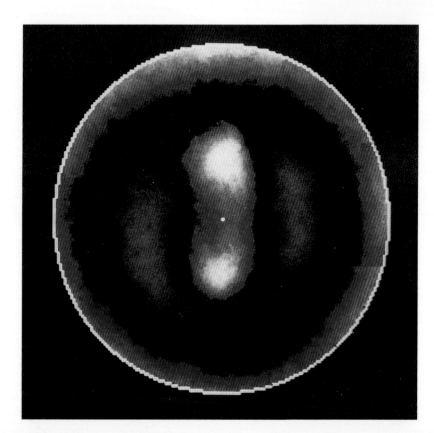

Antoine Pralon
WHICH PAINTER COULD IMAGINE THE STRANGE LIGHT OF A
WORLD ILLUMINATED BY FOUR SUNS AND FOUR MOONS? 1881
from Camille Flammarion, ASTRONOMIE POPULAIRE.

A fantastic illustration of the surface of a planet with four moons in a distant solar system with four suns. This lithograph appeared in the 1881 edition of Camille Flammarion's extremely popular layman's guide to astronomy, which went through many editions published by the great French firm which bears his name.

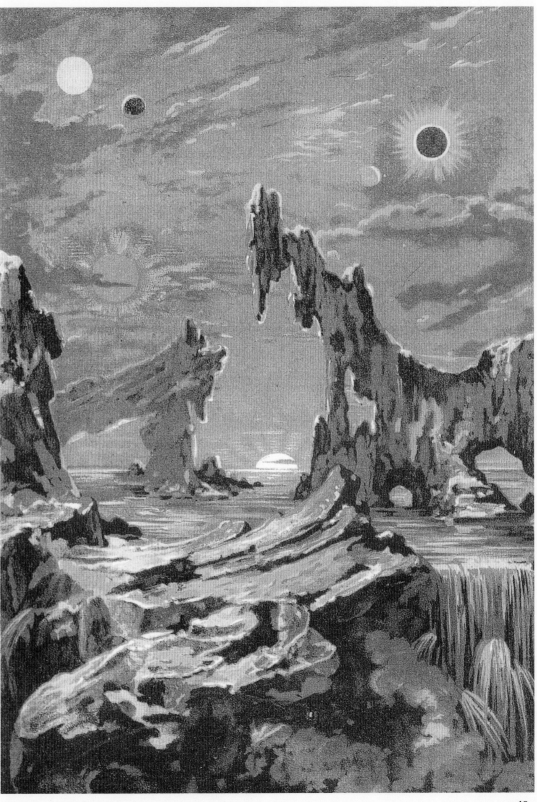

Jean Lurçat
SOLAR TAPESTRY, 1957
Wool, silk, and gold thread
Private collection

India
THE SUN, 18TH CENTURY
Gouache and gold on paper
Private collection

This tantric painting represents the sun as the primal, spiritual light that pervades one's entire being in a state of enlightenment. The painting was intended to be focused upon during meditation as an aid to becoming filled with the light of all-unifying love.

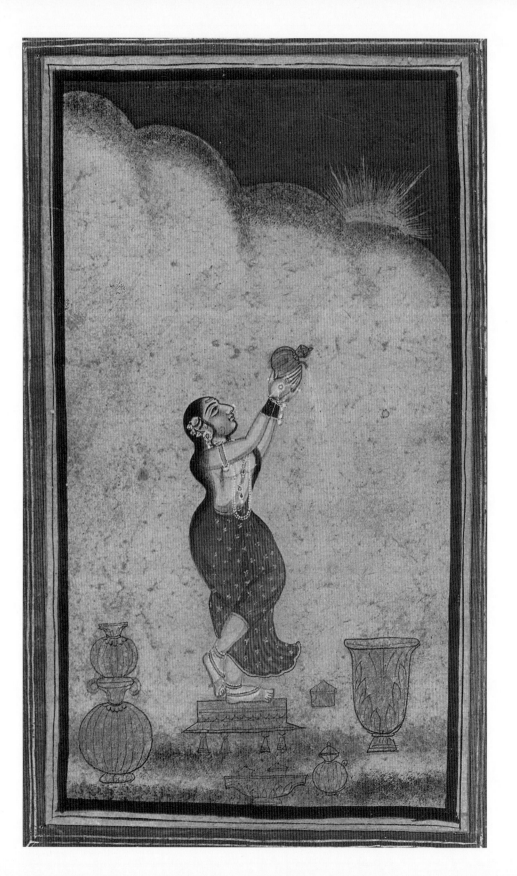

Mewar School, India
A LADY WORSHIPPING THE RISING SUN, c. 1775–1800
Tempera on paper, 3 3/4 x 6 3/4 inches
Private collection

*A*dore the Sun,
rising with all his rays,
receiving the obeisance
of gods and demons,
the shining maker of light.

—THE RAMAYANA

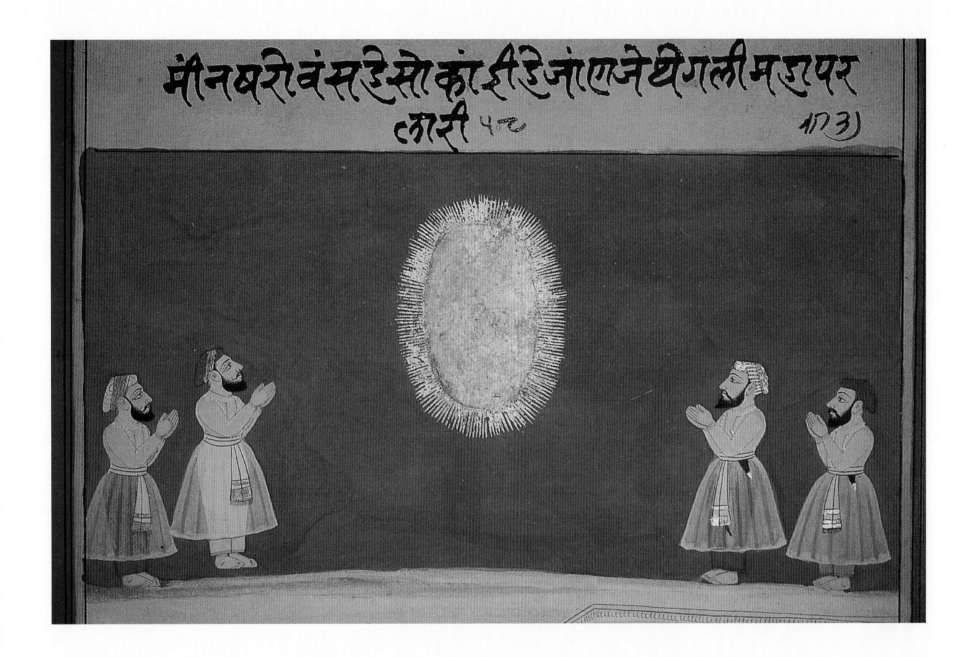

Mughal School, India
DEVOTEES WORSHIPPING THE SUN, 18TH CENTURY
Tempera on paper, 8 x 10 inches
Private collection

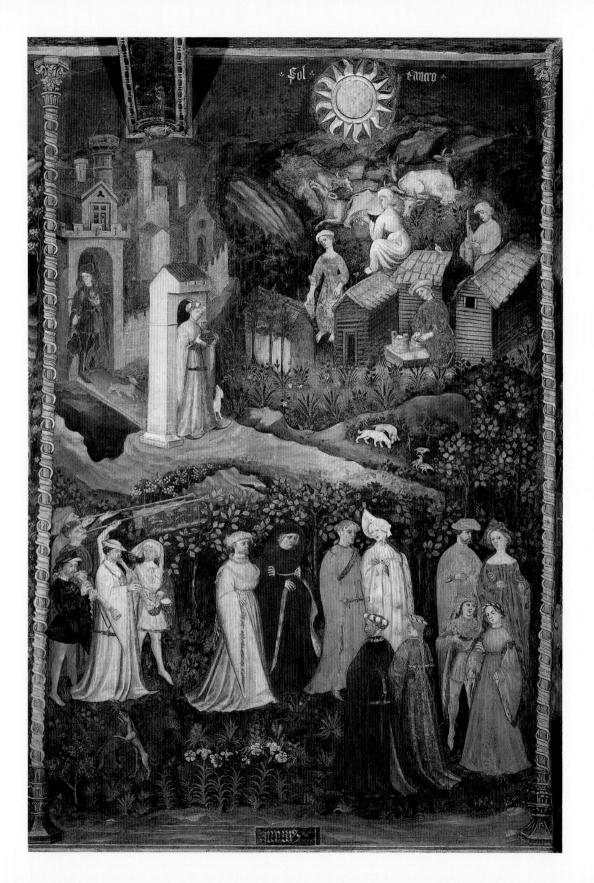

(right)
William Blake
AS IF AN ANGEL DROPPED DOWN FROM THE CLOUDS, 1809
Pen and watercolor
The British Museum, London

An illustration for Act IV, Scene I of Shakespeare's *Henry IV, Part I.* There, Richard Vernon relates how he saw Prince Henry, in full armor, gracefully mount his horse—how he did

> *Rise from the ground like feather'd Mercury,*
> *And vaulted with such ease into his seat,*
> *As if an angel dropp'd down from the clouds,*
> *To turn and wind a fiery Pegasus,*
> *And witch the world with noble horsemanship.*

Although Blake illustrated Shakespeare's image quite literally, he also invested the drawing with his personal symbolism, of which he wrote: "The Horse of Intellect is leaping from the cliffs of Memory and Reasoning; it is a barren Rock; it is also called the Barren Waste of Locke and Newton." Blake despised the work of those two men as hostile to the poetic imagination.

COURTLY PROCESSION
Fresco
Castel del Buonconsiglio, Trento
Courtesy Art Resource, New York

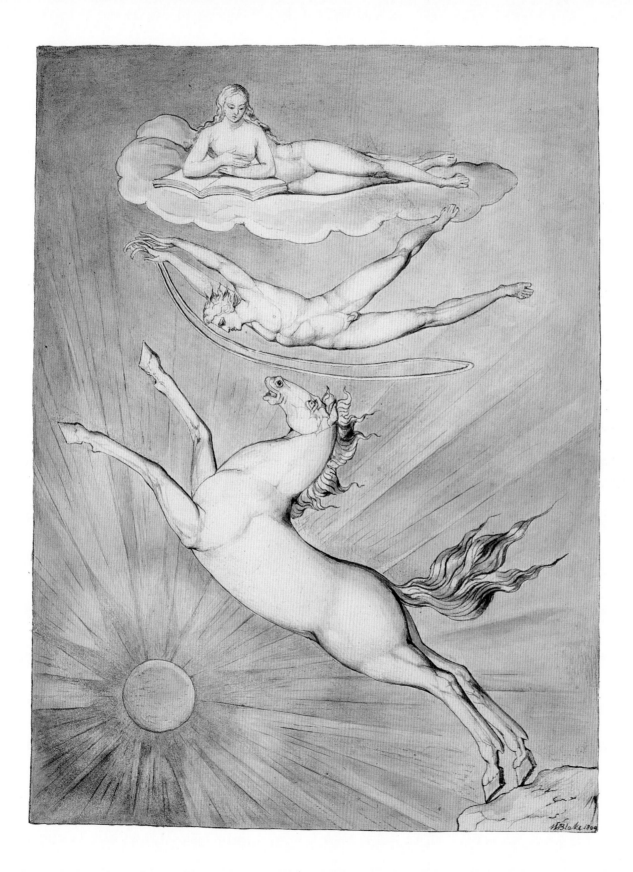

55

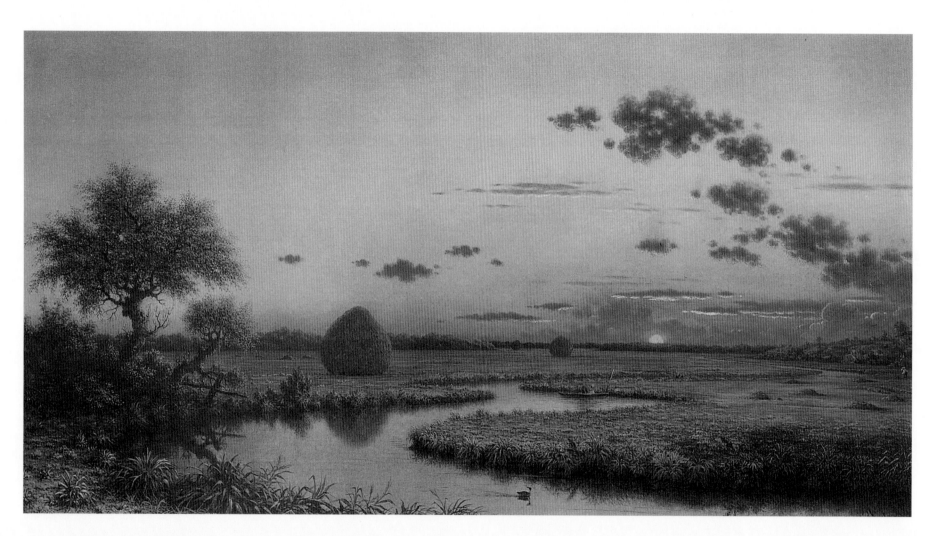

Martin Johnson Heade
SUNSET ON THE MARSHES, 1867
Oil on canvas, 27 x 53 inches
Manoogian Collection

Felix Vallotton
SUNSET, 1918
Oil on canvas, 21 1/4 x 28 3/4 inches
Private collection

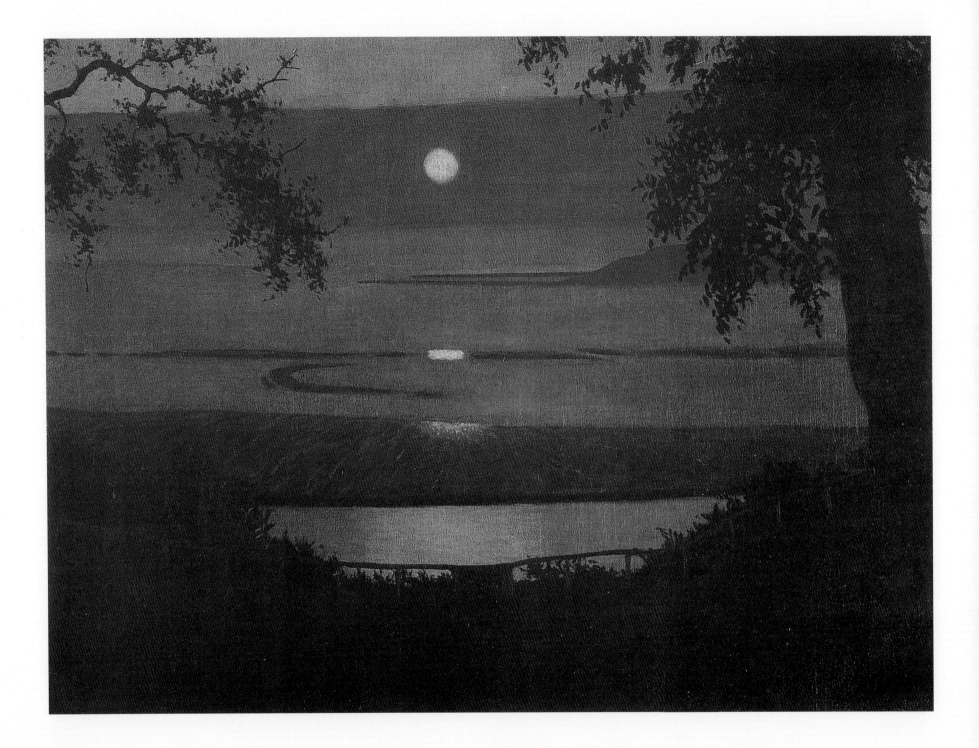

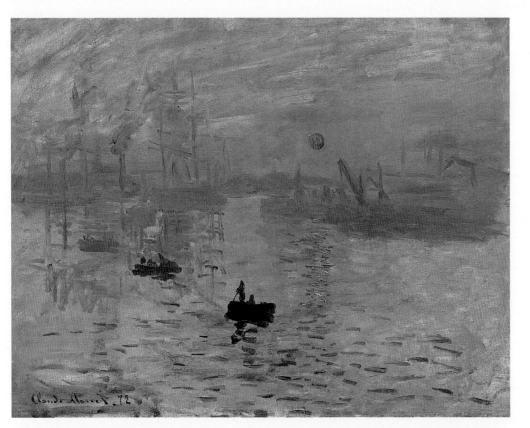

Claude Monet
IMPRESSION, SUNRISE, 1872
Oil on canvas, 18 7/8 x 24 3/4 inches
Musée Marmottan, Paris
Courtesy Giraudon/Art Resource, New York

*T*he glorious lamp
of Heav'n,
the radiant Sun
is Nature's eye.

—JOHN DRYDEN, THE FABLE OF ACIS

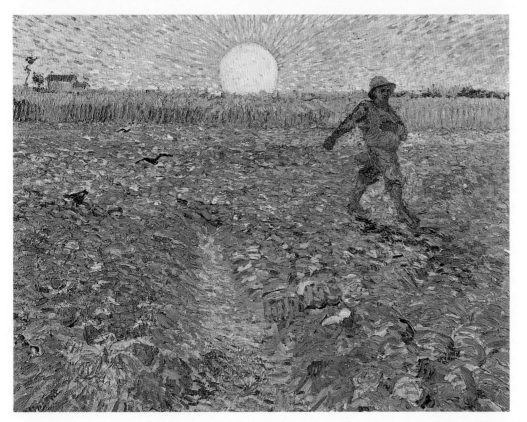

Vincent van Gogh
THE SOWER, 1888
Oil on canvas, 25 1/4 x 31 3/4 inches
Kröller-Müller Museum, Otterlo, The Netherlands

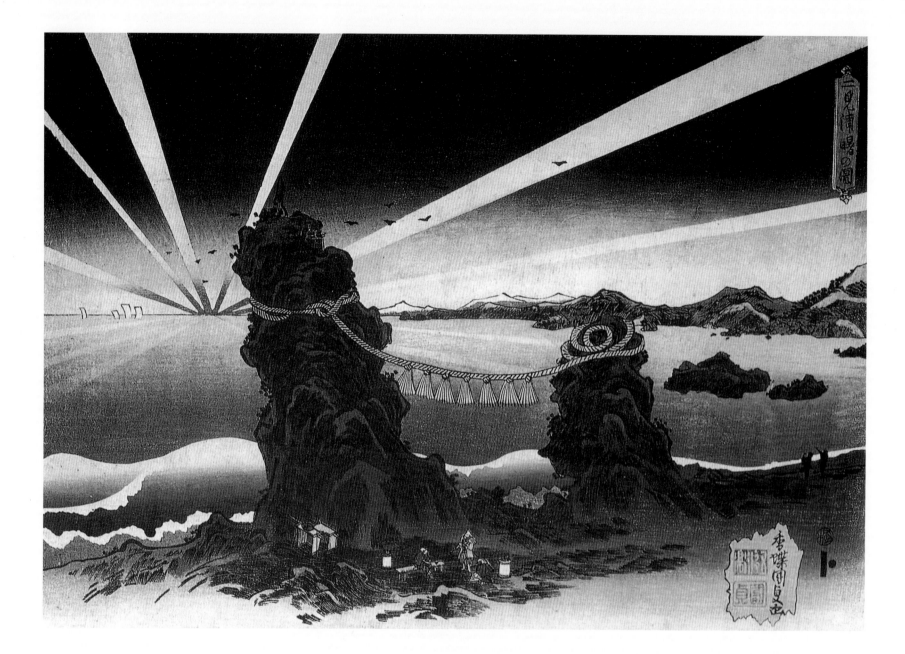

Thousands of people gather every New Year's Eve at the Grand Shrine of Ise Province, at Futami beach, in order to watch the Sun rise and to pay homage to "Heaven Shining" Amaterasu O-mikami, the Shinto Sun goddess, who is said to be the ancestress of the Japanese imperial family. The two greatly exaggerated rocks linked by ropes represent the divine couple, Izanagi and Izanami, who gave birth to the Japanese islands and to the chief divinities, including Amaterasu and Tsukiyomi-no-mikoto, the Moon Ruler.

Kunisada
DAWN AT FUTAMIGAURA, c. 1832
Color woodblock print, 10 1/4 x 15 3/8 inches
Private collection

Constantine Yuon
THE NEW PLANET, 1921
Tempera on cardboard, 28 x 39 3/4 inches
Tretyakov Gallery, Moscow

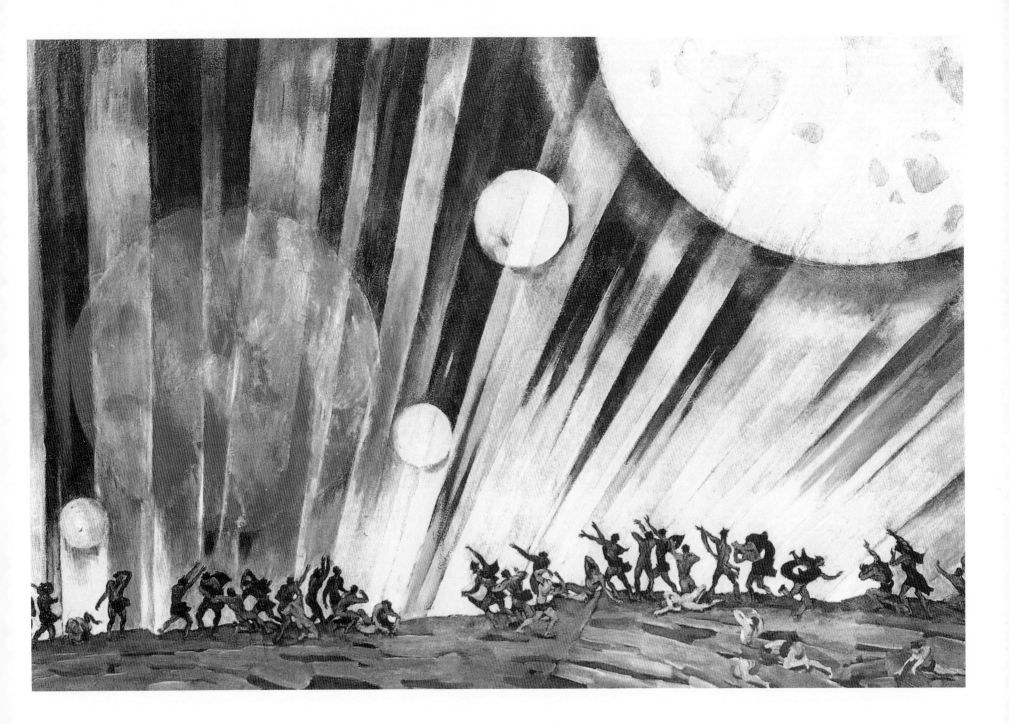

In the early days of the Russian Revolution, before Lenin imposed the horrors of a totalitarian government, idealistic Communists believed that they were helping to establish a new world order of equality and justice. Yuon represented that idea as the actual creation of a new red planet. Witnessing this spectacular event, the creatures of what appears to be the moon fall down in awe or in terror, or else hail the new body with reverence and longing.

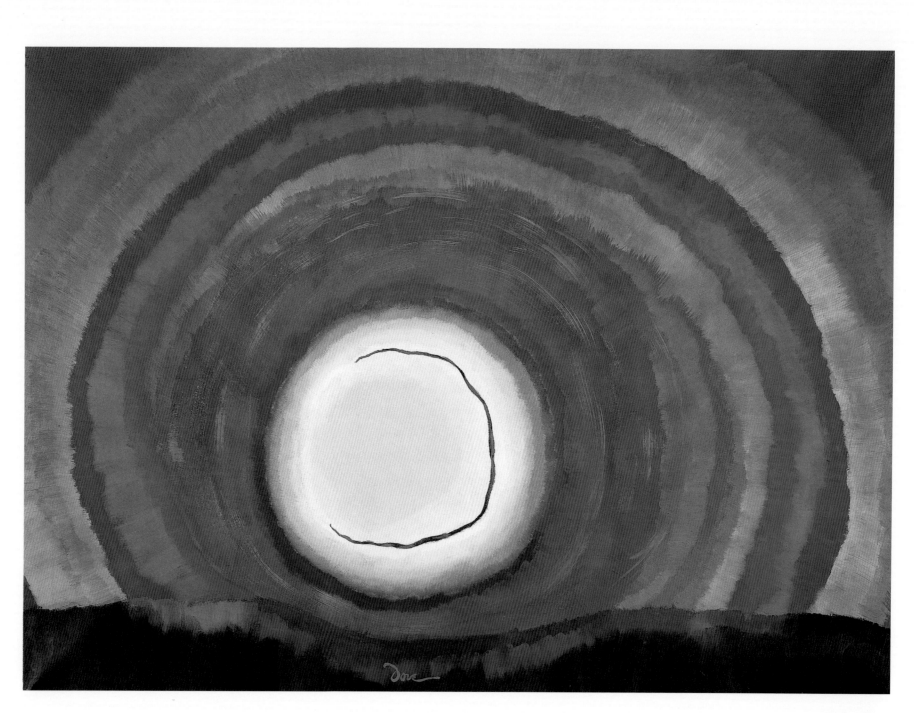

Arthur Dove
SUNRISE III, 1936-1937
Wax emulsion and oil on canvas, 25 x 35 inches
Yale University Art Gallery. Gift of Katherine S. Dreier
to the Collection Société Anonyme

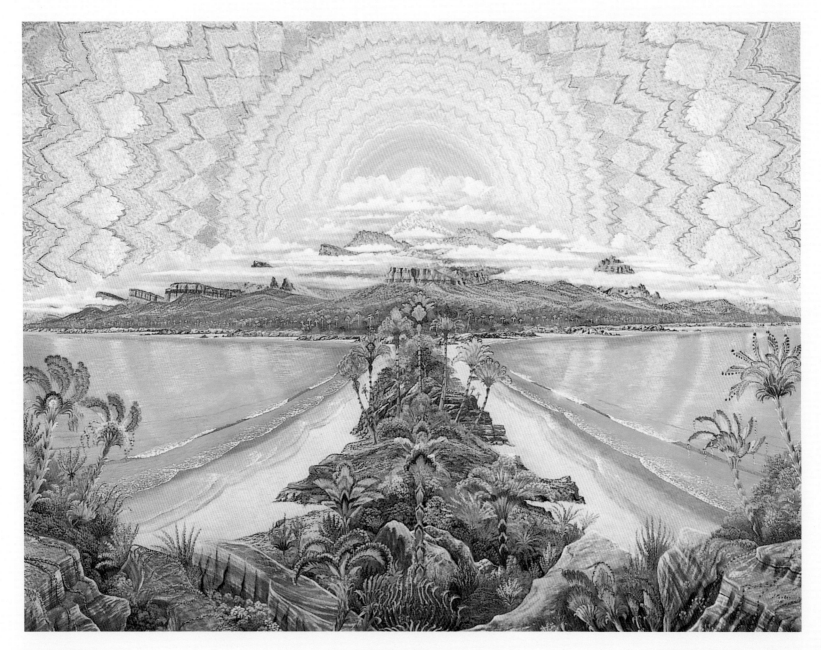

Joseph Parker
UNTITLED, 1985
Oil on canvas, 68 1/2 x 98 1/2 inches
Collection of Kemper Funds

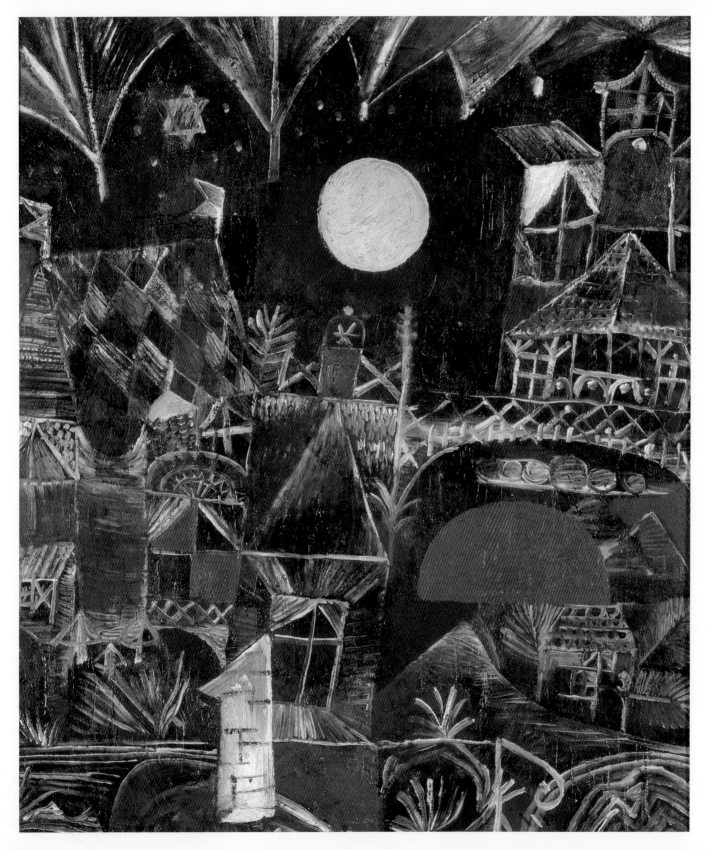

Paul Klee
SUNSET AND MOONRISE, 1919
Oil on board, 16 x 13 5/8 inches
Courtesy Christie's Images, New York

Charles Burchfield
JULY DROUGHT SUN, 1949–60.
Watercolor on paper, 45 x 54 inches.
Fundación Colleción Thyssen-
Bornemisza, Madrid
Courtesy Art Resource, New York

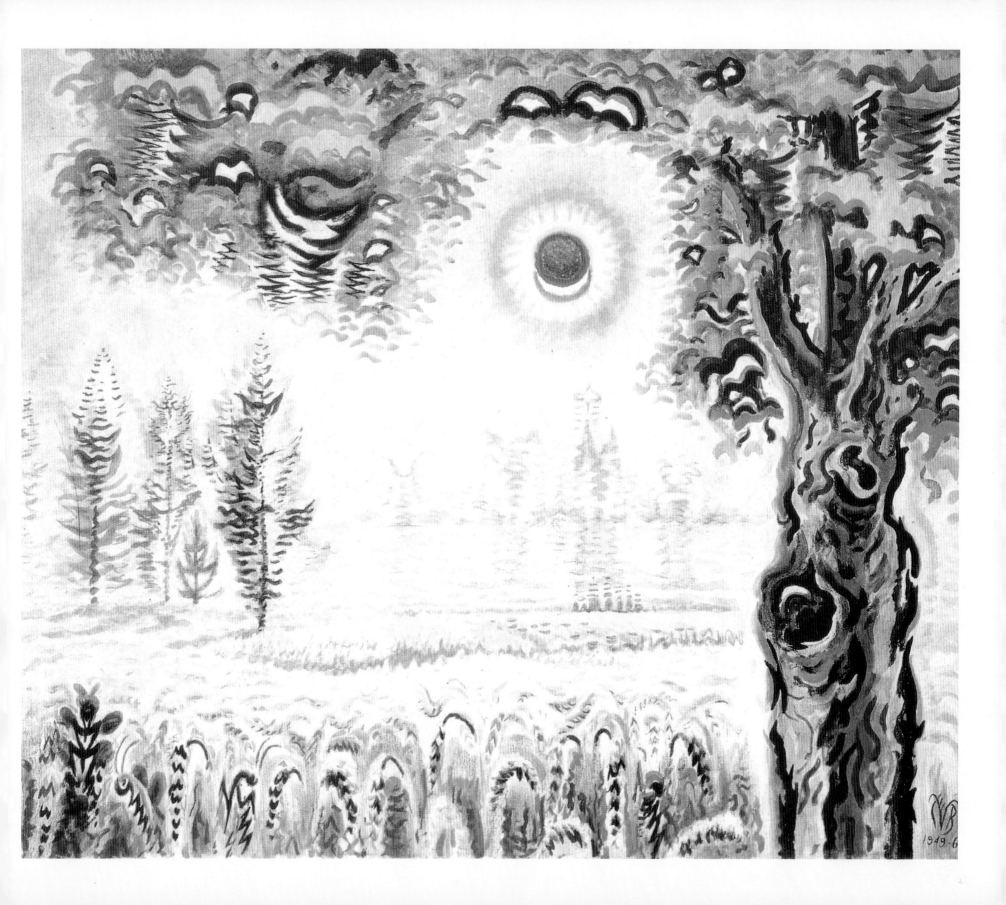

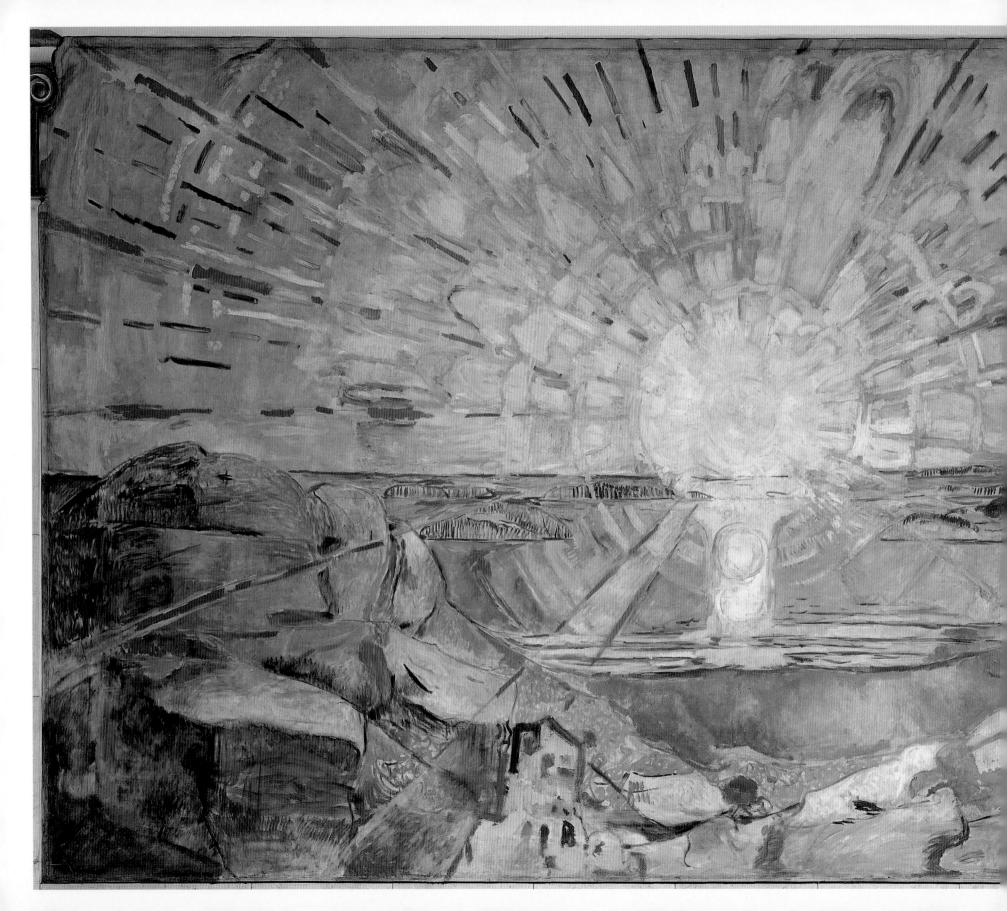

Munch painted this spectacular, 15-by-25-foot canvas of the rising sun for the end wall of the assembly hall of Oslo University. Flanked by nude sunworshipers, the mural represents the Sun as the giver of life and as the light of knowledge. On the side walls are allegories of History and of Alma Mater.

At the first Sound the golden Sun
arises from the Deep,
And shakes his awful hair.
The Echo wakes the Moon
to unbind her silver locks.
The golden Sun bears on my song
And nine spheres of Harmony
rise round the fiery King.

—WILLIAM BLAKE, *SONG OF ENITHARMON* IN *THE FOUR ZOAS*

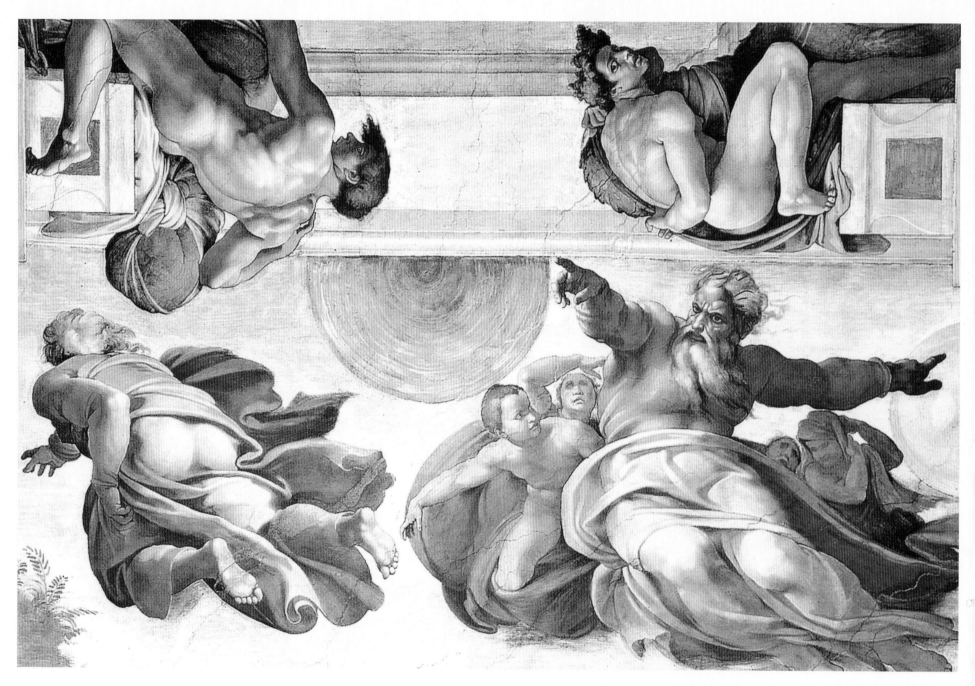

Michelangelo Buonarroti
CREATION OF THE PLANETS, 1508–1512
Fresco. Sistine Chapel ceiling, Vatican City

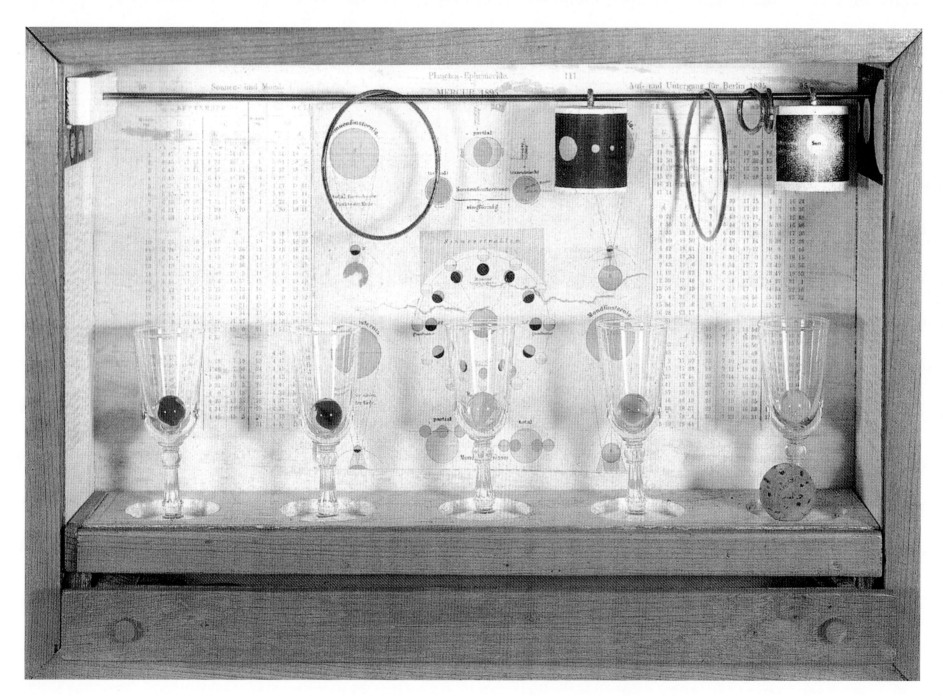

Cornell, Joseph
UNTITLED (SOLAR SET), c. 1956–58
Construction, 11 1/2 x 16 1/4 x 3 5/8 inches
Private collection

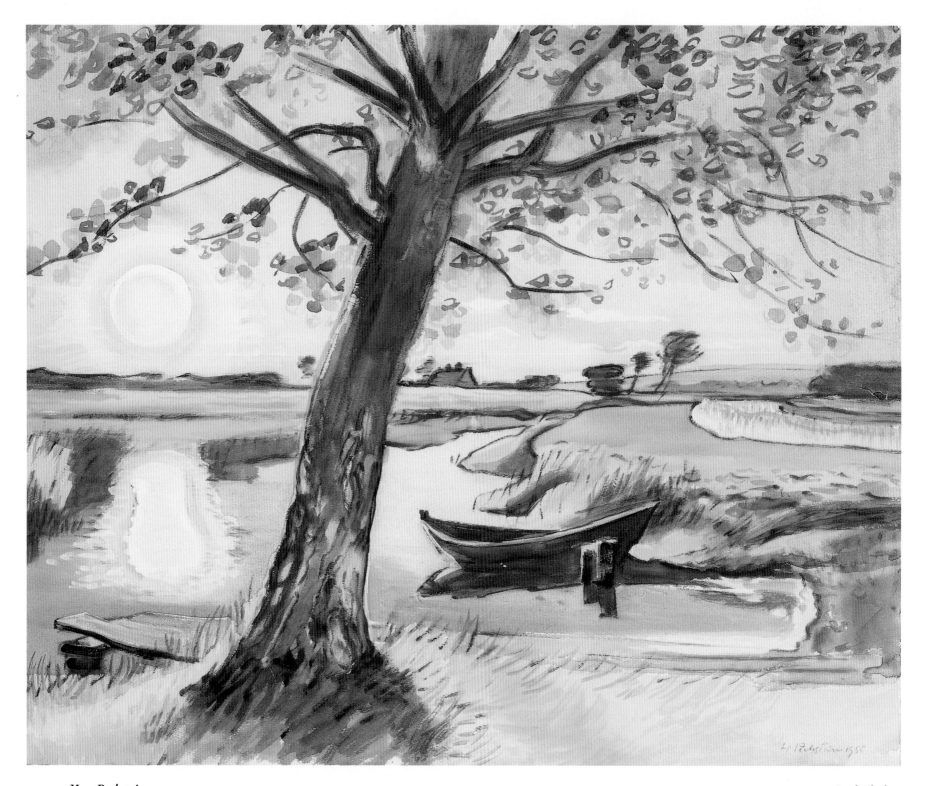

Max Pechstein
TREE BY THE WATER, 1935

70

Watercolor, 23 5/8 x 28 3/4 inches
Courtesy Christie's Images, New York

Carl Blechen
SUNSET AT SEA, c. 1830
Oil on canvas, 9 7/16 x 10 13/16 inches
Oskar Reinhart Foundation, Winterthur, Switzerland

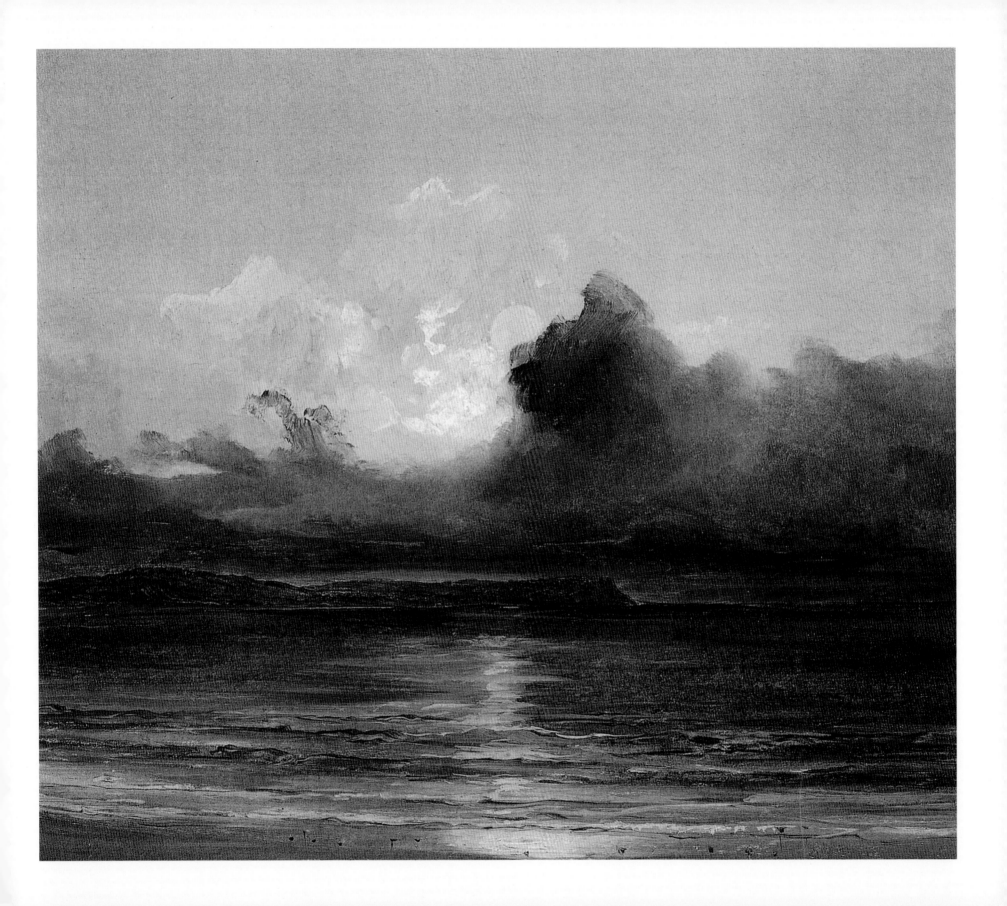

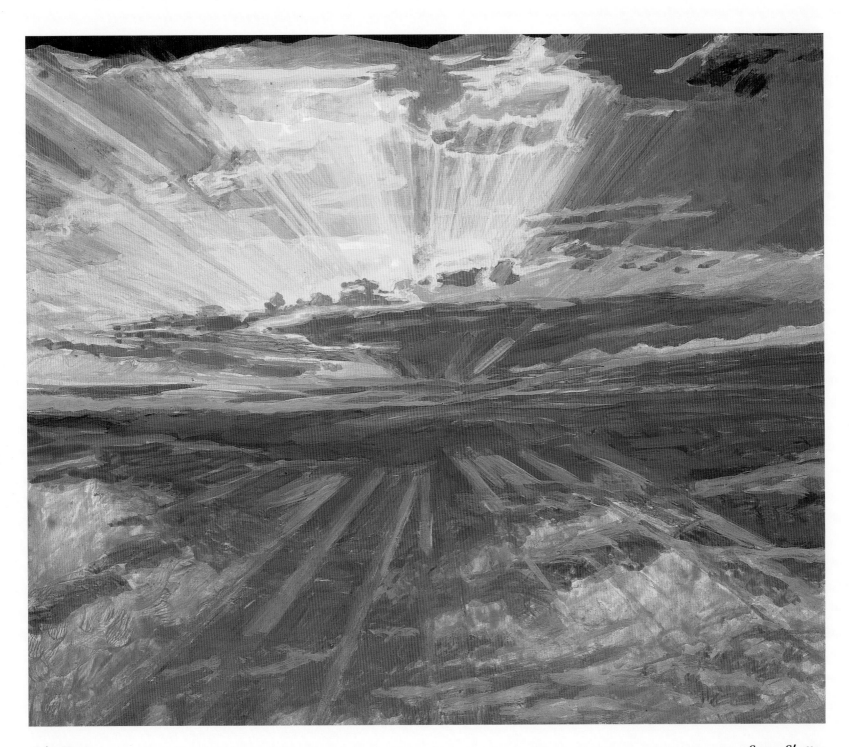

John Marin
SUNSET, 1922
Watercolor, graphite, and charcoal on paper, 17 1/2 x 21 1/2 inches
The Eleanor and C. Thomas May, Jr., Collection, Dallas, Texas

Susan Shatter
LUMINESCENCE, 1992
Egg tempera on wood, 10 x 12 inches
Courtesy Fischbach Gallery, New York

73

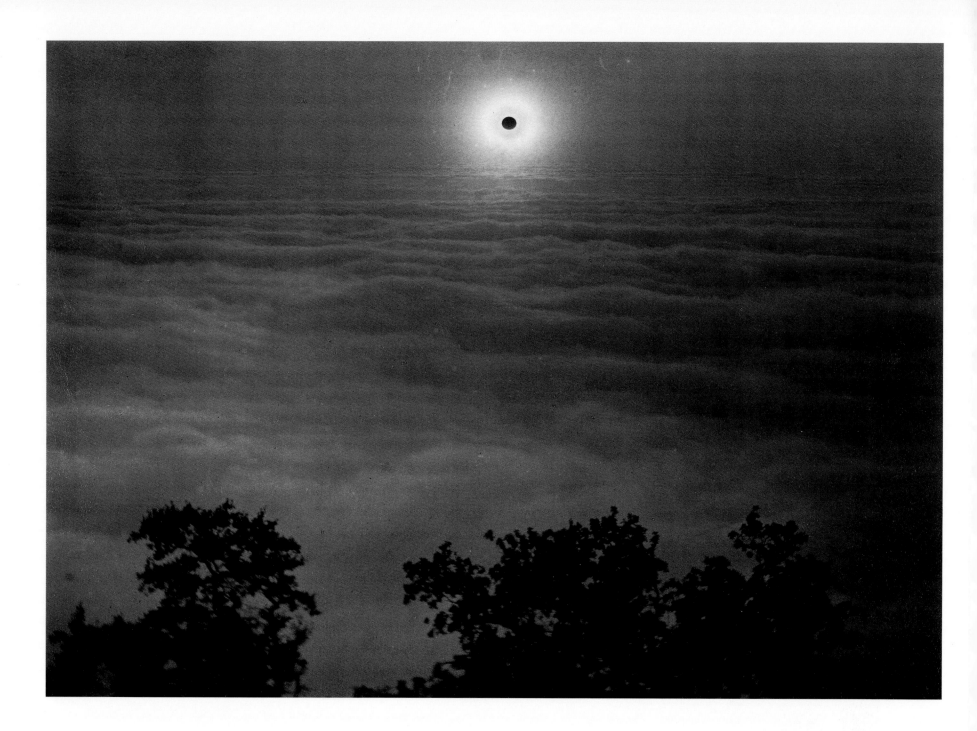

During the 1860s San Francisco photographer Carleton Watkins became famous for his large and impressively composed glass-plate views of Yosemite. Watkins made this photograph of a solar eclipse in January of 1880, at 3:50 in the afternoon. The previous day, when a severe winter storm hit the California coast, it had seemed unlikely that the eclipse would be visible. But the skies cleared, and Watkins ascended Mount Lucia with a party of scientists. Watkins was not the first to succeed in photographing a solar eclipse; that had been accomplished by Warren de la Rue in Spain on July 18, 1860.

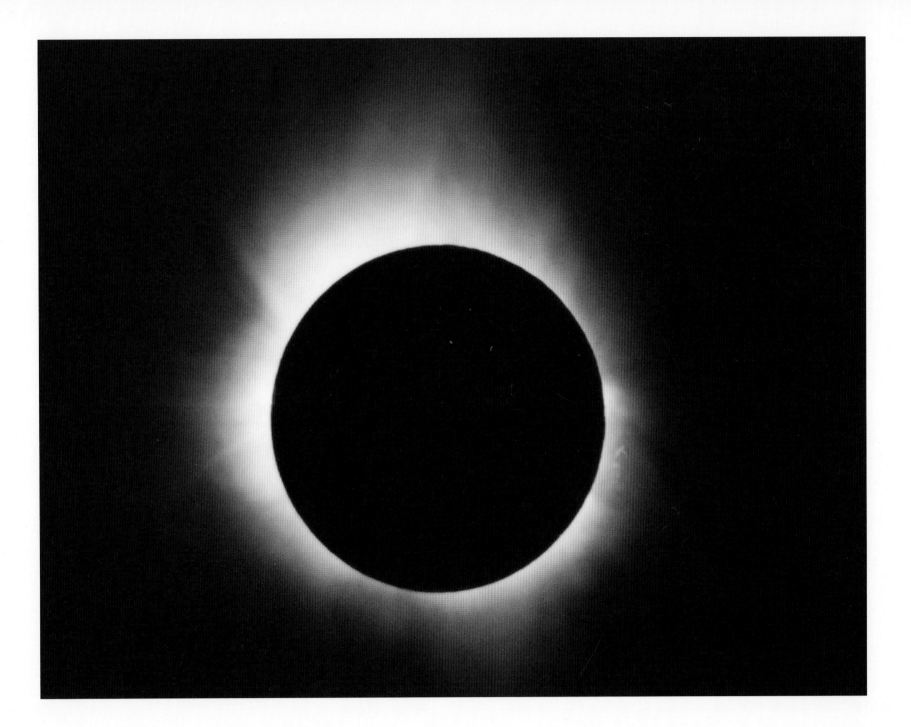

Carleton E. Watkins
SOLAR ECLIPSE FROM MOUNT SANTA LUCIA, JANUARY 1880
Albumen print (photograph), 6 1/2 x 8 1/2 inches
J. Paul Getty Museum, Los Angeles, 88.XM.92.83

Chuck Searls
SOLAR ECLIPSE, VIEWED FROM THE WEST COAST
OF THE ISLAND OF HAWAII, JULY 11, 1991
Color photograph
Courtesy the photographer

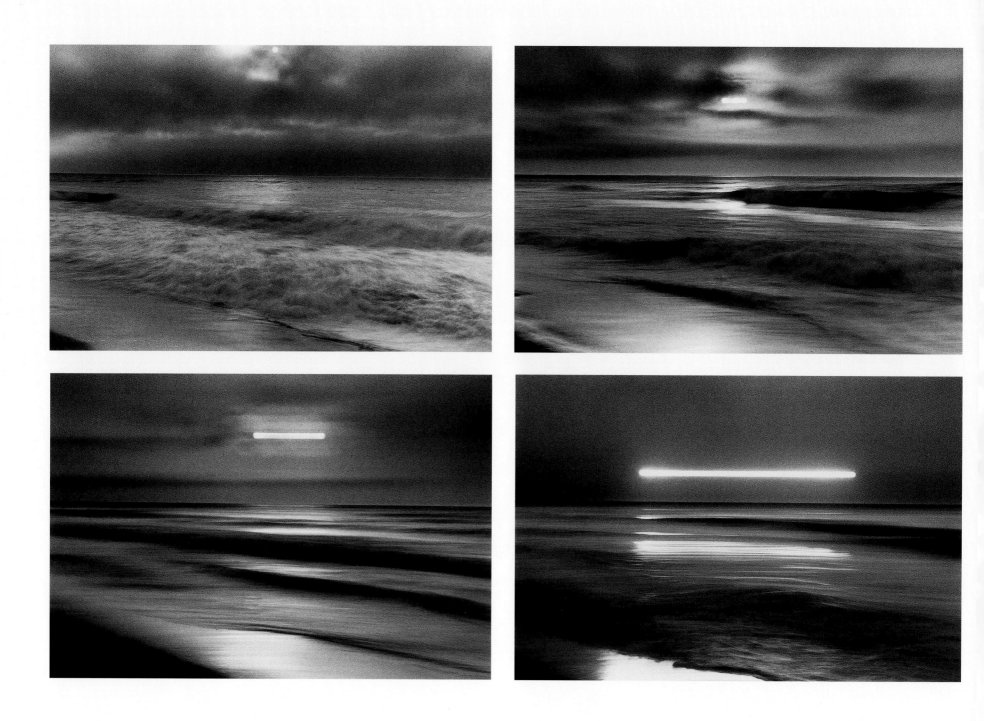

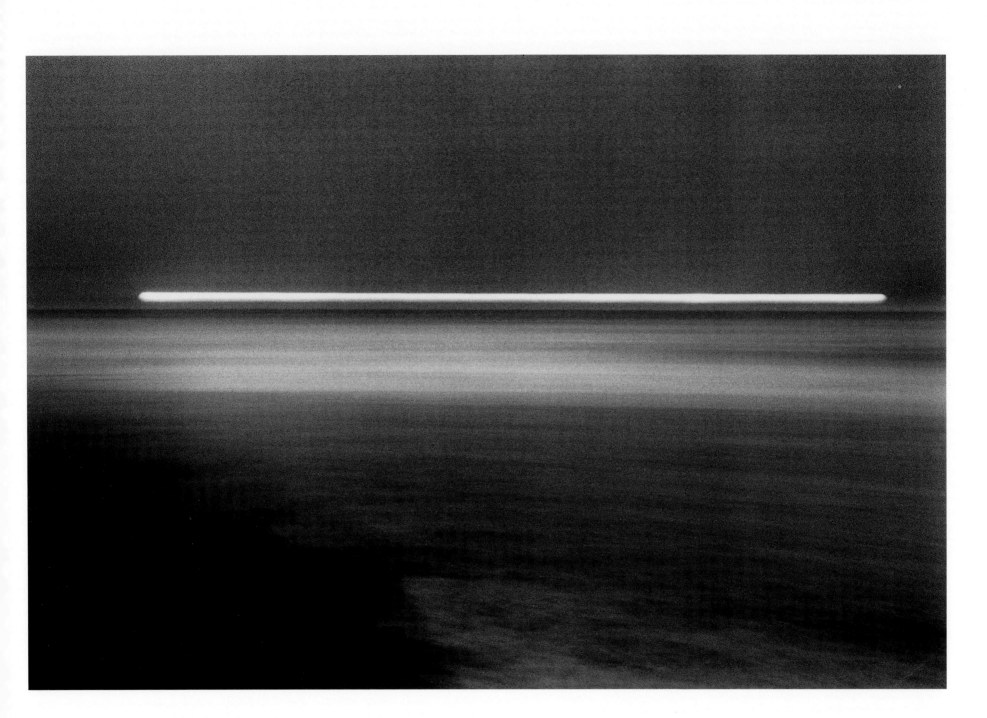

Hiroshi Yamazaki
THE SUN II, PACIFIC OCEAN, 1978
Sequence of five photographs
Courtesy the photographer

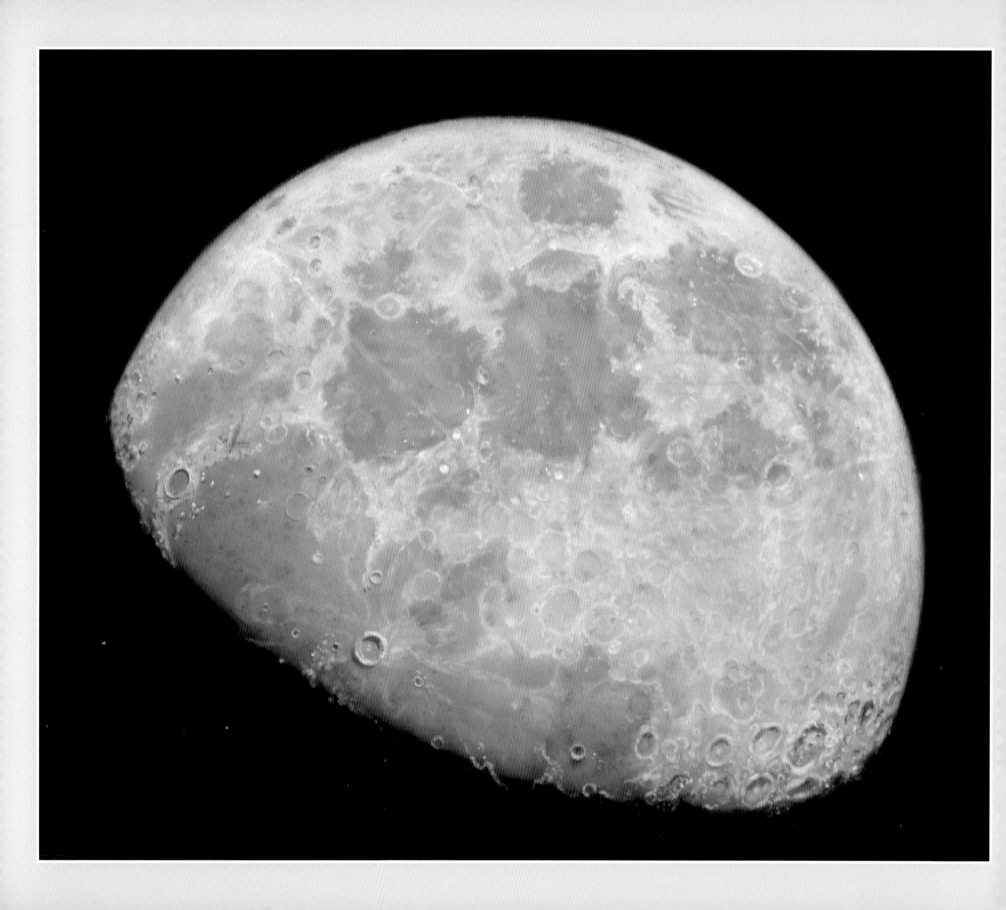

The Moon

Not secondary to the sun, she gives us his blaze again,
Void of its flame, and sheds a softer day....
In Heaven queen she is among the spheres;
She, mistresslike, makes all things to be pure.

—Henry David Thoreau

he Moon, which orbits Earth at an average distance of about 238,600 miles, is probably something like 4.5 billion years old. The most widely accepted theory regarding its formation posits that while Earth was still in a molten state a huge object collided with it, causing a great "splash." The material thus dislodged from Earth may first have formed a ring around the planet and then gradually coalesced into the Moon.

Because the Moon has virtually no insulating atmosphere, its surface temperatures range from -292°F to +248°F. Among the most notable features on the surface, which is made up mostly of volcanic rock, are hundreds of huge craters pockmarking the relatively pale highlands. About 3.6 billion years ago large lowland areas were inundated with molten lava, which hardened into black basalt. Because these dark patches looked like water when viewed through primitive telescopes, they were named with the Latin word for "sea," *mare* (pronounced MAR-ay; the plural is *maria*, pronounced MAR-ee-ah).

The Moon has a diameter of 2,160 miles, as compared to Earth's of 7,900. Earth is the only one of the four inner planets to have such a large moon. Mercury and Venus have no moons at all, and Mars has only two very small ones. Among the moons of Jupiter and Saturn are several larger than Earth's.

The Moon takes 29 days, 12 hours, 44 minutes, and 2.8 seconds to complete one full cycle of its phases. That period is called a lunar month (the word *month* being, of course, derived from moon). Relative to the fixed stars, the Moon takes 27 days, 7 hours, 43 minutes, and 11.5 seconds to complete one orbit around Earth, precisely the same time required for one revolution on its axis. Therefore, the same side of the moon is always turned toward Earth. However, since the Moon appears to wobble slightly in its orbit, a total of about sixty percent of its surface may be seen from Earth over the course of a month. The topography of the far side was unknown until it was photographed by the Soviet space probe Luna 3 in October 1959.

Eclipses occur because the Sun and the Moon appear to be the same size when viewed from Earth. A solar eclipse takes place when the Moon passes directly between Earth and the Sun, covering the solar disk so that only the corona is visible. A lunar eclipse occurs when Earth is between the Sun and the Moon and casts its shadow onto the Moon.

(page 78)
John Russell
THE FACE OF THE MOON, 1795
Pastel
City Museum and Art Gallery, Birmingham, England

Ronald Evans
SEA OF RAINS: THE CRATER COPERNICUS IN THE DISTANCE (at top), 1972
Photograph
Courtesy National Aeronautics and Space Administration (NASA)

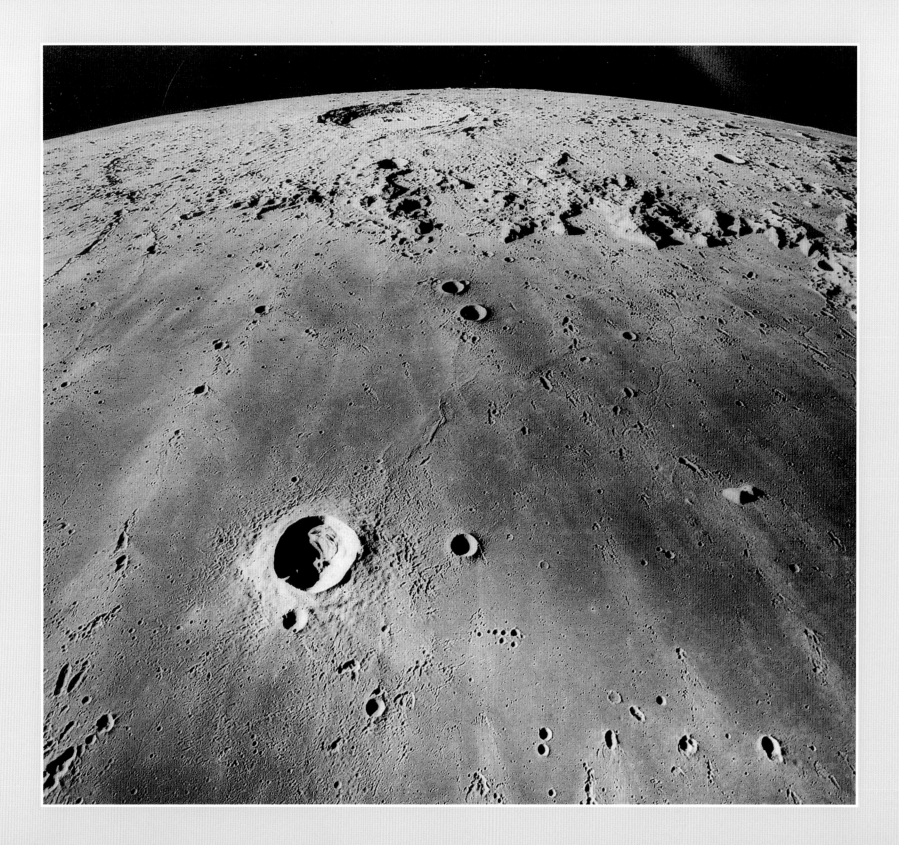

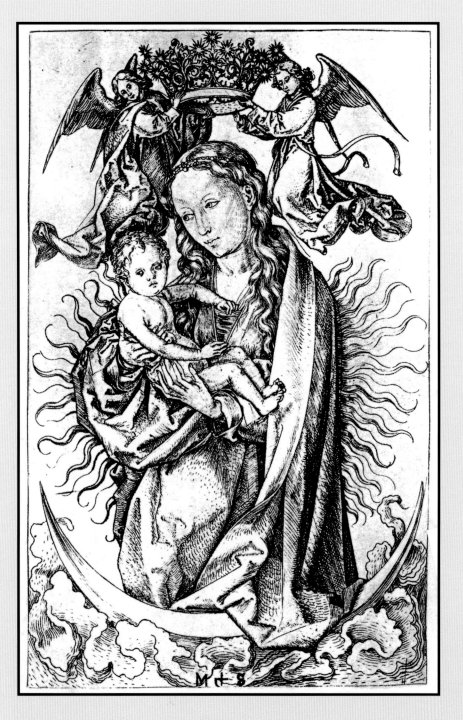

*A*s the Queen of Heaven, the Virgin Mary is "clothed with the sun, with the moon under her feet, and on her head a crown of twelve stars."

—BOOK OF REVELATION, CHAPTER 12, VERSE 1

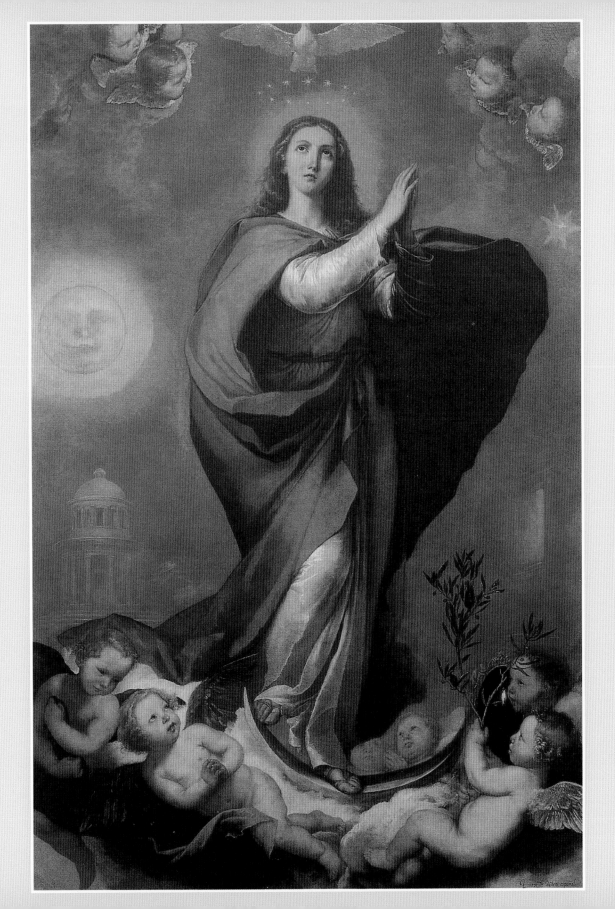

83

Galileo Galilei
THE SURFACE OF THE MOON, AS VIEWED THROUGH A TELESCOPE
1609
Pen and ink on paper

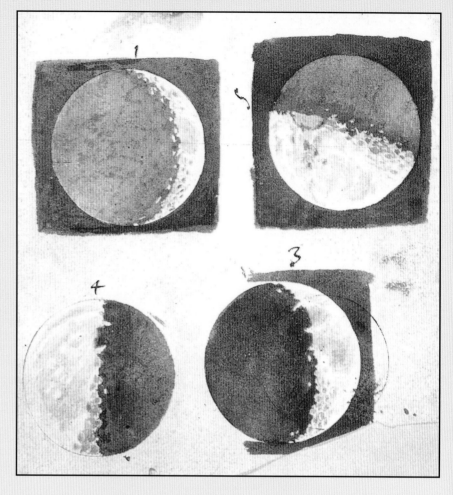

ENGRAVINGS OF THE MOON
from Galileo Galilei, SIDEREUS NUNCIUS (The Starry Messenger)
Venice, 1610

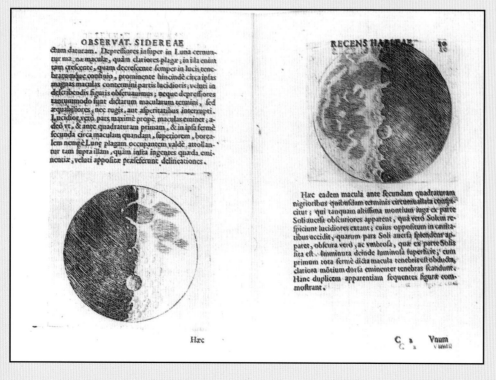

MAP OF THE MOON'S SURFACE
from Johannes Hevelius (Jan Heweliusz), SELENOGRAPHIA;
SIVE LUNAE DESCRIPTIO (Danzig, 1647)

Hevelius was a wealthy Danzig brewer who became so interested in astronomy that he built for himself one of the largest observatories in Europe. Through his telescope, which was exceptionally powerful for its time, he meticulously mapped the surface of the moon.

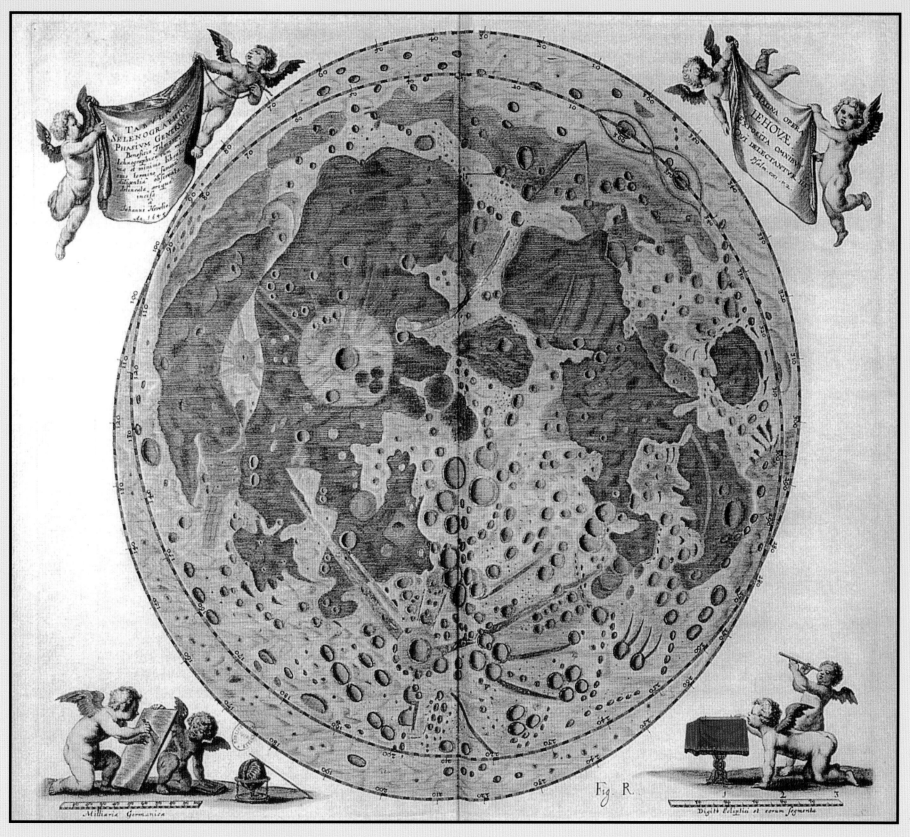

Fig. R.

1493	1493	1494
Eclipsis Lune	Eclipsis Solis	Eclypsis Solis
1 13 58	10 2 38	7 4 12
Aprilis	Octobris	Martij
Dimidia duratio	Di midia duratio	Dimidia duratio
1 49	1 4	1 44
	Puncta octo	Puncta quattuor

1494	1494	1497
Eclipsis Lune	Eclipsis Lune	Eclipsis Lune
21 14 38	14 19 45	18 6 38
Martij	Septembris	Januarij
Dimidia duratio	Dimidia duratio	Dimidia duratio
1 46	1 48	1 46

1497	1500	1501
Eclipsis Solis	Eclipsis Lune	Eclipsis Lune
29 3 2	5 14 2	2 17 49
Julij	Nouembris	Maij
Dimidia duratio	Dimidia duratio	Dimidia duratio
0 36	1 37	1 52
Puncta tria	Puncta decem	

1502	1502	1504
Eclipsis Solis	Eclipsis Lune	Eclipsis Lune
30 19 45	15 12 20	29 13 36
Septembris	Octobris	Februarij
Dimidia duratio	Dimidia duratio	Dimidia duratio
1 7	1 1	1 46
Puncta decem	Puncta tria	

CALENDAR OF SOLAR AND LUNAR ECLIPSES
in Giovanni Regiomontano, CALENDARIUM (Venice, 1483)
Biblioteca Nazionale Universitaria, Turin

Thomas Harland (clockmaker in Norwich, Connecticut)
TALL CASE CLOCK WITH DIAL SHOWING THE PHASES OF THE
MOON, c. 1774
Private collection

87

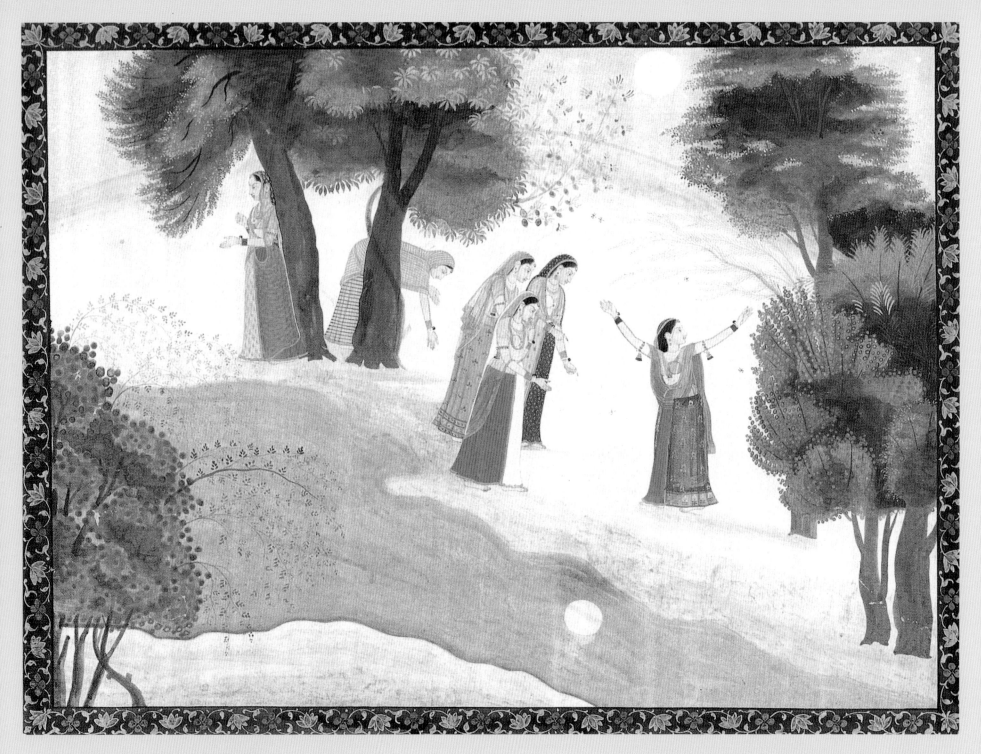

Pahari School, Rajput Hills, India
THE GOPIS DISTRESSED BY KRISHNA'S DISAPPEARANCE, c. 1780-85
Illustration to the Bhagavata Purana
Tempera on paper, 10 7/8 x 13 3/4 inches
Private collection

Kangra School, Punjab Hills, India
KRISHNA GAZES LONGINGLY AT RADHA, c. 1820–25
Page from the "Lumbagraon Gita Govinda" series.
Opaque watercolor and gold on paper, 9 1/2 x 12 5/8 inches
Brooklyn Museum of Art. Designated Purchase Fund 72.43

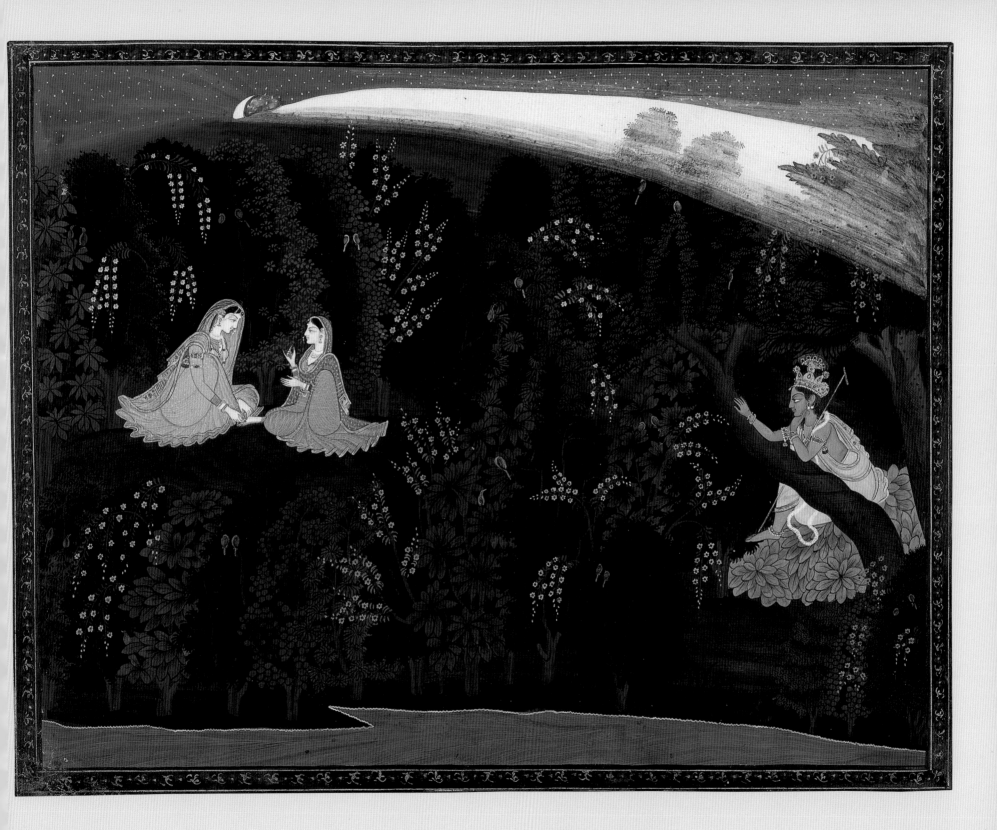

老梅愈老愈精神水店山樓芝
有人清到十分襄滿把始知明月
是前身 凸江外史畫詩書
十月十日

(preceding pages) **Kaiho Yosho. PLUM BY MOONLIGHT, c. 1602**
One of a pair of six-fold screens; ink and slight color on paper
66 1/2 x 139 inches. Nelson-Atkins Museum of Art, Kansas City
Purchase: Nelson Trust

Chu Ta (Bada Shanren), MOON AND MELON, 1689
Hanging scroll, ink on paper, 30 x 17 3/4 inches
Arthur M. Sackler Museum, Harvard University Art Museums
Gift of Earl Morse, Harvard Law School Class of 1930

This boldly simple ink painting of a melon and the full moon seems to have been intended by the artist as a highly charged political statement of loyalty to the ethnic Chinese Ming dynasty, which had been overthrown in 1644 by barbarian Manchu invaders from the north, who would rule China until 1912.

During the 1368 rebellion that had overthrown a previous dynasty of barbarians (the Mongols) and had established the Ming dynasty on the throne, the rebels identified themselves to each other by carrying the sweet beancakes known as mooncakes. Thus to Bada the moon represented the Ming dynasty. Furthermore, the melon was an ancient Chinese symbol of loyalty to a fallen dynasty.

Bada made his painting a year after an unsuccessful rebellion against the Manchus, and the poem he wrote at the top in agitated calligraphy laments that it would be foolish to hope that the melon will ripen—which is to say that no attempt to overthrow the Manchus was likely to succeed.

(opposite) **Chin Nung**
PLUM BLOSSOMS AND MOON, 1757
Album leaf H from a set of twelve. Ink on paper
Private collection

Chin Nung was one of a group known as the "eccentric painters of Yangchow." At the age of seventy, the impoverished artist identified himself with the old plum tree in the cold moonlight. The poem on this painting translates:

The older the plum tree, the more ascetic it becomes.
At the mountain tower by the river inn is a man, wretched
 and poor.
Purity becomes complete when cold fills every crevice,
And only now do I know that we were once the bright moon.

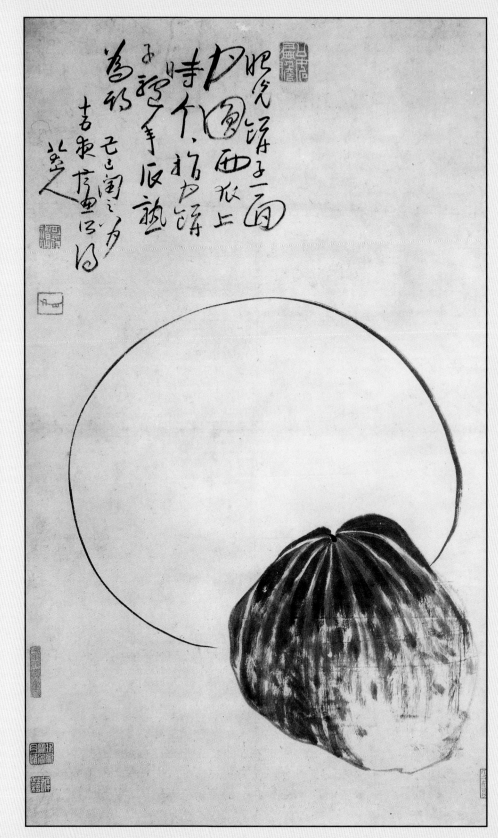

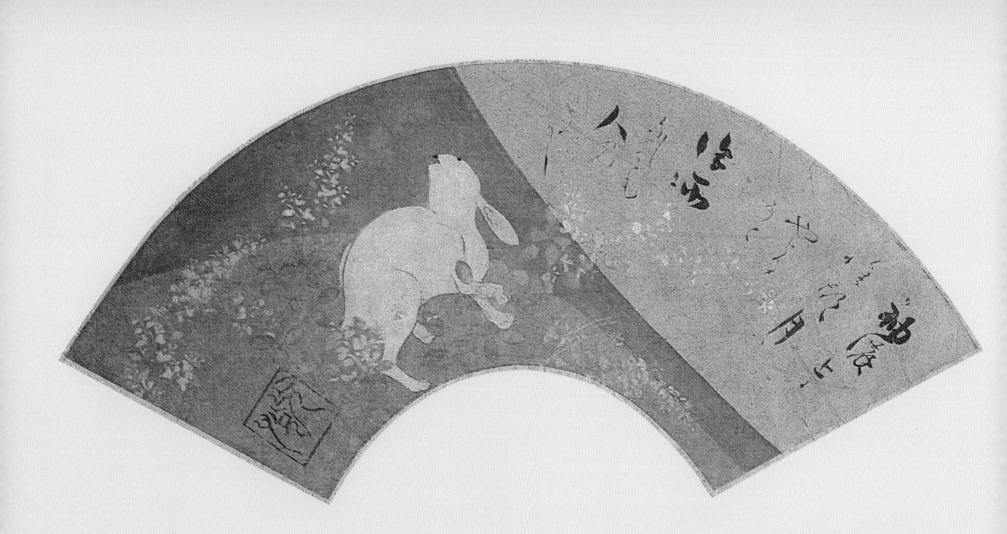

Japanese
RABBIT AND THE MOON, 18TH CENTURY
Hand-painted fan
Private collection

In Japanese mythology the Full Moon was often associated with a rabbit, which was traditionally depicted grinding rice flour for rice cakes. A rabbit was said to inhabit the Moon as a reward for having sacrificed his body to feed Buddha. Because the Moon is often linked with fertility, some cultures have identified the "face" on the Moon as that of a rabbit, a highly philoprogenitive species.

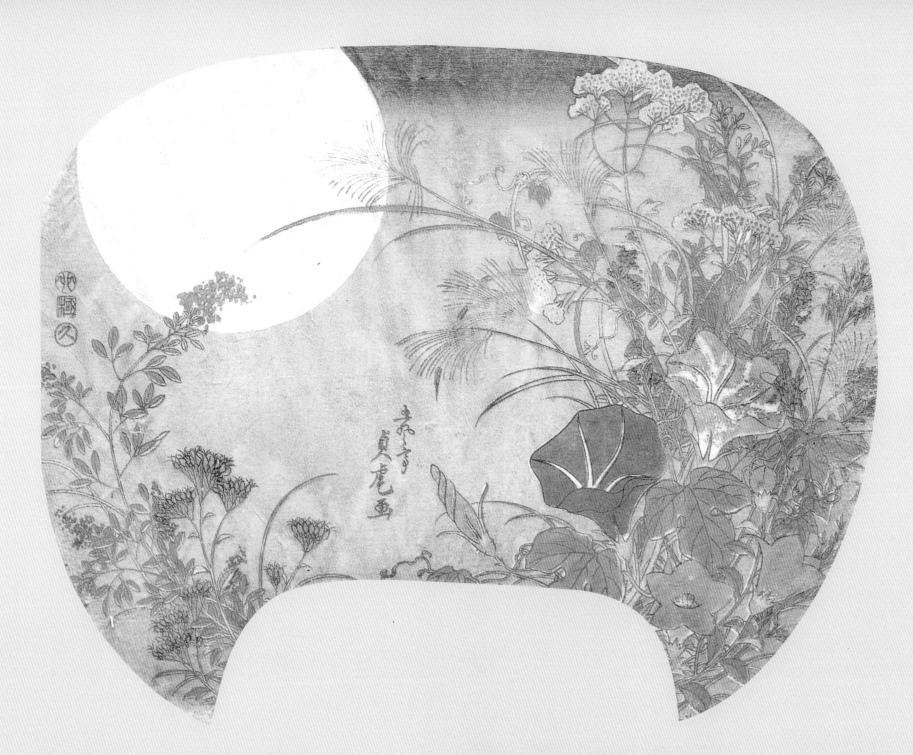

Sadatora, AUTUMN FLOWERS AND THE MOON, 1831
Fan-shaped woodblock print
Victoria & Albert Museum, London

Sadatora depicted a large full moon above the seven traditional Japanese varieties of autumn flowers: morning glory, Chinese bell-flower, bush clover, eulalia, creeper, *ominaeshi*, and boneset.

95

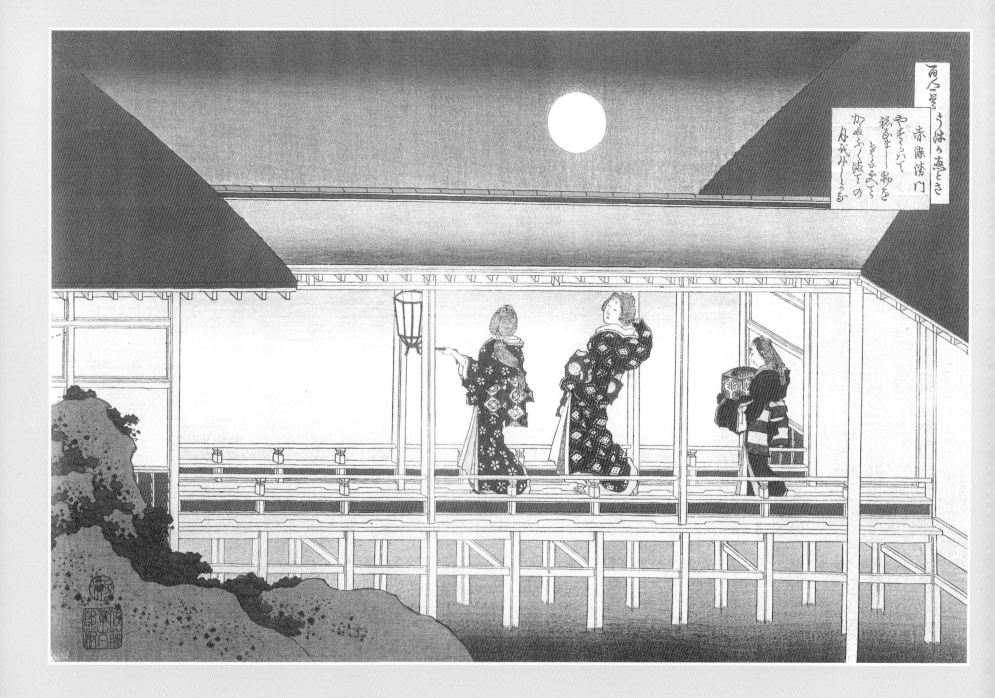

Hokusai
Two woodblock prints, from the series ONE HUNDRED POETS, c. 1835
for poems by Lady Akazome (above) and the Emperor Sanjo (right)
Private collection

In 1835, when he was seventy-five, Hokusai, who must be ranked among the world's greatest artists, began a series of prints to illustrate the Japanese anthology known as the *One Hundred Poets*. The poem by Lady Akazome translates as:

Better to have slept
Carefree than to keep vain watch
Through the passing night,
Till I saw the lonely moon
Traverse her descending path.

The poem by the Emperor Sanjo reads:

If, against my wish,
In the world of sorrows still,
I for long should live;—
How then I would pine, alas!
For this moon of middle-night.

Hokusai's print shows the Shinto service to venerate Susano O no Mikoto, a moon god, brother of the Sun goddess Amaterasu.

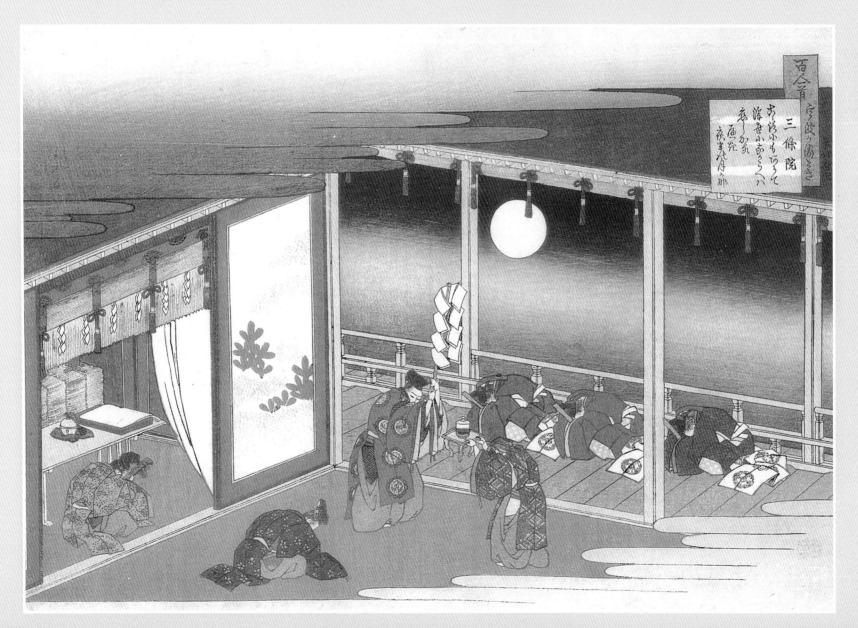

97

Hiroshige
MOON VIEWING POINT, 1857
from the series ONE HUNDRED FAMOUS VIEWS OF EDO
Color woodblock print, 13 7/8 x 9 5/8 inches
Private collection

One of the most refined pleasures enjoyed by the aristocratic and scholarly elites of both Japan and China was contemplation of the moon from a carefully situated room, pavilion, or terrace. In Hiroshige's print from his series *One Hundred Famous Views of Edo* (Tokyo) we look into such a room, in a geisha house, just as the evening is ending. The meal has been finished, and one woman, whose robes are glimpsed on the right, is putting away her musical instrument, while the geisha whose shadow is seen through the shoji at the left is evidently undressing and has already dropped one garment onto the floor.

When the Japanese nobleman Abe no Nakamoro (698-770) was only sixteen years old, he accompanied a Japanese envoy to China for a bit of industrial espionage: to learn the secret of the Chinese method of calculating time. Suspecting foul play, or perhaps only wishing to retain his able services, the emperor never allowed Nakamoro to return home. The young man eventually rose to the position of a regional governor. In a moment of homesickness he wrote the poem illustrated by Hokusai's print:

> When I look over heaven's plain I wonder:
> Is that the same moon that rose
> Over Mount Mikasa in Kasuga?

Looking at this serene view of an anchorage near a bridge *(right)*, one can almost hear the gentle lapping of the water as all that breaks the deep silence pressing in upon one's ears. Beneath the gibbous moon (i.e., between half and full) and a sprinkling of stars a fleet of cargo boats lies at anchor on the right; barely protruding beyond the bridge pillar on the left are the bows of two small boats used for night fishing, their extinguished brazier-lanterns still smoking.

(opposite right) **Hokusai**
ABE NO NAKAMARO GAZING AT THE MOON FROM A TERRACE, c. 1833
Color woodblock print, 20 1/2 x 9 inches
Private collection

Hiroshige, TSUKUDAJIMA FROM EITAI BRIDGE, *1857*
from the series ONE HUNDRED FAMOUS VIEWS OF EDO
Color woodblock print, 13 7/8 x 9 5/8 inches
Private collection

99

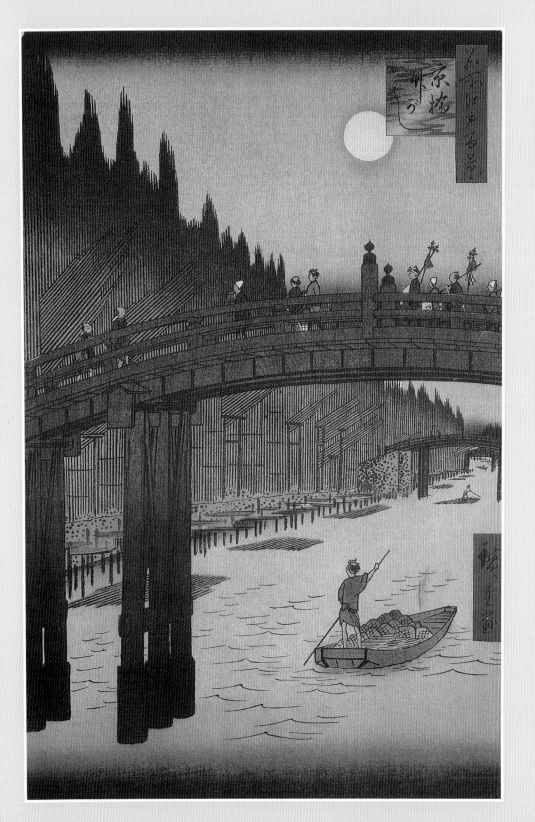

Hiroshige
BAMBOO YARDS, KYOBASHI BRIDGE, 1857
from the series ONE HUNDRED FAMOUS VIEWS OF EDO
Color woodblock print, 13 7/8 x 9 5/8 inches
Private collection

Eleven of the prints in Hiroshige's series *One Hundred Famous Views of Edo* (which ended up consisting of 118 prints) are evening or nighttime scenes, and many more show the reddish colors of sunset on the horizon. It is thought that this print directly influenced the composition of Whistler's *Blue and Silver: Screen with Old Battersea Bridge*.

<div align="right">

James McNeill Whistler
BLUE AND SILVER: SCREEN WITH OLD BATTERSEA BRIDGE, 1872
Two panels, each 67 3/4 x 33 inches
Hunterian Art Gallery, Glasgow

</div>

During the early 1860s Whistler developed an avant-garde taste for the art of Japan, that nation having been opened to American and European trade only in the preceding decade. At first his interest was confined primarily to the decorousness of Japanese kimonos, fans, and ceramics, but he soon adapted elements of daring Japanese formal composition into his paintings, such as that illustrated here.

Whistler was one of the preeminnent advocates of "art for art's sake," and to emphasize his non-literal intentions he began to give to many of his paintings titles such as *Symphony in Grey and Green*, *Harmony in Blue and Silver*, and *Nocturne in Blue and Gold*, suggesting the kinship of his work to music, the most abstract of the arts. Although the present painting lacks such a title, it belongs to Whistler's great series of London nocturnes, in which the artist revealed the surprising romantic beauty of the bustling center of international commerce.

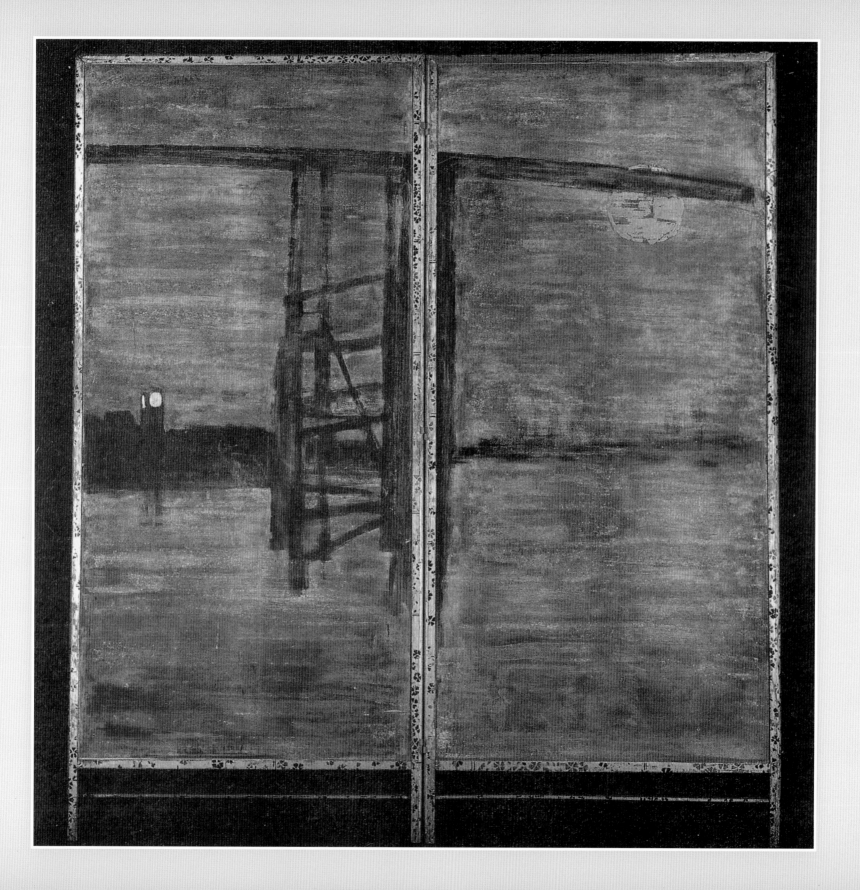

102

Yoshitoshi
Two color woodblock prints from his seris
ONE HUNDRED ASPECTS OF THE MOON, *1885–1891*
Private collection

The nineteenth-century Japanese printmaker Yoshitoshi (1839-1892) was best known, throughout most of his relatively short career, for his portraits of warriors and for his horrifying depictions of lurid murders and ghastly eviscerations and beheadings. In 1885, however, when the artist was forty-six, he began a series of 100 beautiful woodblock prints, entitled *One Hundred Aspects of the Moon*, which he would complete shortly before his death. In this series he dwelt upon the poetic and contemplative side of Japanese life, as well as traditional folklore and mythology. Yoshitoshi clearly wished his series to remind his compatriots of the rich cultural legacy that they were then repudiating in favor of rapid Westernization.

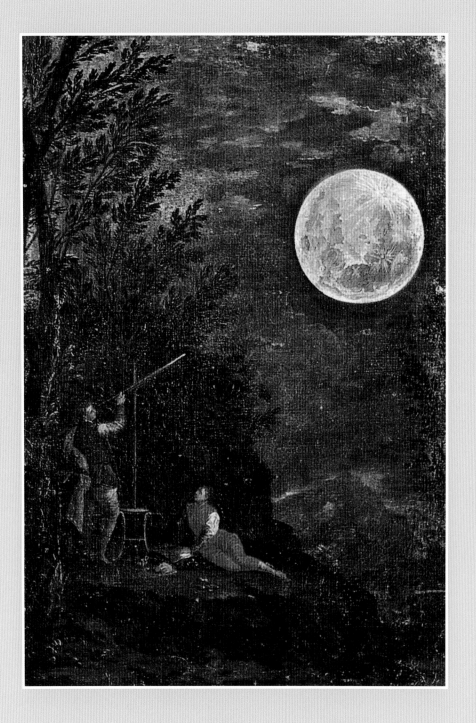

Donato Creti
ASTRONOMICAL OBSERVATIONS: THE MOON, 1711
Oil on canvas, 20 1/4 x 13 3/4 inches
Vatican Museum, Rome

William Blake
THE WAND'RING MOON, c. 1816–20
Ink and watercolor, 6 5/16 x 4 13/16 inches
The Pierpont Morgan Library, New York
Courtesy Art Resource, New York

An illustration to Milton's poem *Il Penseroso*, which celebrates the pleasures of solitary, melancholic contemplation in communion with nature. Milton wrote:

I walk unseen
On the dry smooth-shaven green,
To behold the wand'ring moon,
Riding near her highest noon,
Like one that has been led astray
Through the heaven's wide pathless way;
And oft, as if her head she bowed,
Stooping through a fleecy cloud.

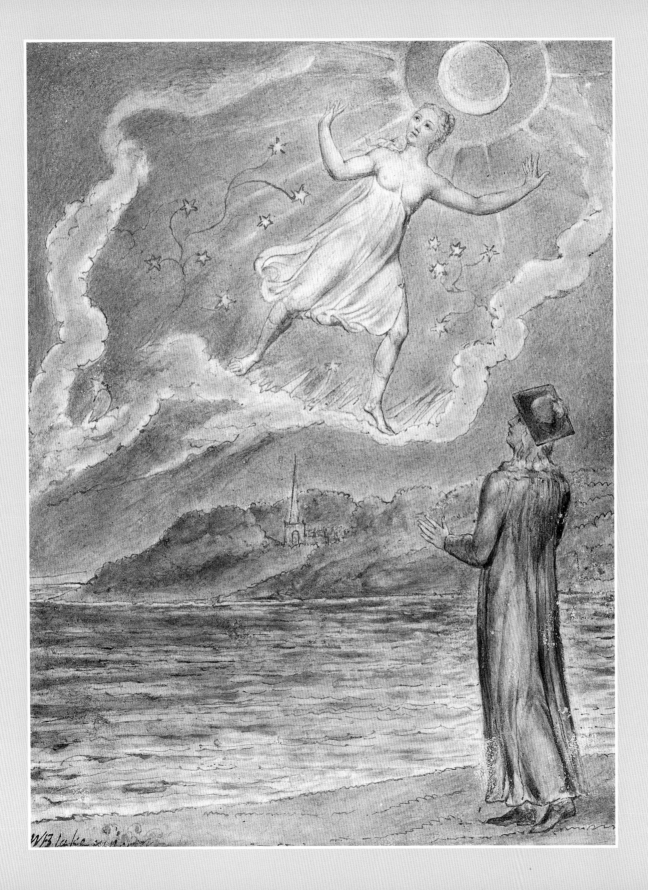

W. Blake

Adam Elsheimer
FLIGHT INTO EGYPT, 1609
Oil on copper, 12 1/4 x 16 1/4 inches
Pinakothek, Munich

Caspar David Friedrich
MAN AND WOMAN CONTEMPLATING THE MOON, c. 1830–35
Oil on canvas, 13 3/8 x 17 3/8 inches
Nationalgalerie, Berlin

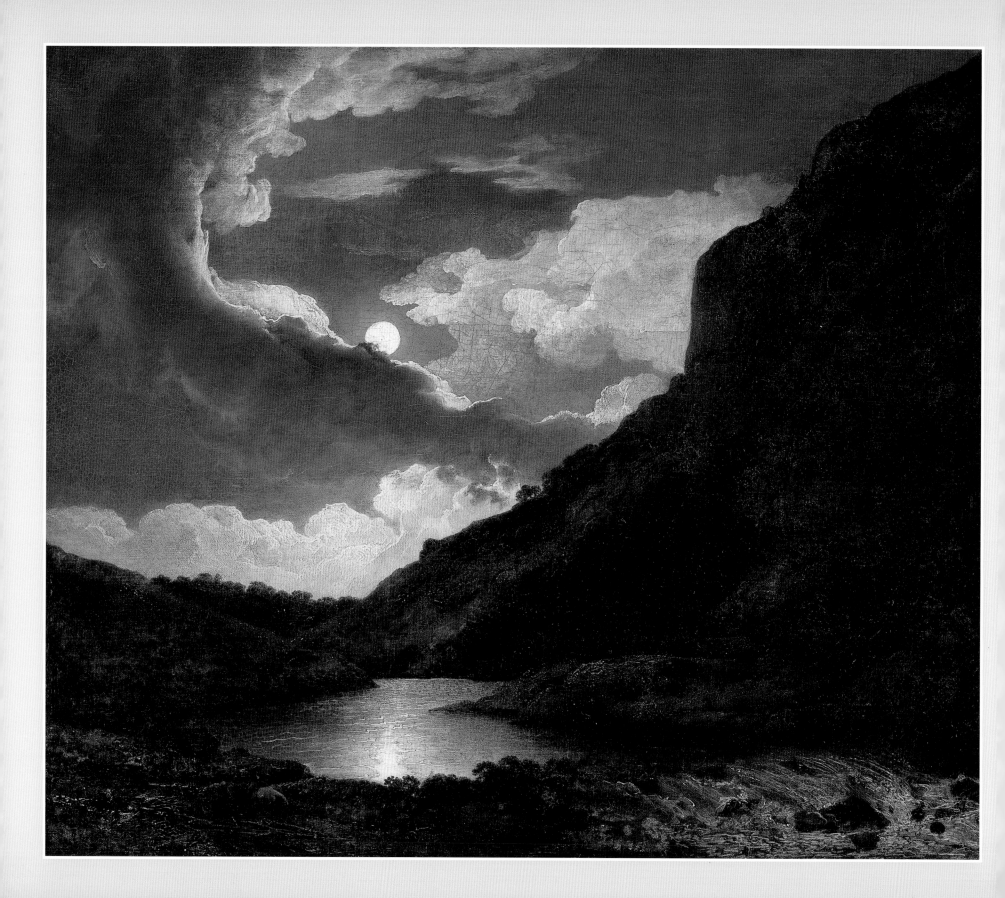

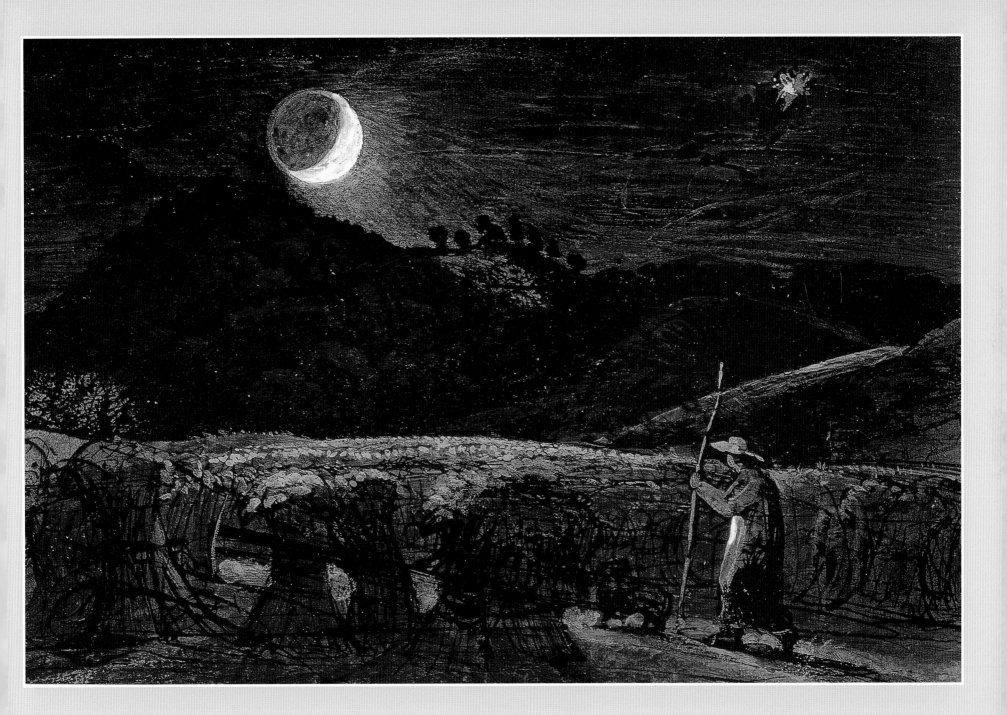

Joseph Wright of Derby
MATLOCK TOR BY MOONLIGHT, 1778/1780
Oil on canvas, 25 1/8 x 30 1/8 inches
Detroit Institute of Arts
Founders Society Purchase, General Membership Fund
Photograph © 1998 The Detroit Institute of Arts

Samuel Palmer
CORNFIELD BY MOONLIGHT
WITH THE EVENING STAR, C. 1830
Watercolor, gouache, and pen on paper
7 3/4 x 11 3/4 inches
The Trustees of the British Museum

109

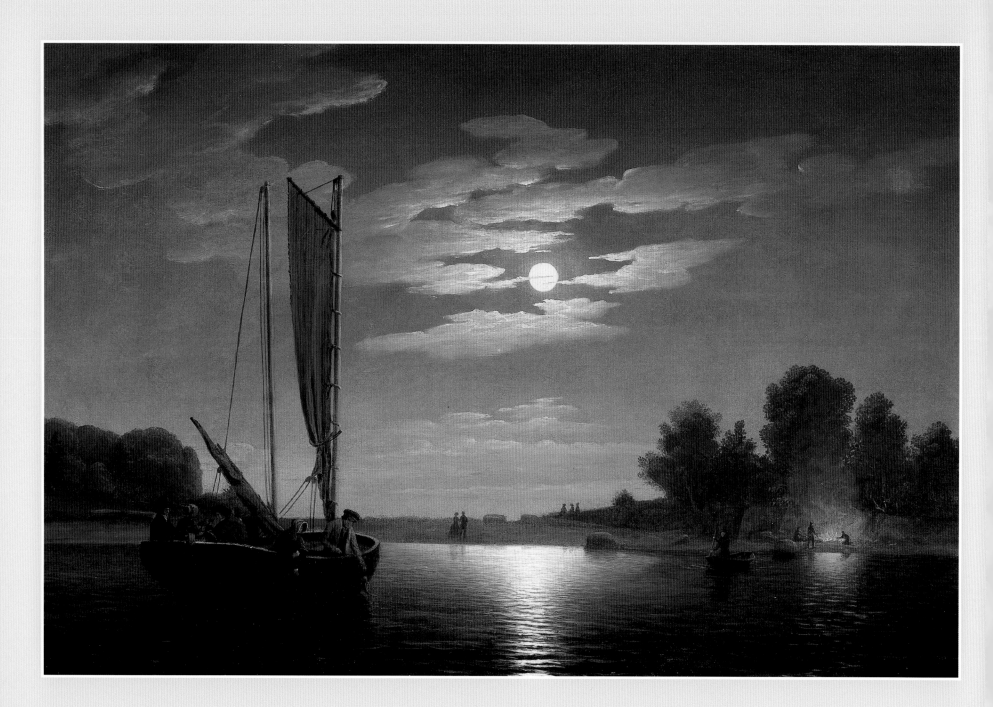

Fitz Hugh Lane
FISHING PARTY, 1850
Oil on canvas, 20 x 30 inches
Museum of Fine Arts, Boston. Gift of Henry Lee Shattuck

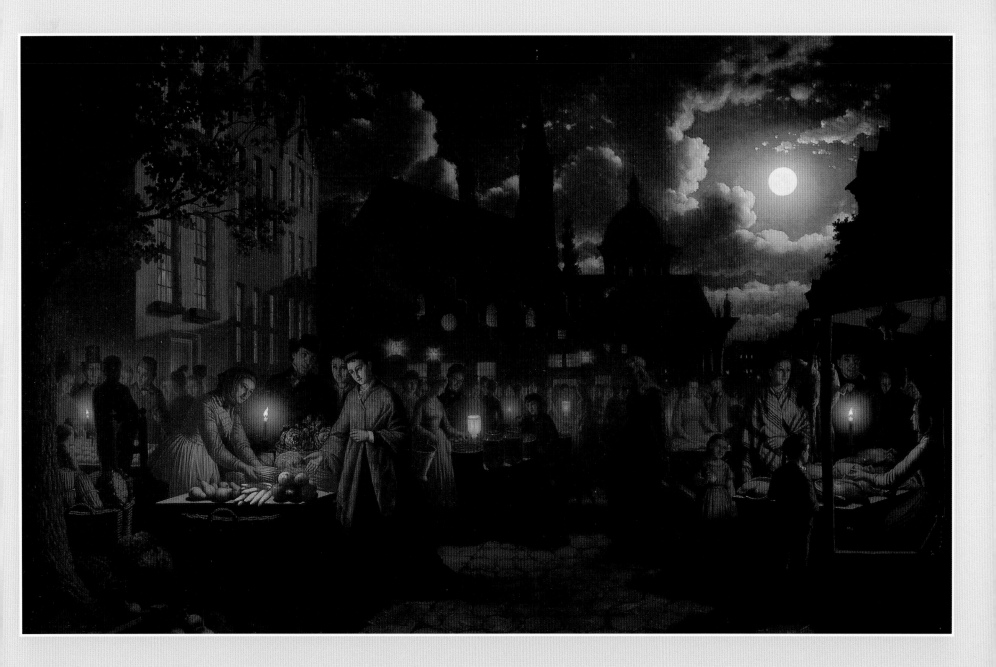

Johan Mengels Culverhouse
MOONLIT MARKET, 1874
Oil on canvas, 23 7/8 x 38 inches
Collection of the High Museum of Art, Atlanta, Georgia
Gift of the James Starr Moore Memorial Foundation, 1985.20

111

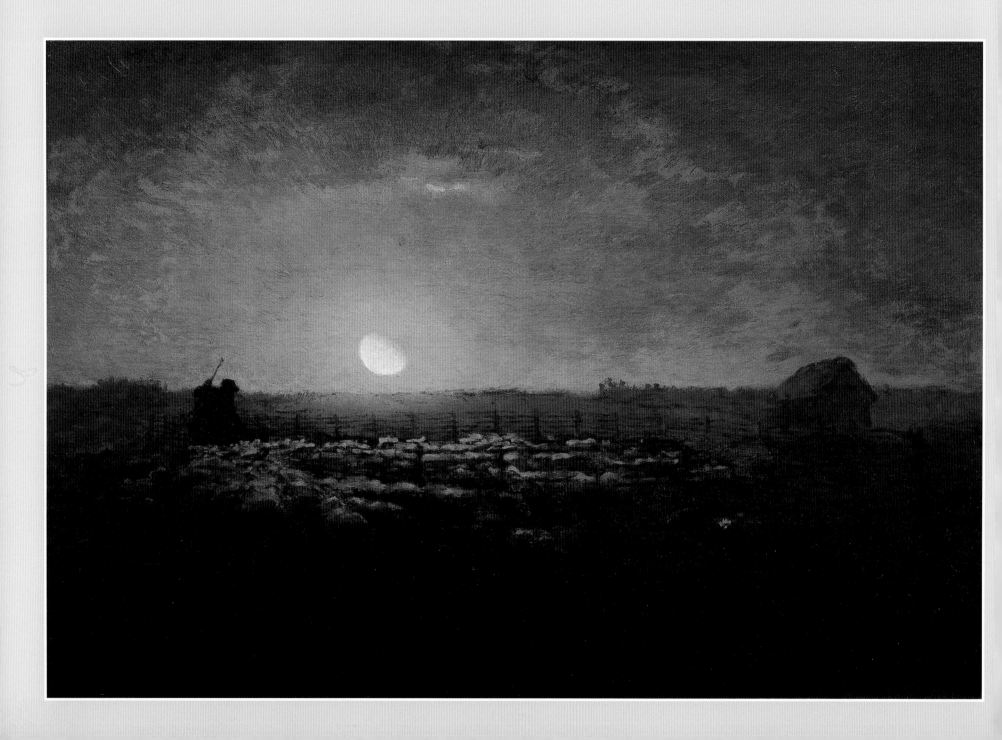

Of this precociously Surrealist painting Jean Cocteau wrote, "The gypsy lying in the middle ground is lost in a dream, or has been carried away by a dream, so far away—like the river in the background—that a lion behind her sniffs at her without being able to reach her. Indeed, the lion, the river, may even be the sleeping woman's dreams. Such peace!" He went on to speculate that perhaps the mysterious gypsy has fallen from the moon, for there are no footprints to record her arrival at the spot where she sleeps.

That orbèd maiden with white fire laden,
Whom mortals call the Moon,
Glides glimmering o'er my fleece-like floor,
By the midnight breezes strewn;
And wherever the beat of her unseen feet,
Which only the angels hear,
May have broken the woof of my tent's thin roof,
The stars peep behind her and peer;
And I laugh to see them whirl and flee,
Like a swarm of golden bees,
When I widen the rent in my wind-built tent,
Till the calm rivers, lakes and seas,
Like strips of the sky fallen through me on high,
Are each paved with the moon and these.

—PERCY BYSSHE SHELLEY, *THE CLOUD*

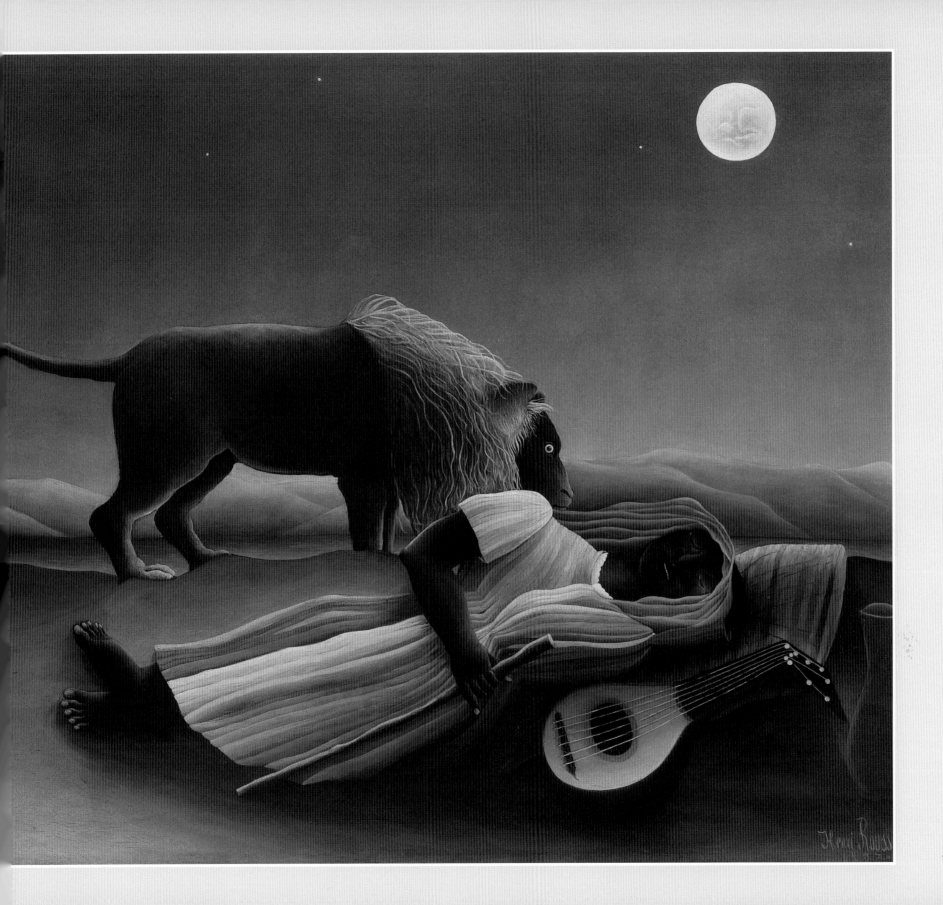

115

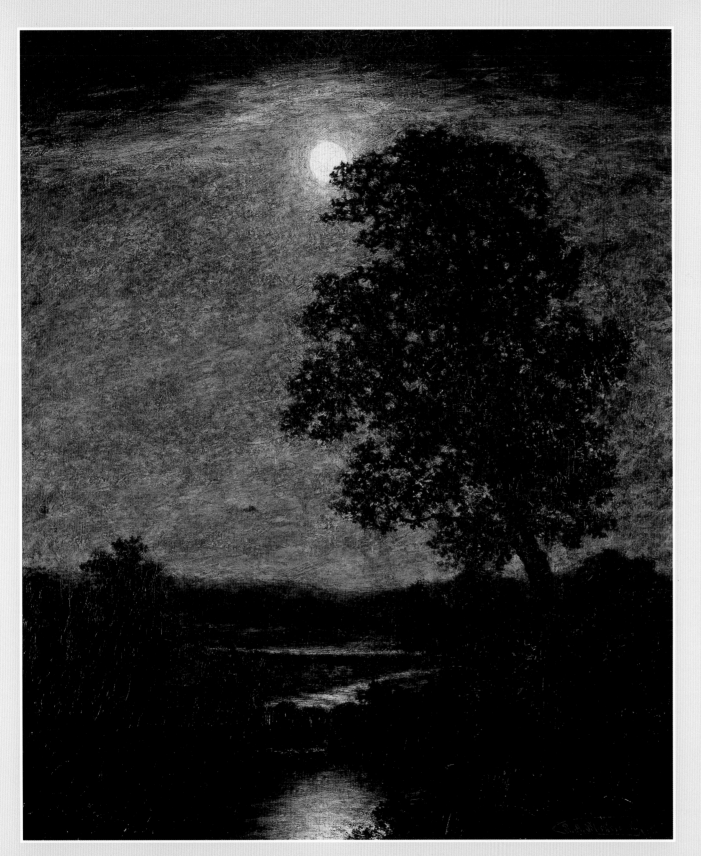

I gazed upon the cloudless
moon,
And loved her all the night,
Till morning came and radiant
noon,
And I forgot her light—

No, not forget—eternally
Remains its memory dear;
But could the day seem dark
 to me
Because the night was fair?

—EMILY BRONTË

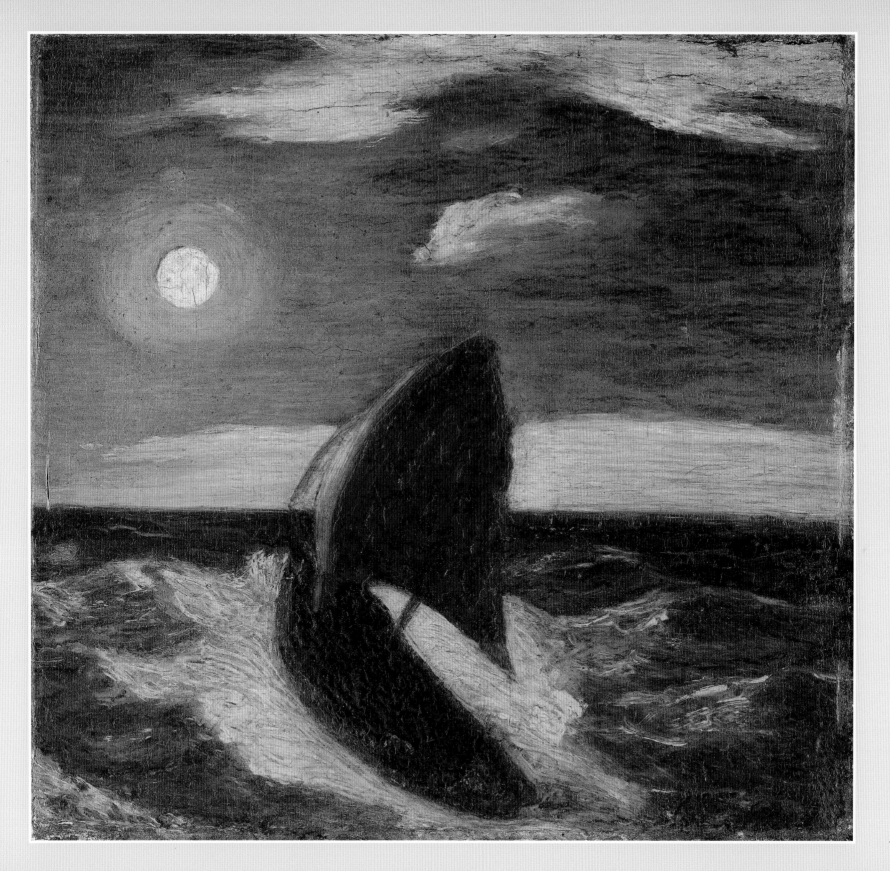

117

118

Georges Seurat
CORBEVOIE, FACTORIES BY MOONLIGHT, 1882–1883
Crayon, 8 5/8 x 11 3/8 inches
Private collection

Giacomo Balla
STREET LIGHT, dated by the artist 1909
Oil on canvas, 68 3/4 x 45 1/4 inches.
Museum of Modern Art, New York
Hillman Periodicals Fund
Photograph © 1998 The Museum of Modern Art New York

119

Edvard Munch
STUMP, MOONLIGHT, 1899
Woodcut with gouache, 14 1/2 x 22 1/4 inches
Private collection

Joseph Stella
FULL MOON, BARBADOS, 1940
Oil on canvas, 36 x 24 inches
Richard York Gallery, New York

A
TRIP
TO THE
MOON.

By Mr. *MURTAGH Mc.DERMOT.*

CONTAINING

Some Obſervations and Reflections, made
by him during his Stay in that *Planet*,
upon the Manners of the Inhabitants.

Quæ genus aut Flexum variant Heteroclita ſunto.
Lill. Gram.

————Ridentem dicere verum
————quid vetat. Hor.

Printed at *DUBLIN:*
And Reprinted at *LONDON*, for J. ROBERTS
in *Warwick-Lane.* MDCCXXVIII.
(Price One Shilling.)

(left) Murtagh McDermot (pseud.)
A TRIP TO THE MOON…CONTAINING SOME
OBSERVATIONS AND REFLECTIONS, MADE BY HIM
DURING HIS STAY IN THAT PLANET, UPON THE
MANNERS OF THE INHABITANTS (London, 1728)

(right) John Wilkins
THE DISCOVERY OF A WORLD IN THE MOONE
(London, 1638)

(below) Richard Adams Locke
THE MOON HOAX; OR, A DISCOVERY THAT
THE MOON HAS A VAST POPULATION OF
HUMAN BEINGS (New York, 1859)

THE
DISCOVERY
OF A
WORLD
IN THE
MOONE.

THE MOON,
AS SEEN BY
LORD ROSSE'S TELESCOPE.
1856.

THE
MOON HOAX;
OR,
A DISCOVERY THAT THE
MOON
HAS A VAST POPULATION OF
HUMAN BEINGS.
BY
RICHARD ADAMS LOCKE.
Illustrated with a View of the Moon,
AS SEEN BY LORD ROSSE'S TELESCOPE.

NEW YORK:
WILLIAM GOWANS.
1859.

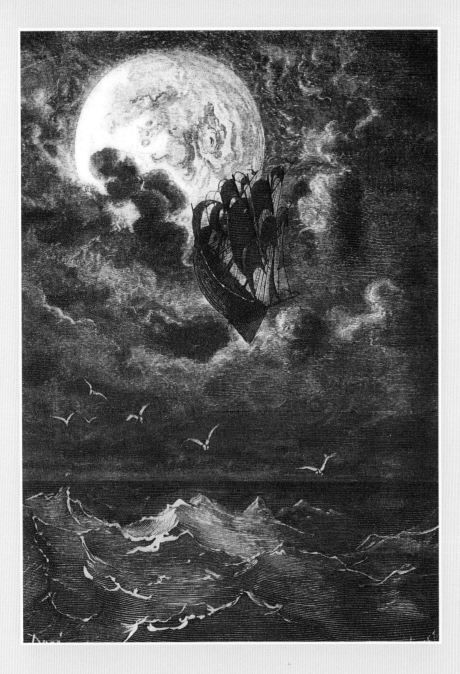

Neil Armstrong
BUZZ ALDRIN ON THE
SURFACE OF THE MOON, 1969
Color photograph
Courtesy National Aeronautics
and Space Administration (NASA)

Gustave Doré
Illustration for THE ADVENTURES OF
BARON VON MUNCHHAUSEN: A SECOND JOURNEY
TO THE MOON *(Paris, 1862)*

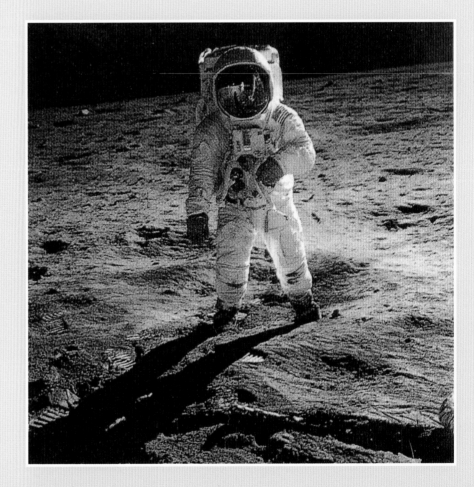

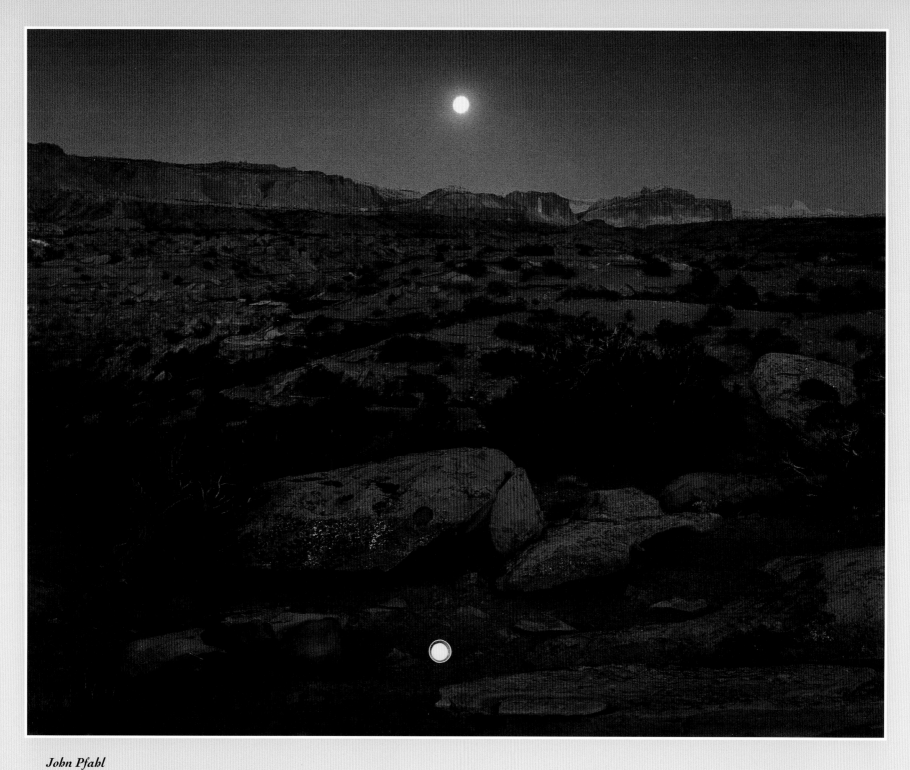

John Pfahl
MOONRISE OVER PIE PAN
(CAPITOL REEF NATIONAL PARK, UTAH), 1977
Chromogenic color photographic print from the series
ALTERED LANDSCAPES, 16 x 20 inches
Courtesy Janet Borden, Inc., New York

124

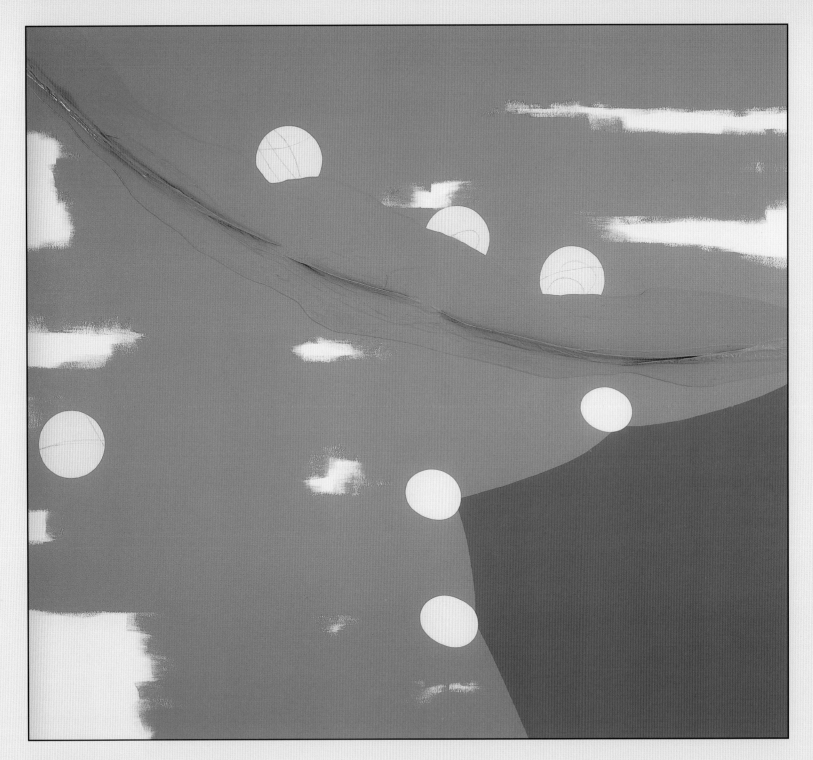

Dona Nelson
KNIGHT, 1996
Latex enamel and muslin on canvas, 70 x 78 inches
Courtesy the artist

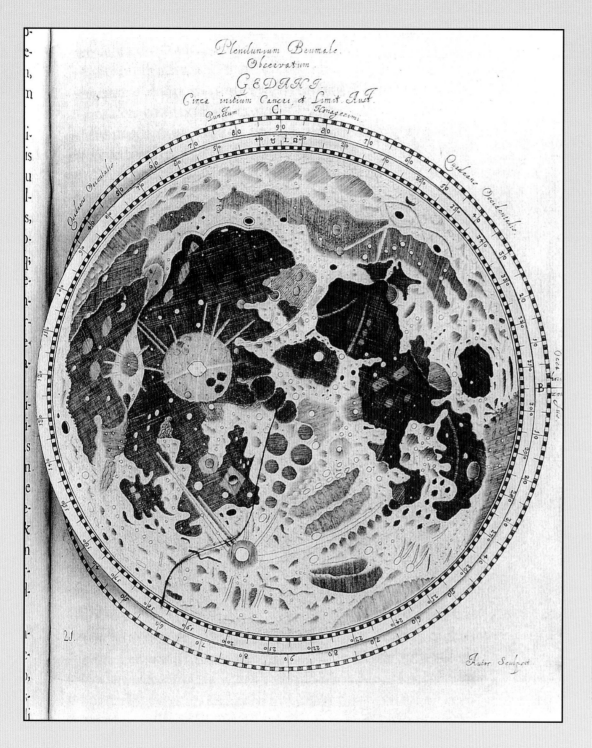

MAP OF THE MOON'S SURFACE
in Johannes Hevelius, SELENOGRAPHIA;
SIVE LUNAE DESCRIPTIO
(Danzig, 1647)

*T*he moon's the North Wind's cooky:
He bites it, day by day,
Until there's but a rim of scraps
That crumbles all away.

The South Wind is a baker,
He kneads the clouds in his den,
And bakes a crisp new moon that
 that…greedy…
North…Wind…eats…again!

—VACHEL LINDSAY

Joseph Cornell
UNTITLED (SOAP BUBBLE SET), 1936
Construction, 15 3/4 x 14 1/4 x 5 7/8 inches.
Wadsworth Atheneum, Hartford, Connecticut.
The Henry and Walter Keney Fund.

Cornell has wittily placed the soap-bubble pipe in relation to a map of the moon in a way that suggests that the moon is a giant bubble, evoking the wonderfully playful image of God creating the astronomical bodies as He whiled away a celestial afternoon blowing soap bubbles.

CARTE GÉOGRAPHIQUE DE LA LUNE

John Adams Whipple
THE MOON, 1851
Daguerreotype, 3 x 4 1/4 inches
Science Museum, London

In March 1851 John Adams Whipple, of Boston, became the first person to make a successful daguerreotype of the moon.

A daguerreotype of a solar eclipse had been made in 1843 by G.A. Majocchi, of Milan. Making a daguerreotype of the sun itself was more difficult, and that feat was not accomplished until April 1845, when Hippolyte Fizeau and J.-B.-Léon Foucault succeeded.

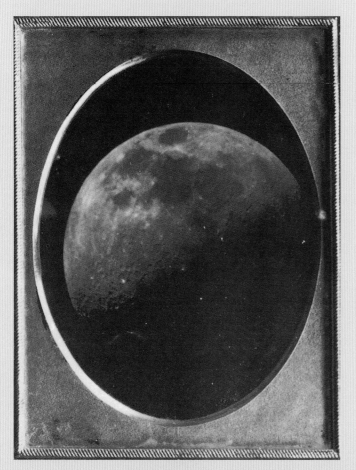

*L*ook downward on that globe, whose hither side
With light from hence, though but reflected, shines;
That is Earth, the seat of Man; that light
His day, which else, as th'other hemisphere,
Night would invade; but there the neighbouring Moon
(So call that opposite fair star) her aid
Timely interposes; and, her monthly round
Still ending, still renewing, through mid-Heav'n,
With borrowed light her countenance triform
Hence fills and empties to enlighten the Earth,
And in her pale dominion checks the night.

—JOHN MILTON, *PARADISE LOST*, III

William Anders
THE MOON, 1968
Photograph
Courtesy National Aeronautics and
Space Administration (NASA)

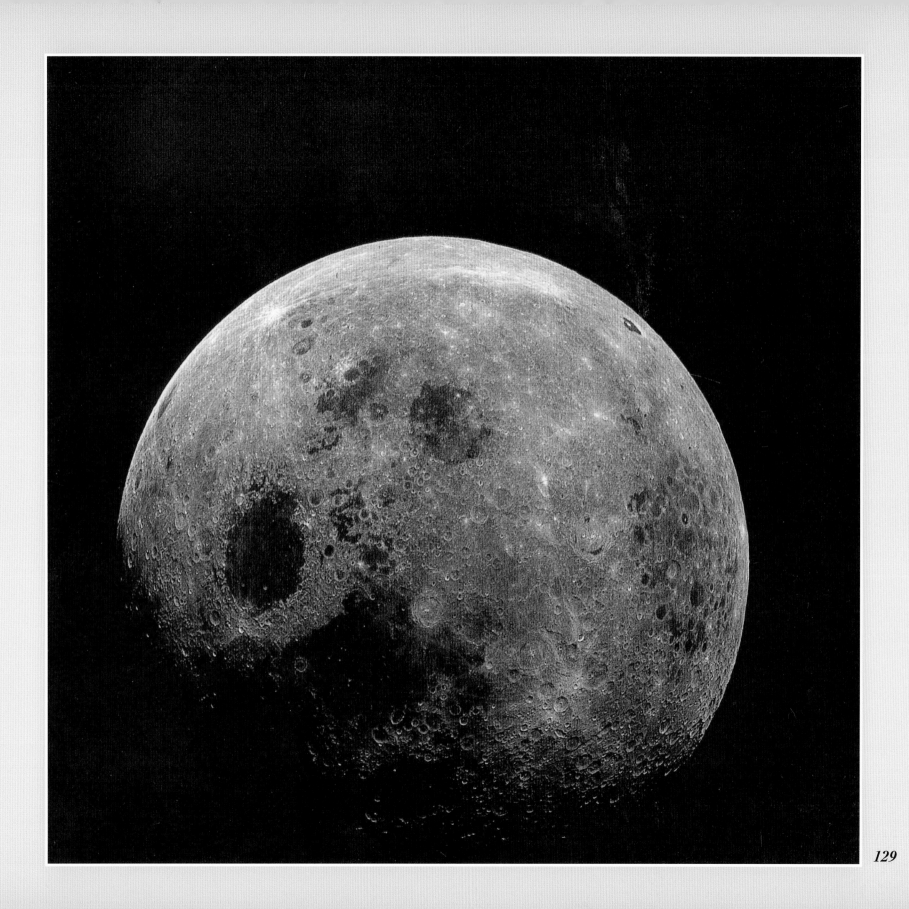

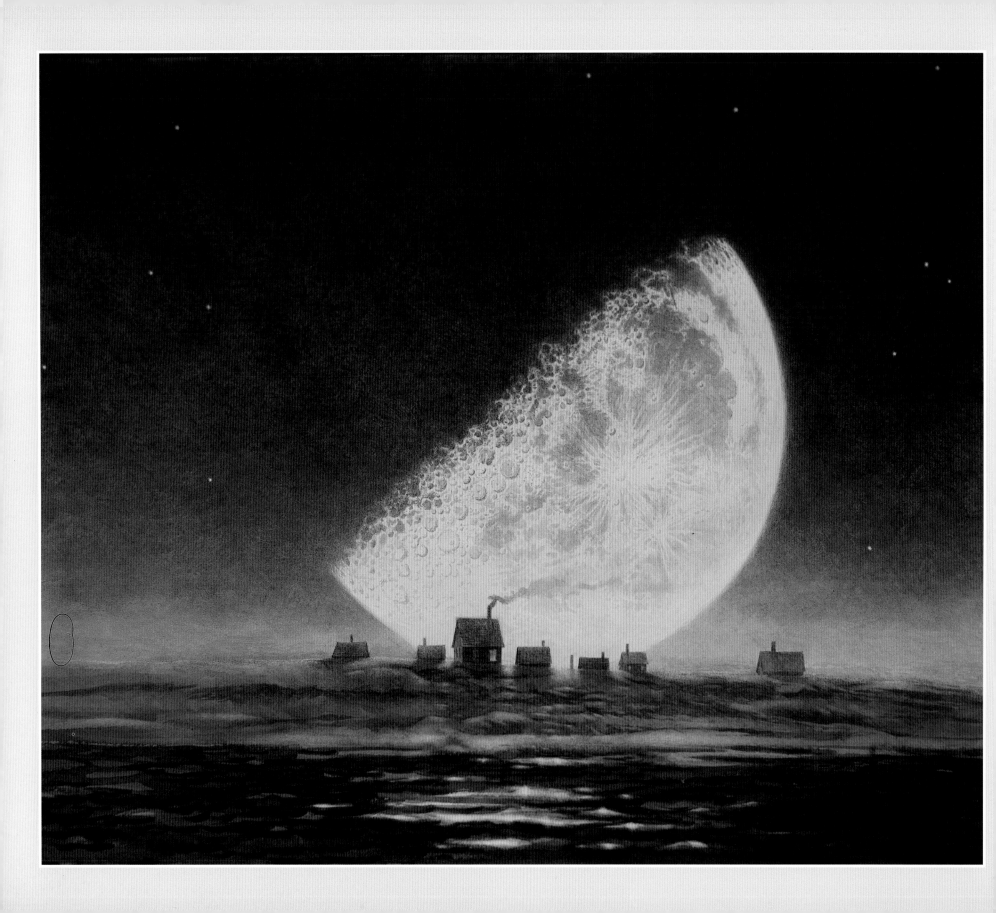

The Moon was but a Chin of Gold
A Night or two ago—
And now she turns Her perfect Face
Upon the World below.

Her Forehead is of Amplest Blonde,
Her Cheek a Beryl hewn,
Her Eye unto the Summer Dew
The likest I have known.

Her Lips of Amber never part,
But what must be the smile
Upon Her Friend she could confer
Were such Her Silver Will.

And what a privilege to be
But the remotest Star—
For Certaintly She'd take Her Way
Beside Your Palace Door.

Her Bonnet is the Firmament,
The Universe Her Shoe,
The Stars the Trinkets at Her Belt,
Her Dimities of Blue.

—EMILY DICKINSON

Greg Mort
HOUSES ON THE MOON, 1995
Watercolor on paper,
21 x 28 inches
Courtesy the artist

KC Scott
APPLE TREES, 1992
Watercolor and conte crayon,
18 7/8 x 9 1/8 inches
Collection the artist

131

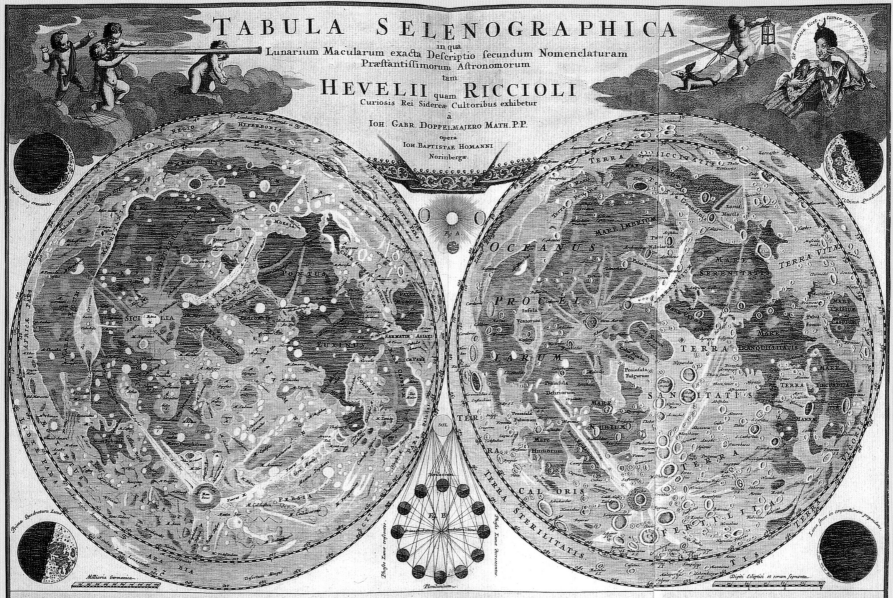

TABULA SELENOGRAPHICA

in qua
Lunarium Macularum exacta Descriptio secundum Nomenclaturam
Praestantissimorum Astronomorum
tam

HEVELII quam RICCIOLI

Curiosis Rei Sidereae Cultoribus exhibetur
a
IOH. GABR. DOPPELMAJERO MATH. P.P.
opera
IOH. BAPTISTAE HOMANNI
Norinbergae

When looked at through a special viewer, the two side-by-side images of a stereograph merged into a single astonishingly three-dimensional image. Perfected about 1854, stereographs were introduced to the United States in 1858 and quickly became immensely popular. They were usually made with a special camera whose two lenses were spaced about as far apart as a normal pair if eyes; simultaneous exposures through the two lenses would yield an approximation of binocular vision. For this stereograph of the moon, however, photographs made on two different occasions were paired in order to provide the disparity necessary for the spatial illusion.

If you hold the reproduction about twelve inches from your eyes and then focus halfway between the two images with gently crossed eyes (be very careful not to strain!), you should see a picture of the moon not as a flat disk but as a fully spherical body in space.

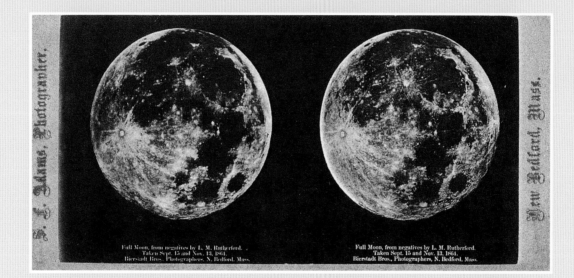

Johan Baptist Homann
TABULA SELENGRAPHICA, C. 1730
Library of Congress, Washington, DC

Homann's plate compares the maps of the moon by Hevelius and by the Jesuit scholar Giambattista Riccioli. It was the latter who gave many of the lunar features the names by which they are still known today.

L.M. Rutherford
FULL MOON, FROM NEGATIVES…TAKEN
SEPTEMBER 15 AND NOVEMBER 13, 1864
Stereograph
Private collection

The Stars

The stars awaken a certain reverence,
because though always present, they are inaccessible.

—RALPH WALDO EMERSON, *NATURE*

*e*arth is in the Milky Way galaxy, named for the band of stars that may be seen stretching across part of the night sky, as in Greg Mort's painting *Night River.* Tintoretto illustrated the myth according to which the infant Hercules bit Hera's breast and the drops of milk that streamed out formed the Milky Way. The term galaxy is derived from the ancient Greek word for milk.

The Milky Way galaxy, made up of about 100 billion stars, consists of a central bulge of very old stars surrounded by a thin disk of spiral arms of younger stars; this disk has a radius of about 50,000 lightyears. Our solar system is located in one of the spiral arms, about 33,000 light-years from the center. Astronomers estimate that there may be 100 billion galaxies in the universe, each containing untold billions of stars.

The life cycle of a star depends on its size at birth. The larger the star, the shorter its life. The largest stars, up to about fifty times more massive than our Sun, burn themselves out within one million years or so. When the core of one of these giants collapses, the star explodes, causing a spectacular supernova, which eventually contracts into a black hole of infinite density.

A quasar (quasi-stellar object) is one of the huge and extremely distant starlike bodies that give off immense quantities of radio waves. Among the most surprising conclusions that Einstein advanced in his General Theory of Relativity is that the path of light, which has no mass, is bent by gravity. John Wallace's painting of a so-called Einstein cross shows the most dramatic manifestation of this phenomenon. What looks like a group of five stars is actually the light from a single quasar, eight billion light-years away, that has been gravitationally lensed, which is to say, bent into various paths by the gravitational field of a faint galaxy that lies between the quasar and Earth.

Neither the morning star nor the evening star is actually a star at all. Indeed, they are both the planet Venus, which is so bright that it is the first small celestial object to become visible as evening approaches and the last to disappear in the morning. Nor are comets stars, though throughout much of history they have been mistaken as such; it is quite possible that the Star of Bethlehem was actually a comet.

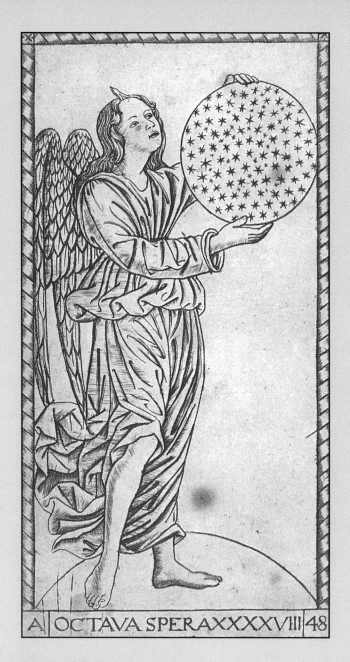

Master of the S-series
OCTAVA SPERA (EIGHTH SPHERE), c. 1460
Engraving, 7 x 3 7/8 inches
National Gallery of Art, Washington, DC

*T*ill, at his second bidding, Darkness fled,
Light shone, and order from disorder sprung.
Swift to their several quarters hasted then
The cumbrous elements—Earth, Flood, Air, Fire;
And this ethereal quintessence of Heaven
Flew upward, spirited with various forms,
That rolled orbicular, and turned to stars
Numberless, as thou seest, and how they move:
Each had his place appointed, each his course;
The rest in circuit walls this Universe.

—JOHN MILTON, *PARADISE LOST*, III

THE CREATION OF THE HEAVENLY BODIES,
13TH CENTURY
Mosaic
Basilica of San Marco, Venice

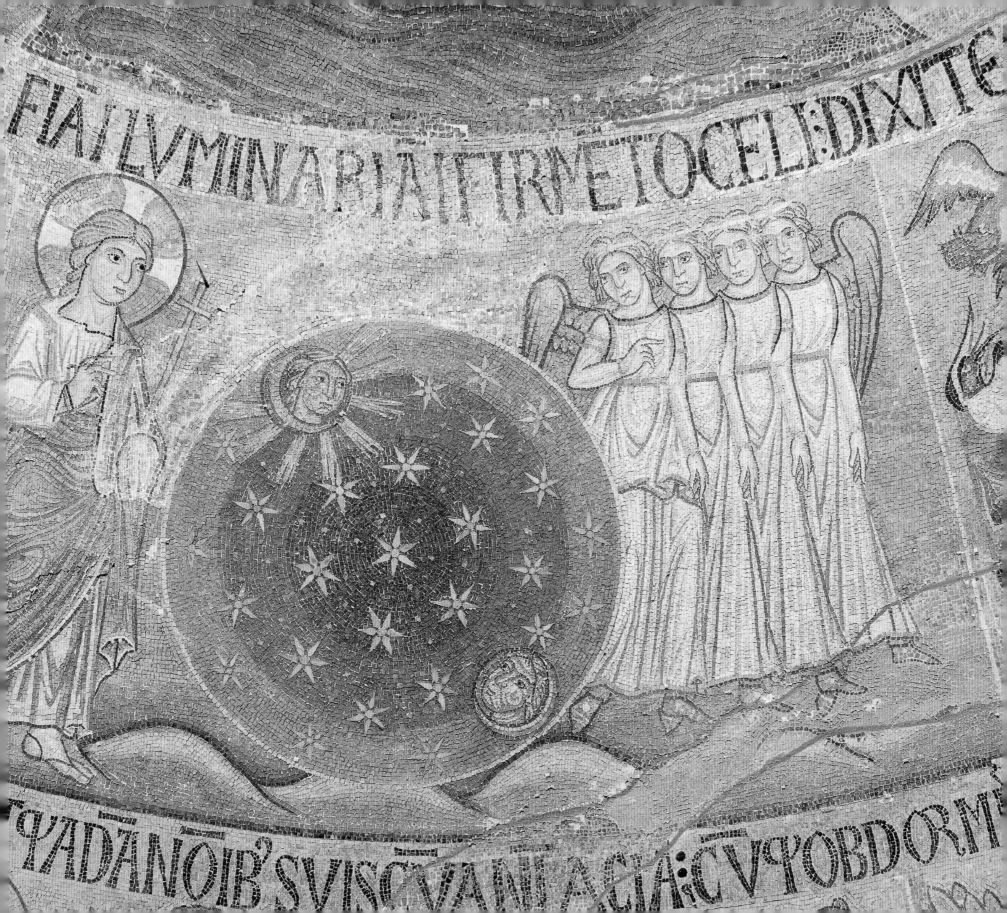

FIAT LVMINARIA IN FIRMETO CELI DIXIT E[T]

[T] VT A[D]NOIB[VS] SVIS QVAN[T]A GRA CV[M] OBDORM[E]

THE CONSTELLATIONS SAGITARIUS, CASSIOPEIA, ANDROMEDA, AND PERSEUS,
15TH CENTURY
from a manuscript of Hyginus's POETICA ASTRONOMICA
Ink and colors on vellum
Bodleian Library, Oxford. Ms. Canon Class. Lat 179, fols. 30r, 34v, 35r, 35v

Andromeda prope casiepiam supra caput pscis brevi in
teruallo dissidente collocata pspicitur manib; diuersis
ut antiquis hystoriis est traditum cui[us] caput equi pe
gasi uenti contingit. Eadem enim stella ut umbelicus pegasi et
andromede caput appellat. huius medium pectus et manuum sunt
stram circulus estiuus diuidit. Occidit autem cum pisce d[e] duob;
secundo quem andromede subiectum brachio supra diximus. Ex o
riente libra. et scorpione capite pri[us]q[ue] reliquo corpore puenit ad
tectam. Exorit[ur] autem cu[m] piscib; et ariete. hec ut supra diximus. Et in
capite stella[m] clare lucete[m] una[m]. in usq[ue] humero una[m] [et] cubito d[e]xt[er]o una[m]
in ipsa manu unam [et] sinistro cubito l[et] in brachio una[m]. in manu
altera. in zona tres sup[er] zona[m] quattuor. in utroq[ue] genu una [et] pe
dib; autem binas. ita omnino ... est stellar[um] n[umer]us uiginti.

Perseus sinistr[am] cru[us] [et] humer[us] leuu[m] circul[us] esti[us] a reliquo
corpore diuidit. ip[s]e manu dextra archicu[m] circulum tagete
dextro pede caput ariet[is] premere u[e]lut currens uidet. [et] se
occidens sagittario [et] capricorno exorto inclinat ad caput uertit[ur] cu[m]
ariete et tauro rec[t]o exorit[ur]. Et autem in utraq; humero stella una
in manu dextra clar[am] lucentem unam qua falcem tenere dicit. quo
telo gorgonam interfecit. In sinistra altera[m] q[uam] caput corg[on]is te[net]
exulat[ur]. Et p[er]sea in uentre stellam unam. in lumbis alteram. In
dextro femore unam ad genu. in tibia unam. [et] pede una obscura [et] si
nistro femore unam [et] genu alteram. in tibia duas [et] sinistra manu q[uam]
gorgon[is] caput uc[c]at[ur] stellas quattuor. O[mn]i[n]o est stellar[um] n[umer]us dece [et]
septem. caput ei[us] et falx si sideris apparent. hunc aiu[n]t cu[m] inter
sydera cecoruit m[er] non figuratum acceperint. qui et plur[es] eu[m] pul
uerulentum dixere q[uod] i[n] nine eouenit posse inter sydera et pulua
rulentum acceperit. Q[uod] uol si esset dignior erat orion. quidem asc[er]e[t]e
Primum q[uod] assidue est uenatur[us] et semp[er] in terra sint. Deinde q[uod] ad
huc inter sydera uenari uidet[ur]. Perseus aut[em] qui assidue uolabit
non pot[est] pulueream habere. Q[uod] uid ig[itur] est cum uellet arachus eum
uenaturum obscure signif[i]care usus etholog[us]. consuetudine ec[er]nit
menon dixit. Etholi enim eum uolunt aliquem decurrere signif[i]
care ad p[er]uisse dicere id q[uo]d aratus uolunt demostrare. no ut illu[m]
uolantem assidue puluerulentum dicat q[uod] a multis pp[e]ta est in
tellectum.

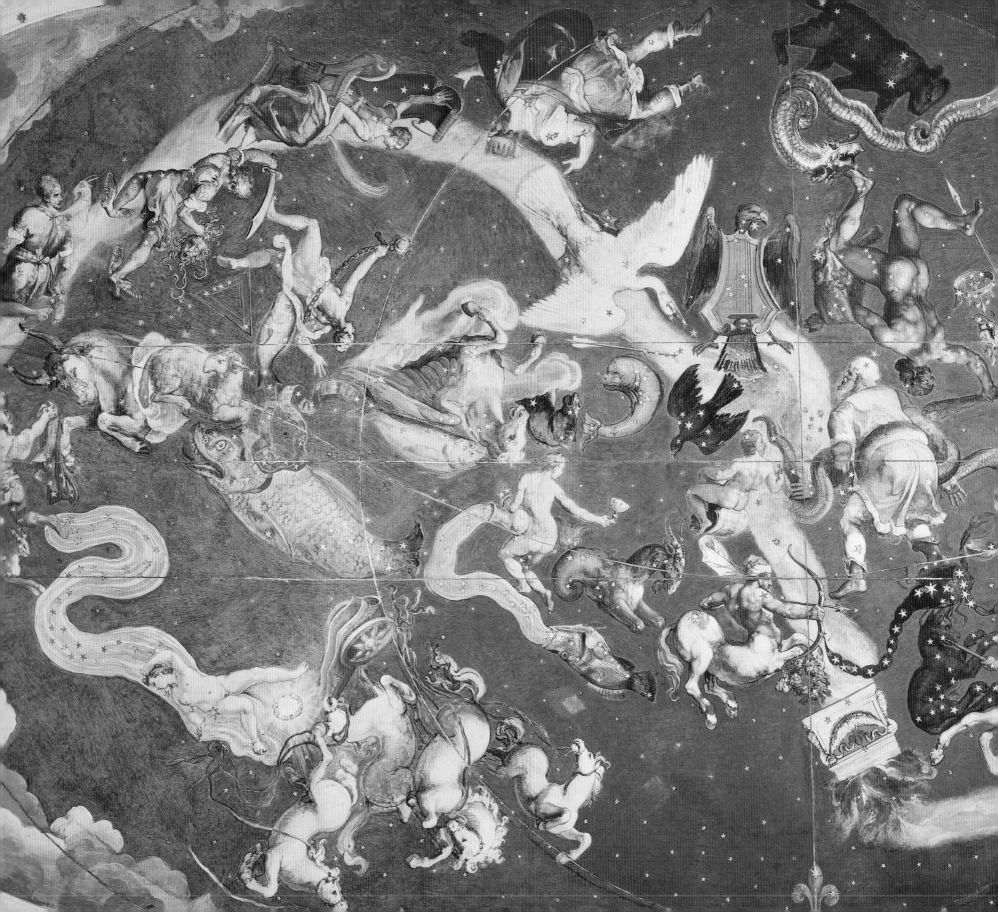

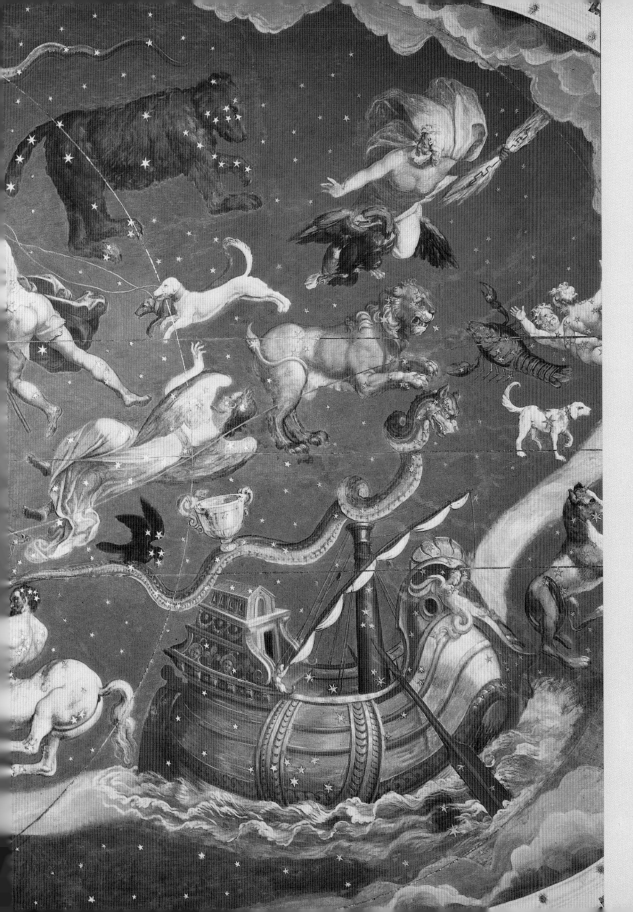

Taddeo Zuccaro
THE ZODIAC AND OTHER CONSTELLATIONS, 1575
Ceiling fresco, 474 x 236 inches
Palazzo Farnese, Caprarola (Viterbo), Italy
Photograph Scala. Courtesy Art Resource, New York

This fresco, measuring nearly forty feet by twenty,
combines the constellations of the northern and
southern hemispheres. In the lower left corner is
Phaethon tumbling from the chariot of the Sun.

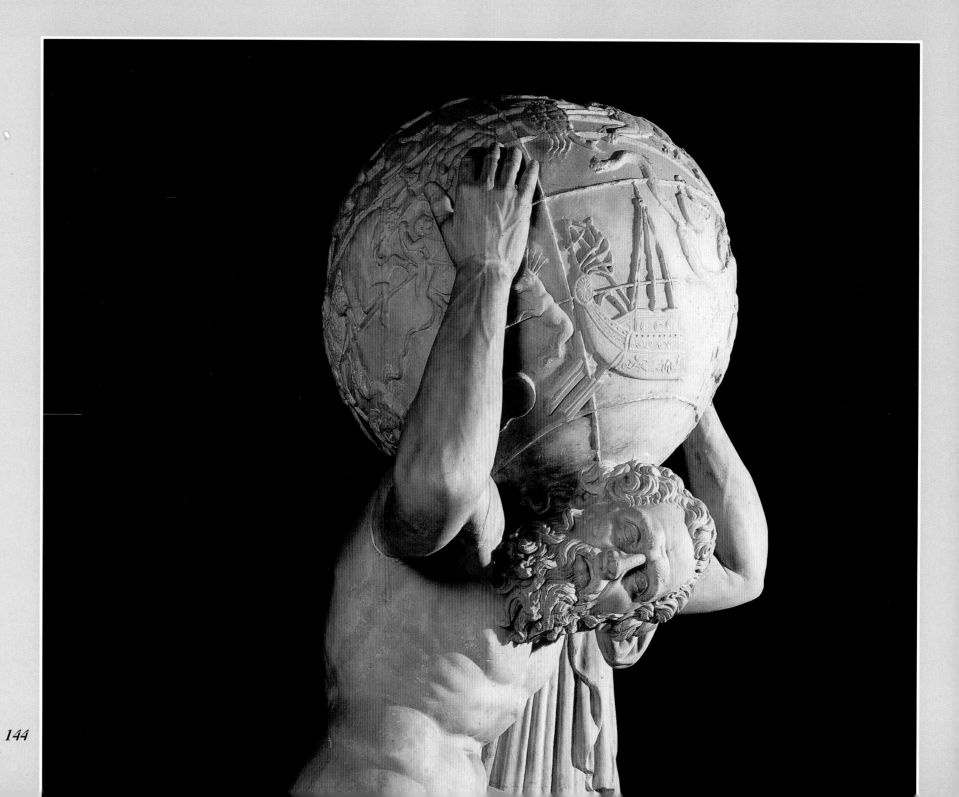

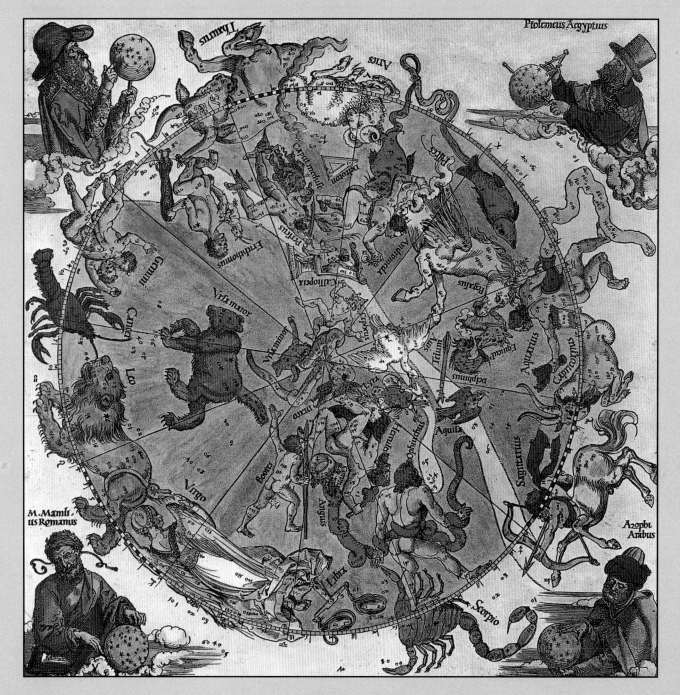

Resting on the shoulders of Atlas, a Titan condemned to support the heavens as punishment for having taken part in an unsuccessful revolt against Zeus, is the oldest surviving celestial globe. The constellations, in which no individual stars are indicated, are shown in reverse from the way they appear when viewed from the Earth—for here we are looking at the celestial sphere from the outside.

In 1515 Albrecht Dürer collaborated with the Nuremberg astronomer Konrad Heinfogel to produce two woodcut celestial maps, one of the northern sky and one of the southern. Heinfogel marked the positions of the stars, around which Dürer drew representations of the creatures and mythological figures who gave their names to the constellations.

145

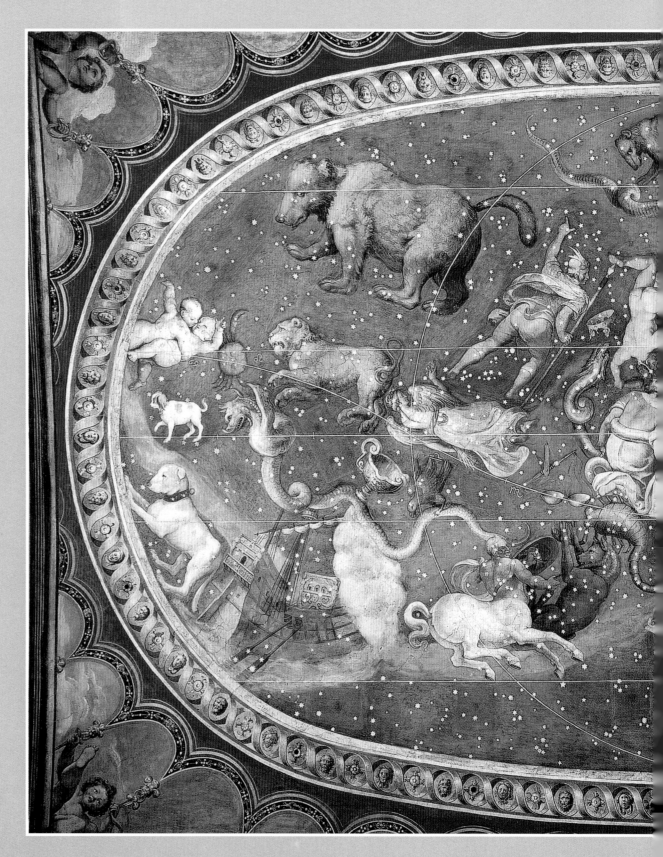

Giovanni Antonio da Varese
CONSTELLATIONS, INCLUDING THE ZODIAC, 1562–64
Ceiling fresco
Loggia della Cosmografia, Vatican Palace, Rome

146

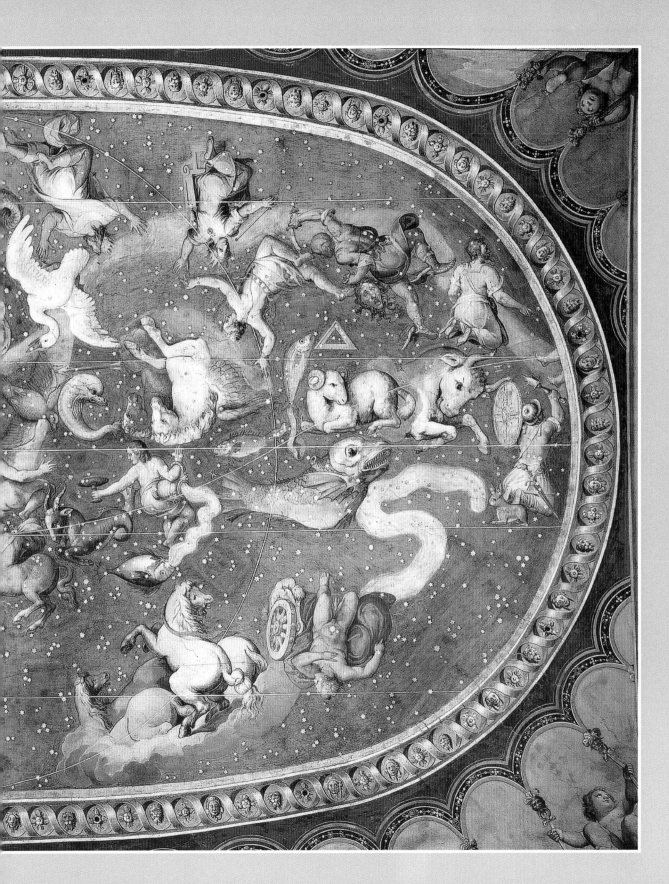

*T*he fortunes of cities as well as of men…have their certain periods of time prefixed, which may be collected and foreknown from the position of the stars at their first foundation.

—PLUTARCH, *ROMULUS*

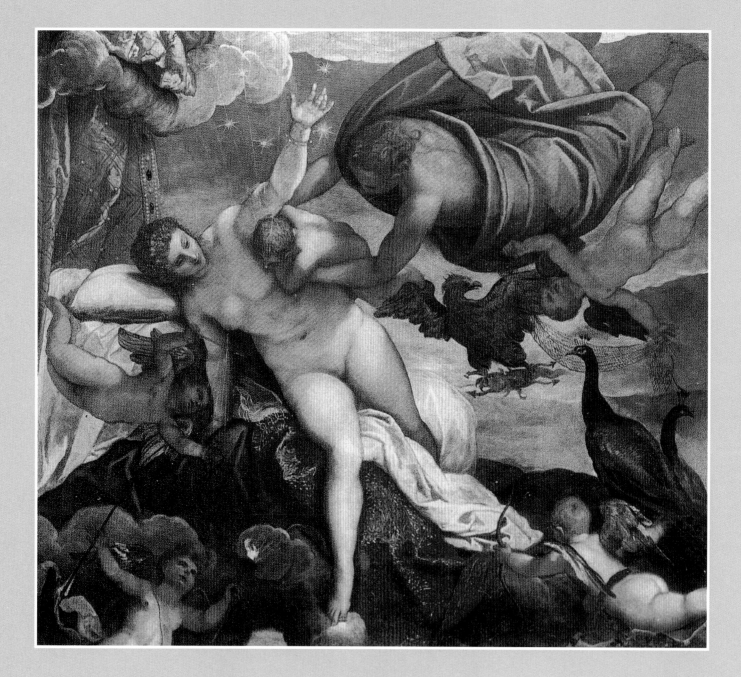

Jacopo Robusti, called Tintoretto
THE ORIGIN OF THE MILKY WAY, late 1570s
Oil on canvas, 58 1/4 x 70 inches
National Gallery, London

James Thornhill
THE CONSTELLATIONS PERSEUS AND ANDROMEDA
Engraving in John Flamsteed, ATLAS COELESTIS, 1729

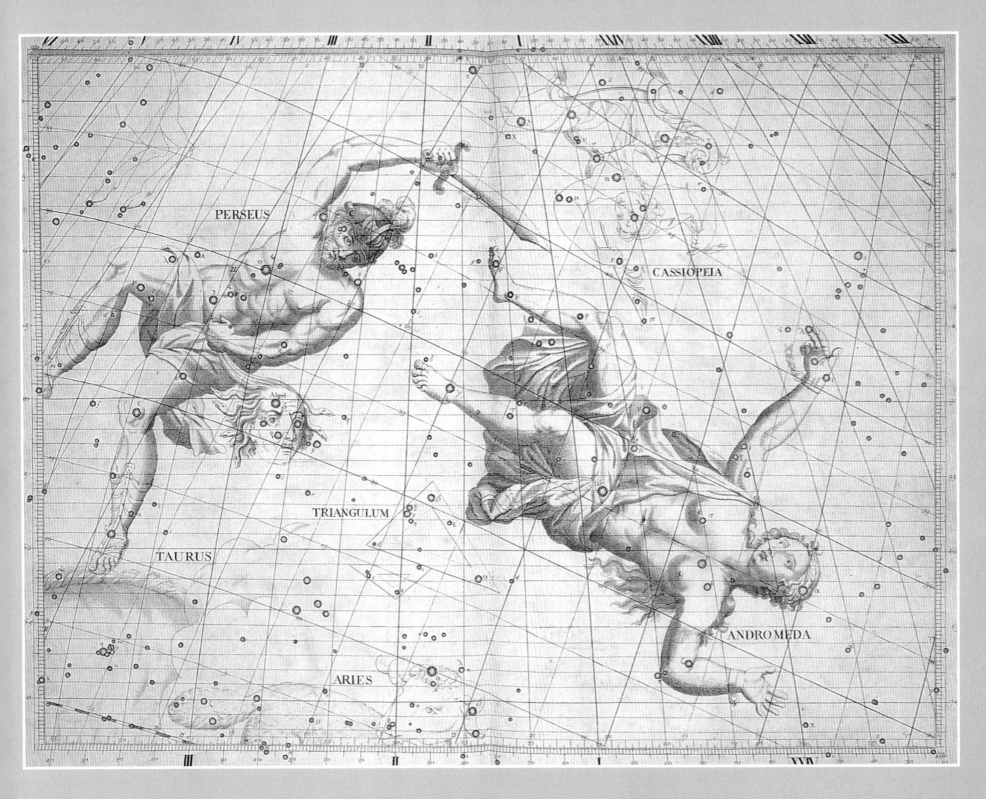

PERSEUS

CASSIOPEIA

TAURUS

TRIANGULUM

Algol

ANDROMEDA

ARIES

(opposite)
Mattheus Seutter
COMETA, QUI ANNO CHRISTI 1742
Library of Congress, Washington, DC

A map, published in 1742, showing the path of the comet that was visible in the constellations Draco and Cepheus from March 13 to April 15 of that year.

THE GREAT COMET OF 1577
Single-sheet engraving, 1577
Library of Congress, Washington, DC

ARMILLARY SPHERE, 16TH CENTURY
Gilt wood and metal
Monasterio-Palacio Real El Escorial, Spain

Giovanni Galucci
ARMILLARY SPHERE, 1588
Woodcut
Library of Congress, Washington, DC

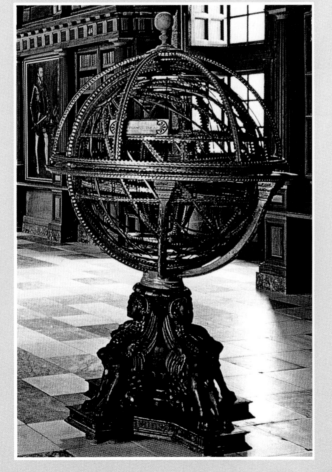

150

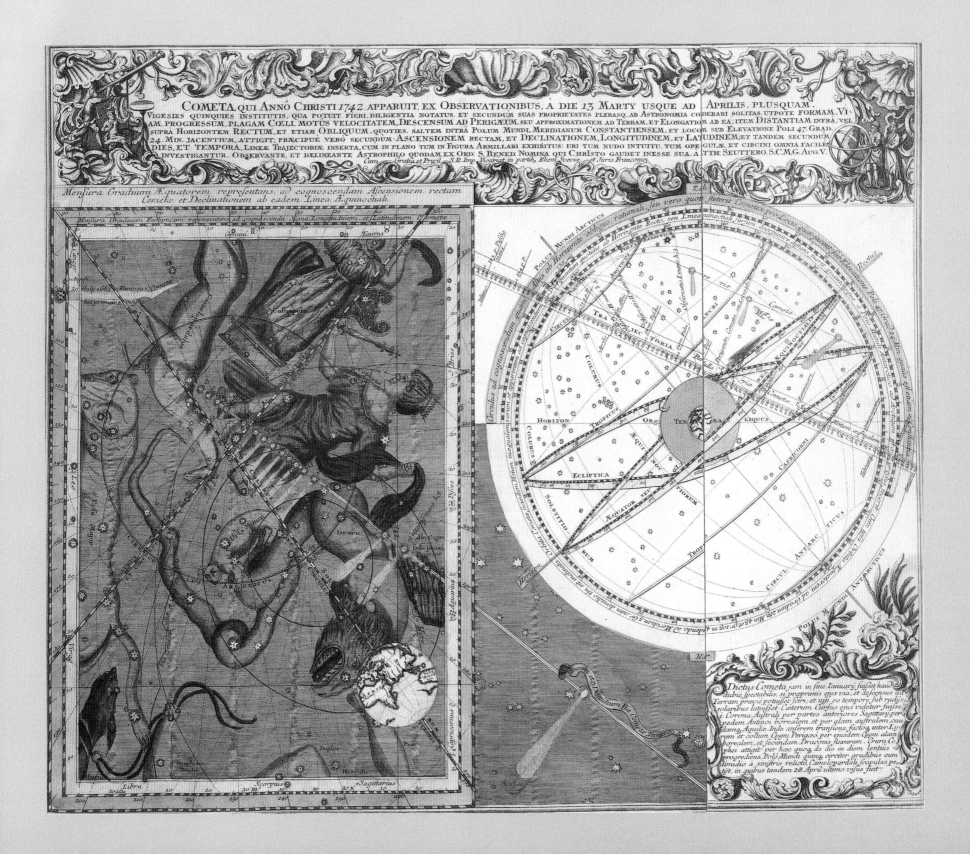

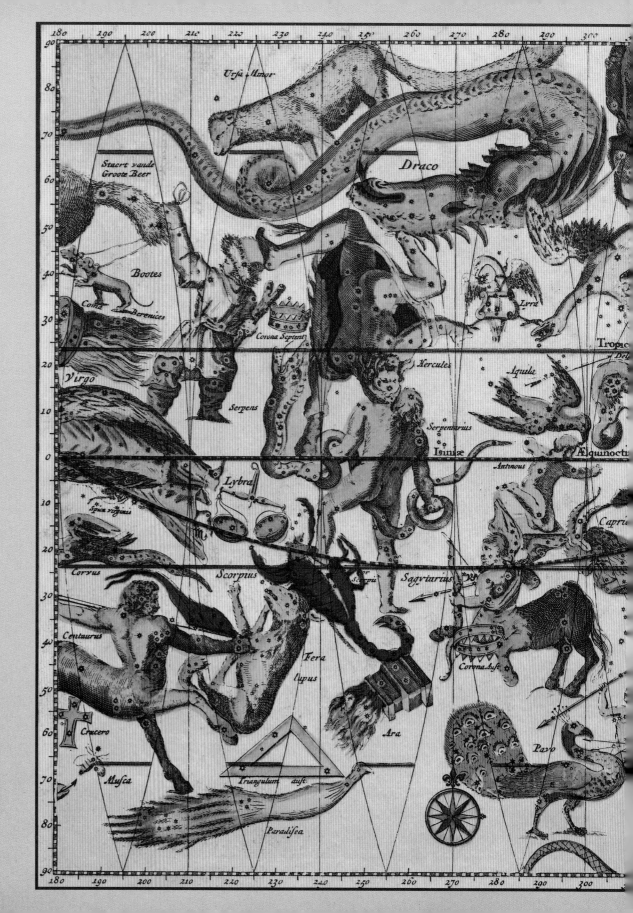

Remmet Backer
MAP OF THE HEAVENS, c. 1710
Library of Congress, Washington, DC

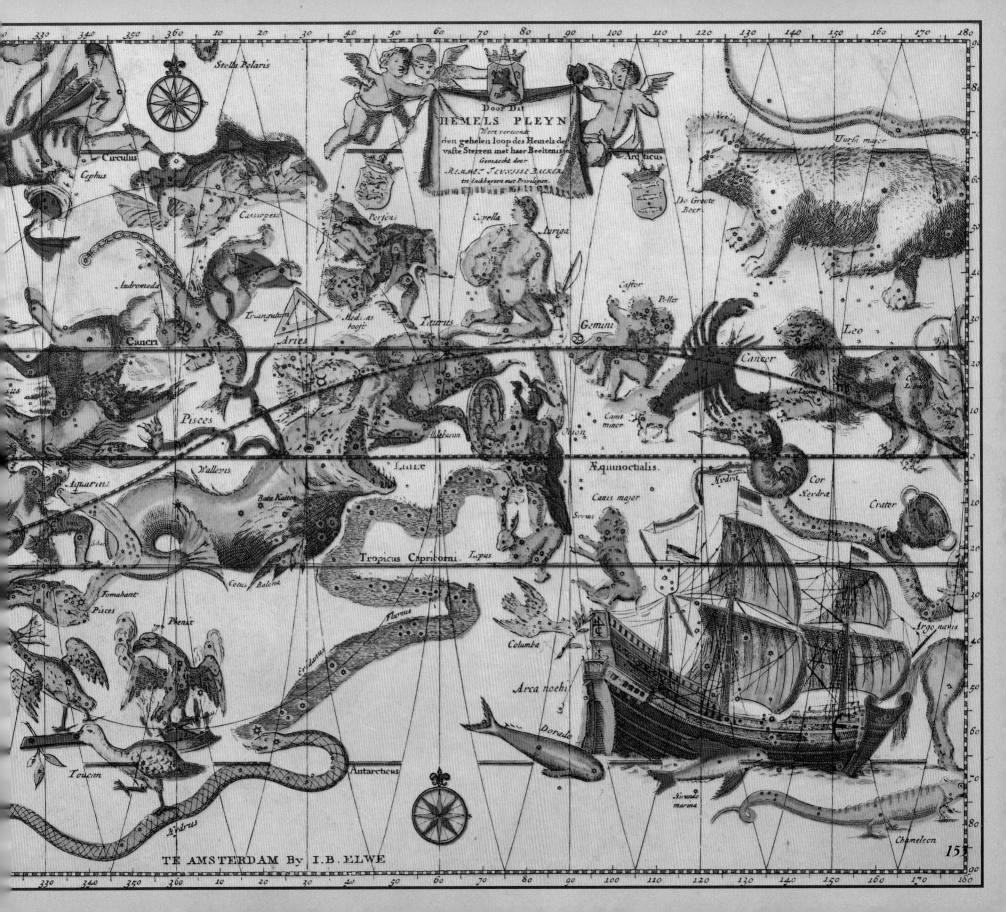

Door Dit
HEMELS PLEYN
Wert vertoondt
den geheelen loop des Hemels der
vaste Sterren met haer Beeltenissen
Gemaeckt door
REINIER JEURISSE BACKER
tot Enckhusen met Privilegien.

Stella Polaris

Circulus
Cephus
Cassiopeia
Andromeda
Triangulum
Cancri
Aries
Pisces
Aquarius
Walleivis
Bata Kaitos
Schat
Fomahant
Pisces
Phenix
Toucan
Hydrus
Antarcticus

Perseus
Medusas hooft
Taurus
Aldebaran
Linie
Tropicus Capricorni
Cetus Baleha
Eridanus
Fluvius
Columba
Arca noehi
Dorado
Hirundo marina
Lepus

Capella
Auriga
Gemini
Castor
Pollex
Cancer
Canis minor
Orion
Æquinoctialis
Canis major
Sirius

Arcticus
Ursa major
De Groote Beer
Leo
Cor Leonis
Hydra
Cor Hydra
Crater
Argo navis
Chaneleon

TE AMSTERDAM By I.B. ELWE

220 340 350 360 10 20 30 40 50 60 70 80 90 100 110 120 130 140 150 160 170 280
330 340 350 360 10 20 30 40 50 60 70 80 90 100 110 120 130 140 150 160 170 180

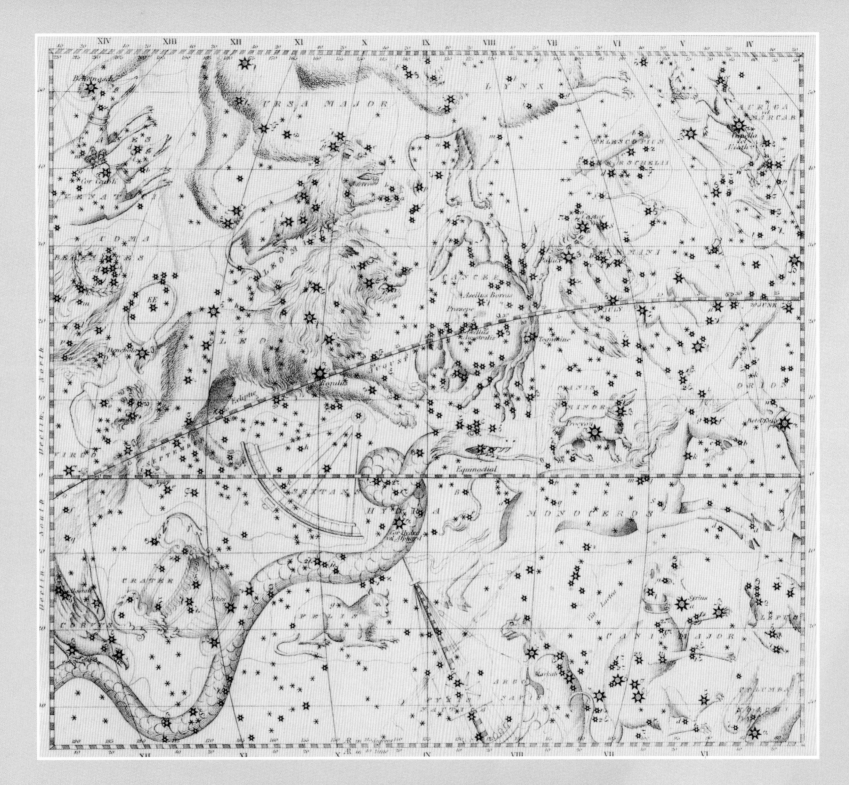

TWO MAPS OF THE SAME SECTION OF THE SPRING SKY OVER BRITAIN
from James Middleton, CELESTIAL ATLAS, 1843
Library of Congress, Washington, DC

O, thou art fairer than the evening air
Clad in the beauty of a thousand stars.

—CHRISTOPHER MARLOWE, *DOCTOR FAUSTUS*

Vincent van Gogh
STARRY NIGHT, 1889
Oil on canvas, 29 x 36 1/4 inches
The Museum of Modern Art, New York
Acquired through the Lillie P. Bliss Bequest
Photograph © 1998 The Museum of Modern Art, New York

156

Over all the sky—the sky! far, far out of reach,
studded, breaking out, the eternal stars.

—Walt Whitman, *Bivouac on a Mountain Side*

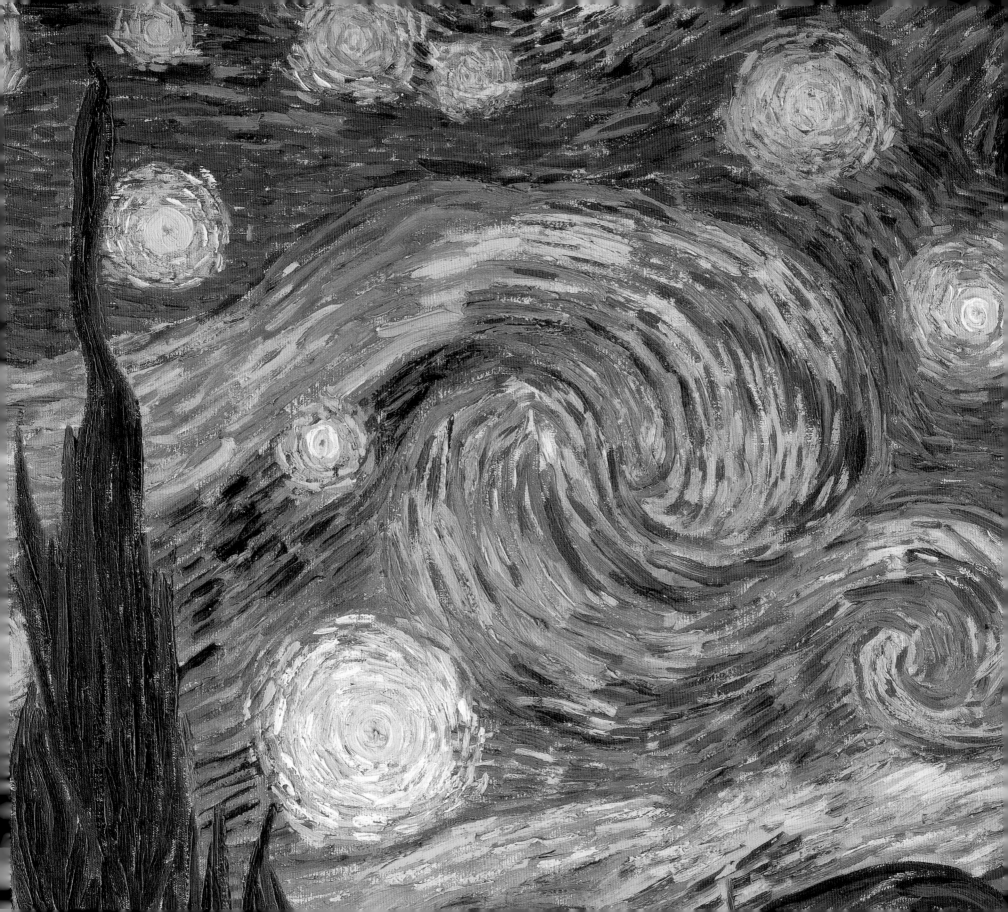

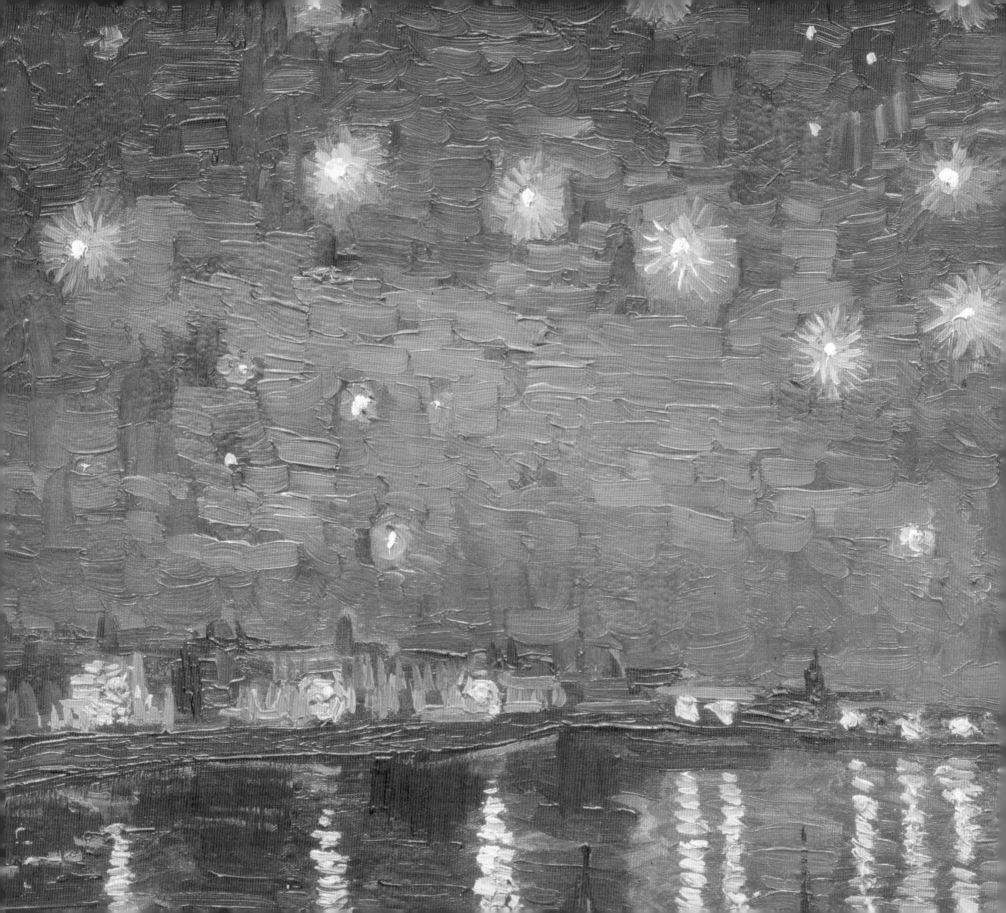

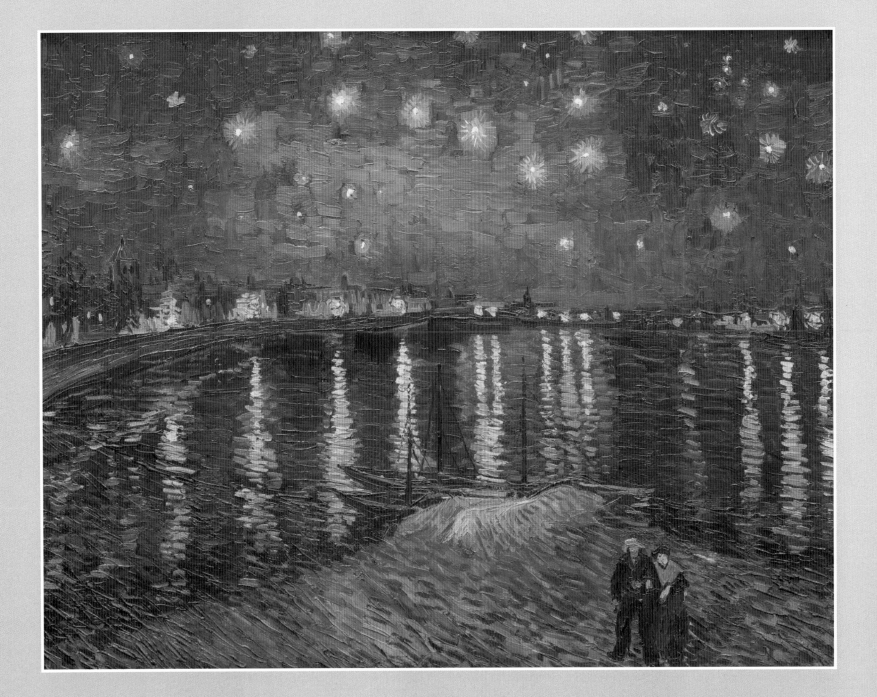

Vincent van Gogh
STARRY NIGHT OVER THE RHONE, 1888
Oil on canvas, 28 1/2 x 36 1/4 inches
On loan to the Musée d'Orsay, Paris
Courtesy Art Resource, New York

159

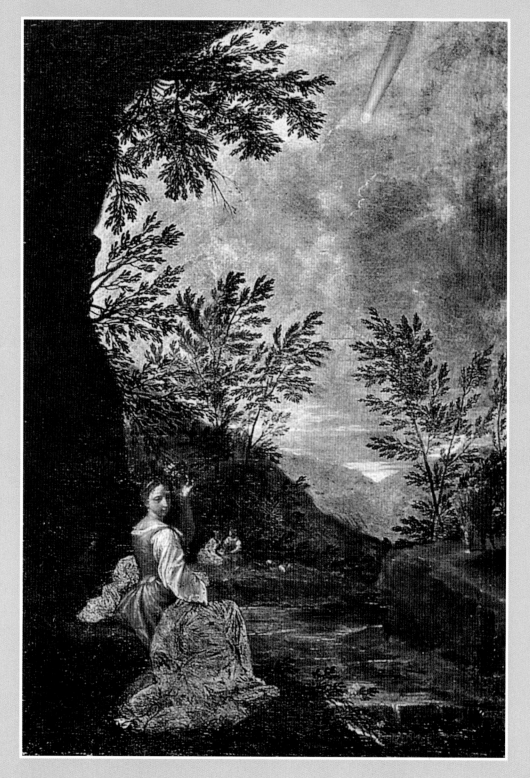

Donato Creti
ASTRONOMICAL OBSERVATIONS: A COMET, 1711
Oil on canvas, 20 1/4 x 13 3/4 inches
Vatican Museum, Rome

Houghton Cranford Smith
COMET, NEW MEXICO, c. 1948–49
Oil on canvas, 16 3/4 x 30 1/2 inches
Richard York Gallery, New York

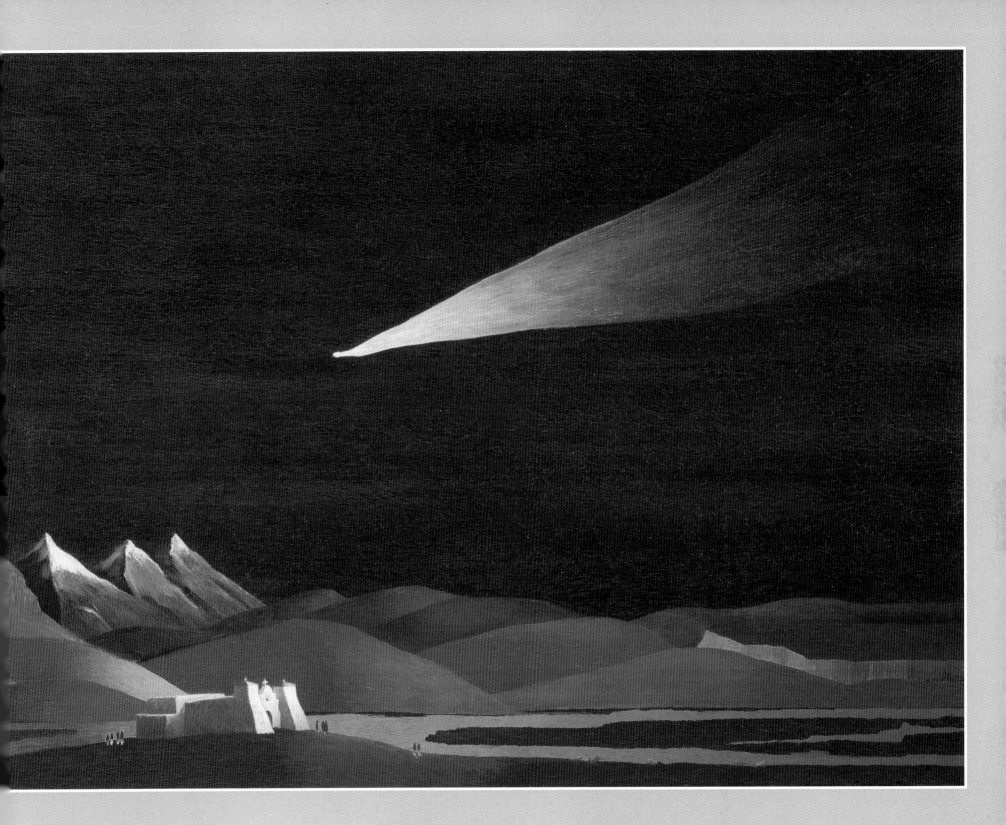

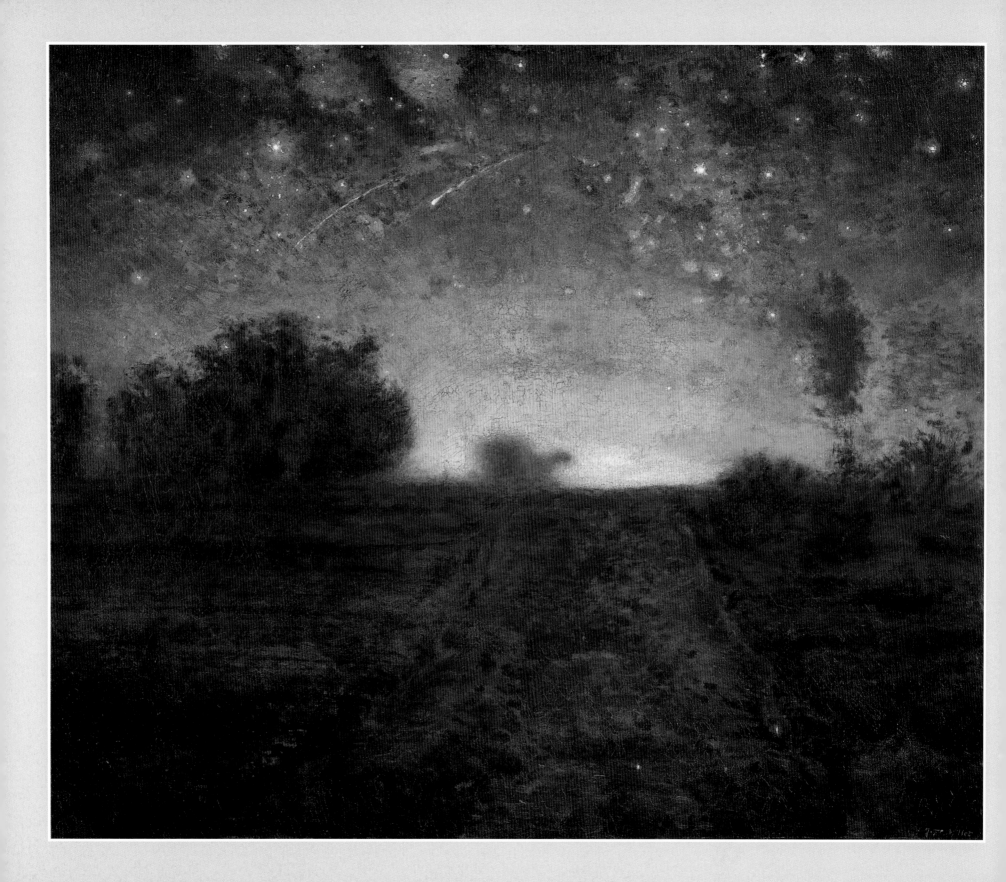

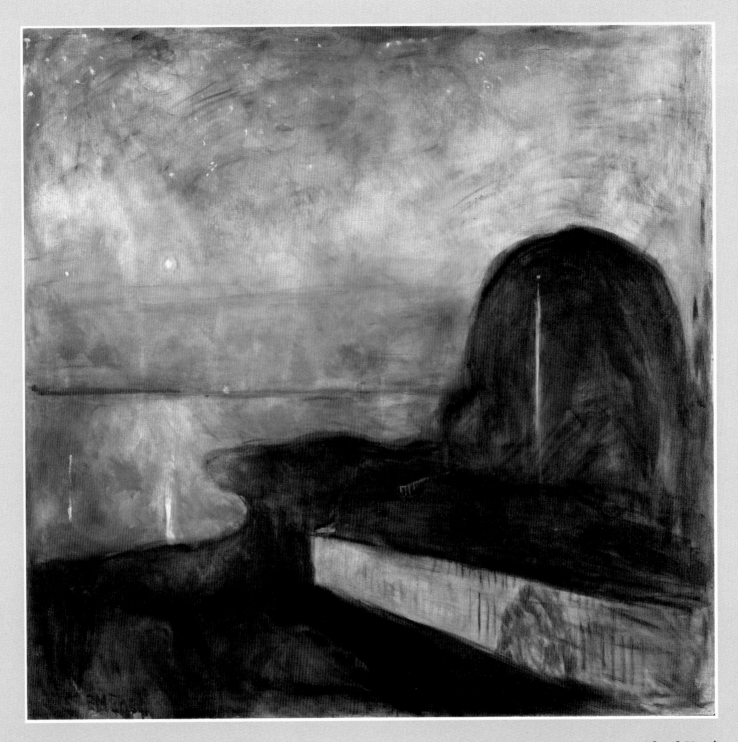

Jean François Millet,
STARRY NIGHT, 1850–51
Oil on canvas, 29 x 40 1/8 inches
Yale University Art Gallery
Leonard C. Hanna, Jr., B. A. 1913, Fund

Edvard Munch
STARRY NIGHT, 1893
Oil on canvas, 53 3/8 x 55 1/8 inches
J. Paul Getty Museum, Los Angeles 84.PA.681

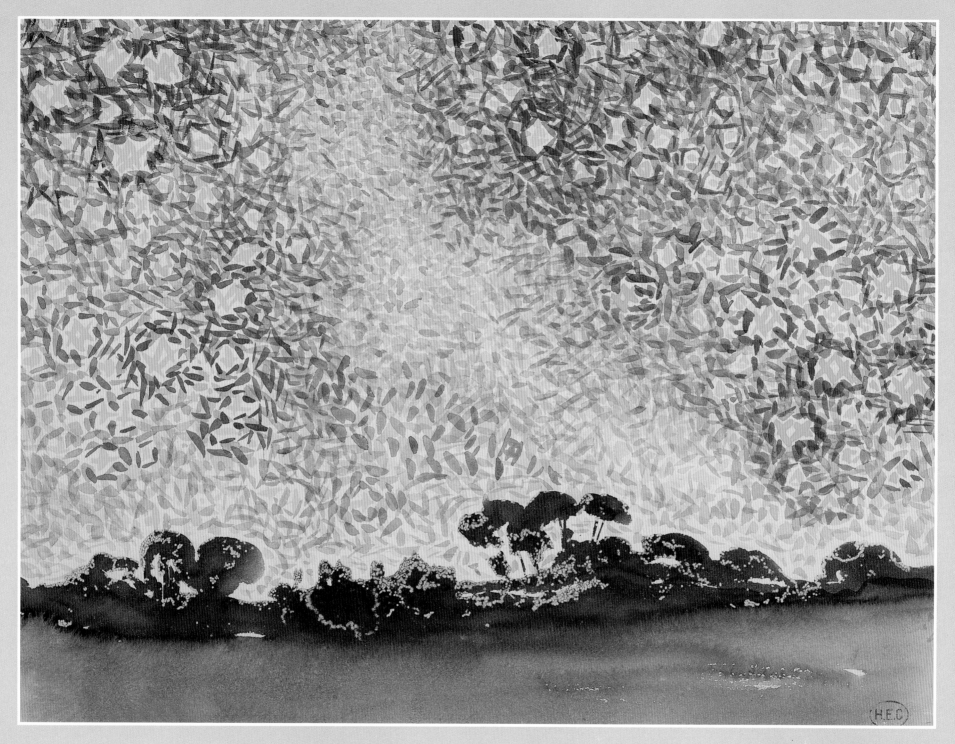

Henri-Edmond Cross
LANDSCAPE WITH STARS, n.d.
Watercolor on paper, 9 5/8 x 12 5/8 inches
Metropolitan Museum of Art, New York
Robert Lehman Collection, 1975 (1975.1.592)

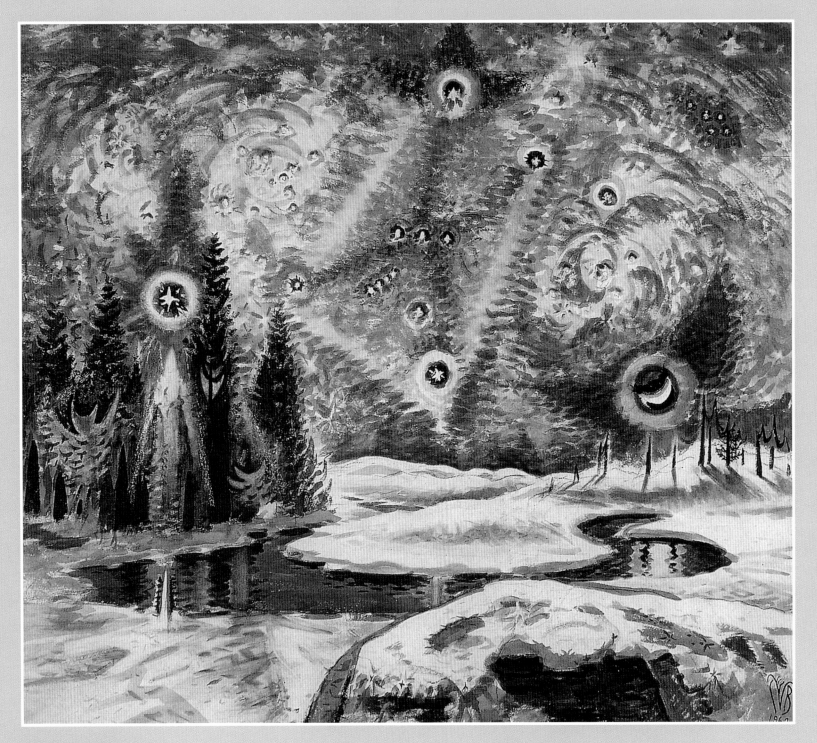

Charles Burchfield
ORION IN WINTER, 1962.
Watercolor, 48 x 54 inches.
Fundación Colleción Thyssen-Bornemisza, Madrid.
Courtesy Art Resource, New York

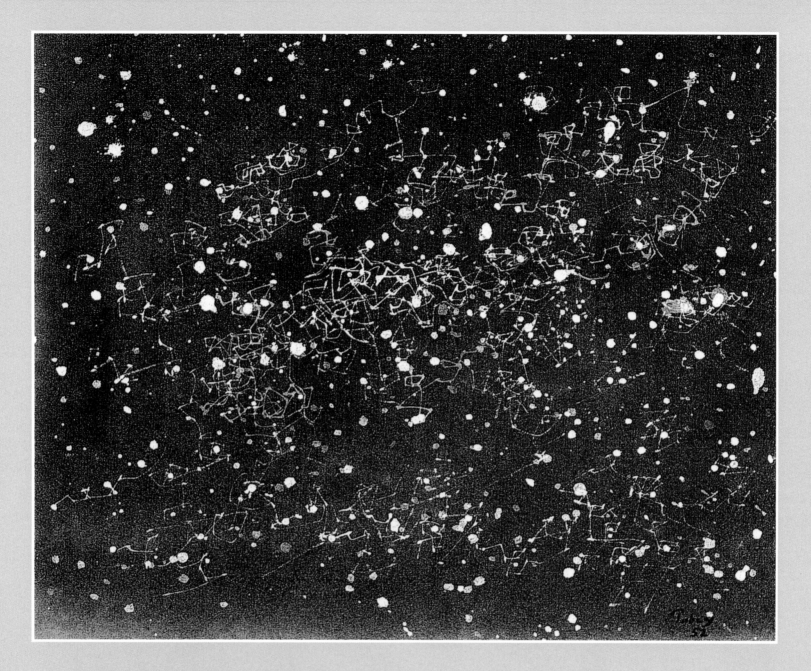

If a man would be alone, let him look at the stars.

—Ralph Waldo Emerson, *Nature*

Arthur Dove
STARRY HEAVENS, 1924
Oil and metallic paint on reverse side of glass
with black paper, 18 x 16 inches
Michael Scharf G. I. T.

Mark Tobey
SOUTHERN NIGHT, 1952
Tempera on paper, 8 7/8 x 11 inches
Private collection

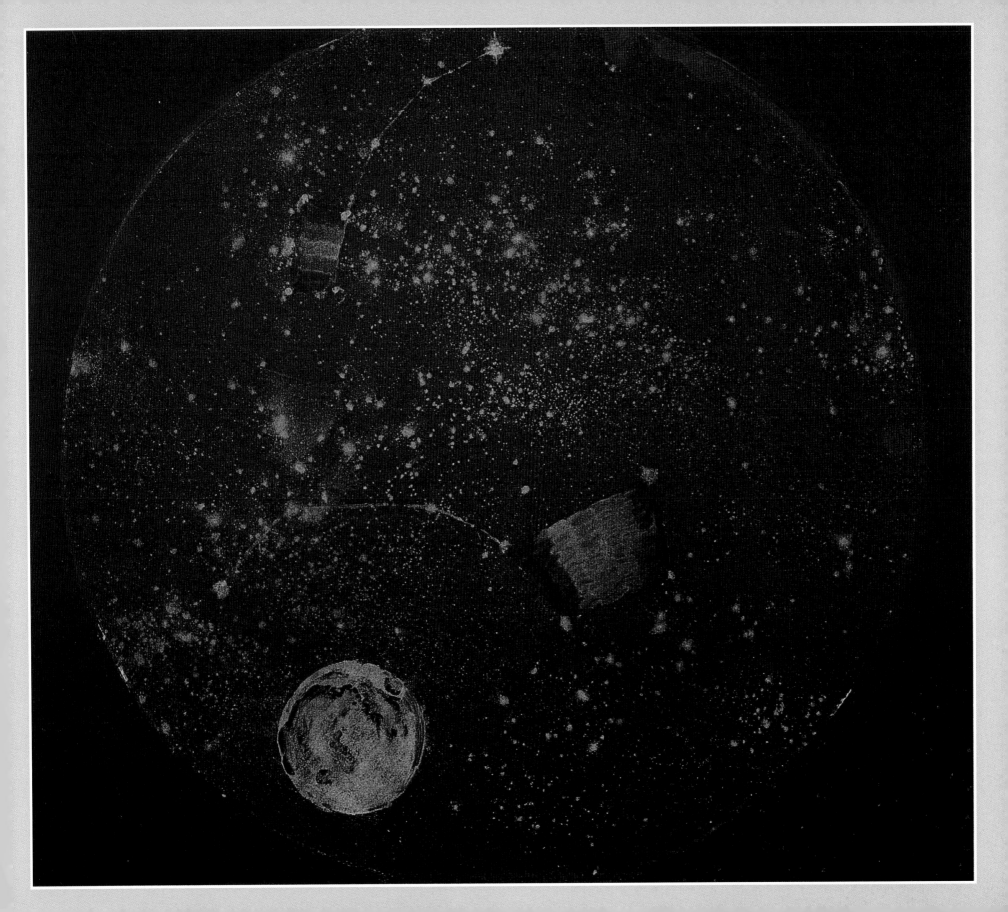

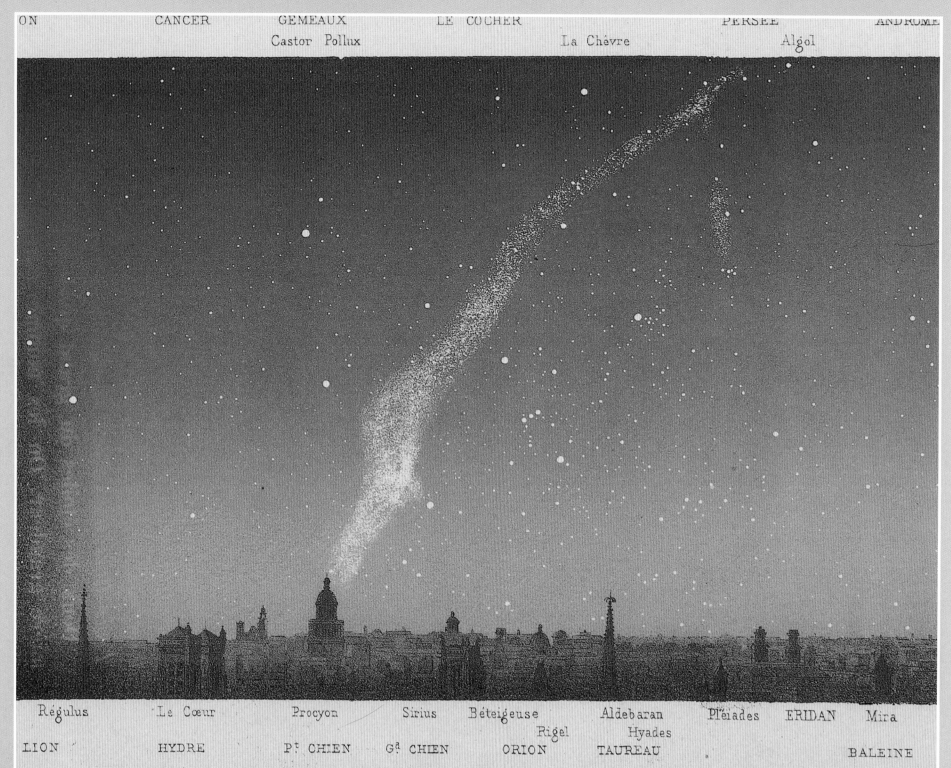

Régulus Le Cœur Procyon Sirius Béteigeuse Aldebaran Pléiades ERIDAN Mira

Rigel Hyades

LION HYDRE Pᵗ CHIEN Gᵈ CHIEN ORION TAUREAU BALEINE

LE CIEL DE L'HORIZON DE PARIS (Côté Sud)

168

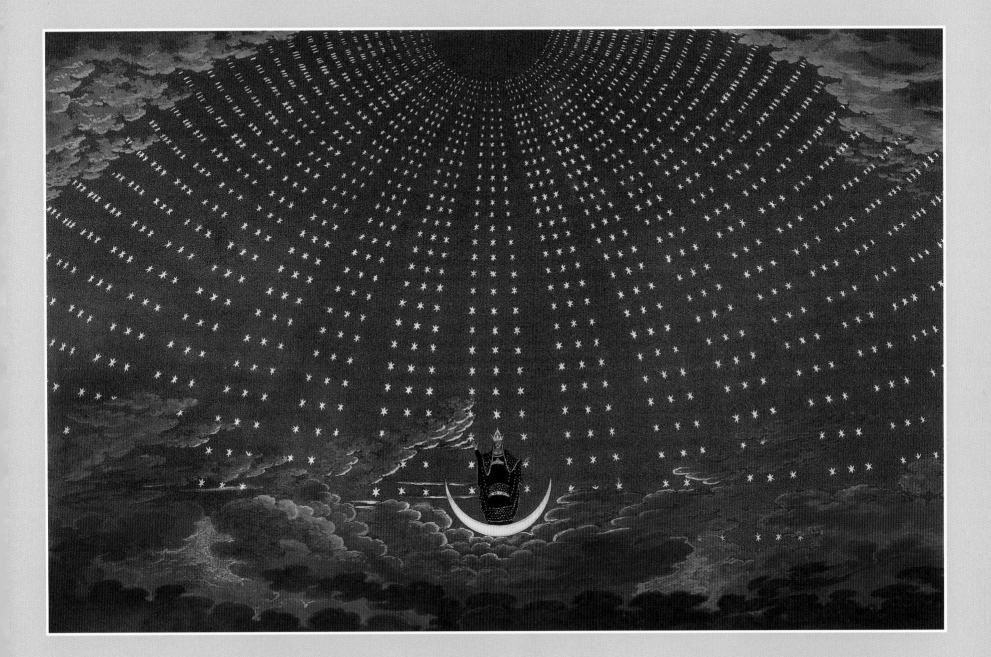

Amadé Guillemin
THE SKY OVER PARIS, LOOKING SOUTH, 1865
Library of Congress, Washington, DC

Thiele, Karl Friedrich (after Karl Friedrich Schinkel)
SET DESIGN FOR THE ENTRANCE OF THE QUEEN OF THE NIGHT
IN MOZART'S OPERA THE MAGIC FLUTE, 1819
Hand- and plate-colored aquatint, 11 1/4 x 14 3/4 inches
Metropolitan Museum of Art, New York
Elisha Whittelsey Collection, 1954 (54.602.1.14) 169

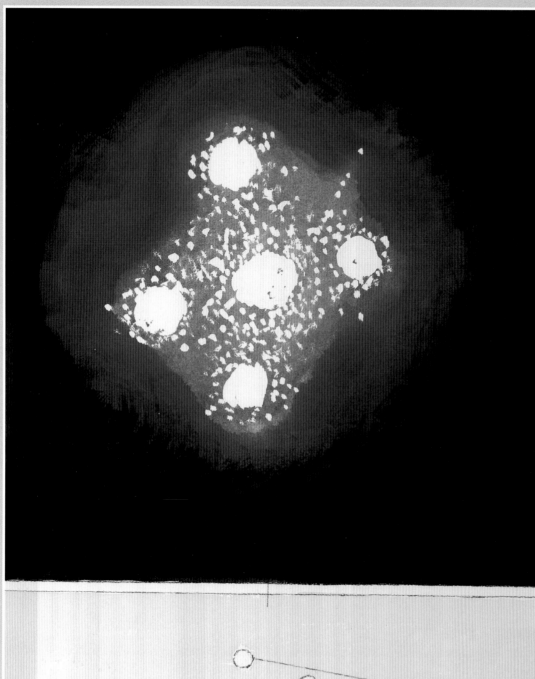

John Wallace
THE EINSTEIN CROSS:
GRAVITATIONALLY LENSED QUASAR, 1995
Watercolor and egg tempera, 23 1/2 x 16 inches
Courtesy the artist

A broad and ample road,
whose dust is gold,
And pavement stars,
as stars to thee appear
Seen in the galaxy,
that milky way
Which nightly as a circling zone
thou seest
Powder'd with stars.

—JOHN MILTON, *PARADISE LOST*, VII

Greg Mort
NIGHT RIVER, 1996
Watercolor, 28 x 21 inches
Private collection

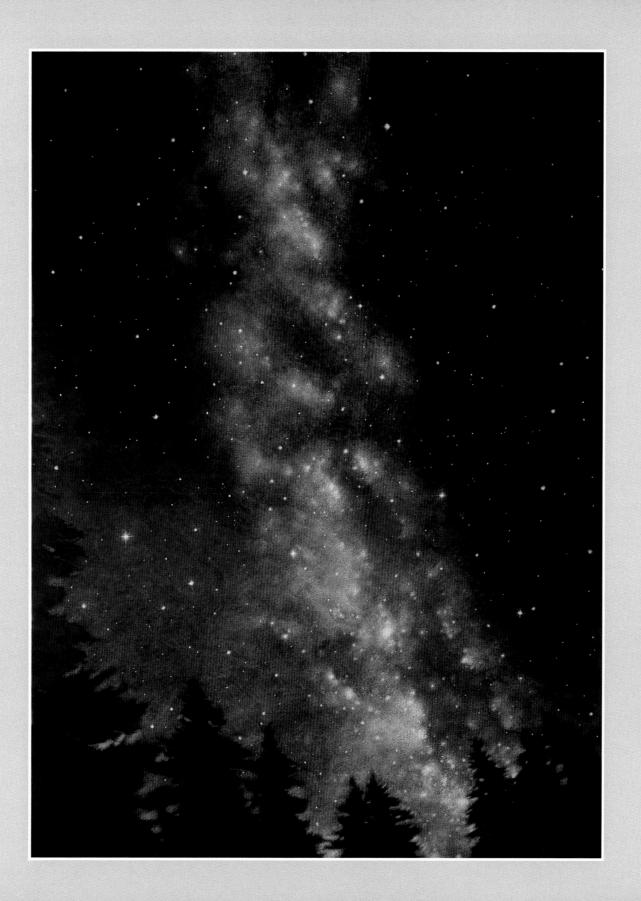

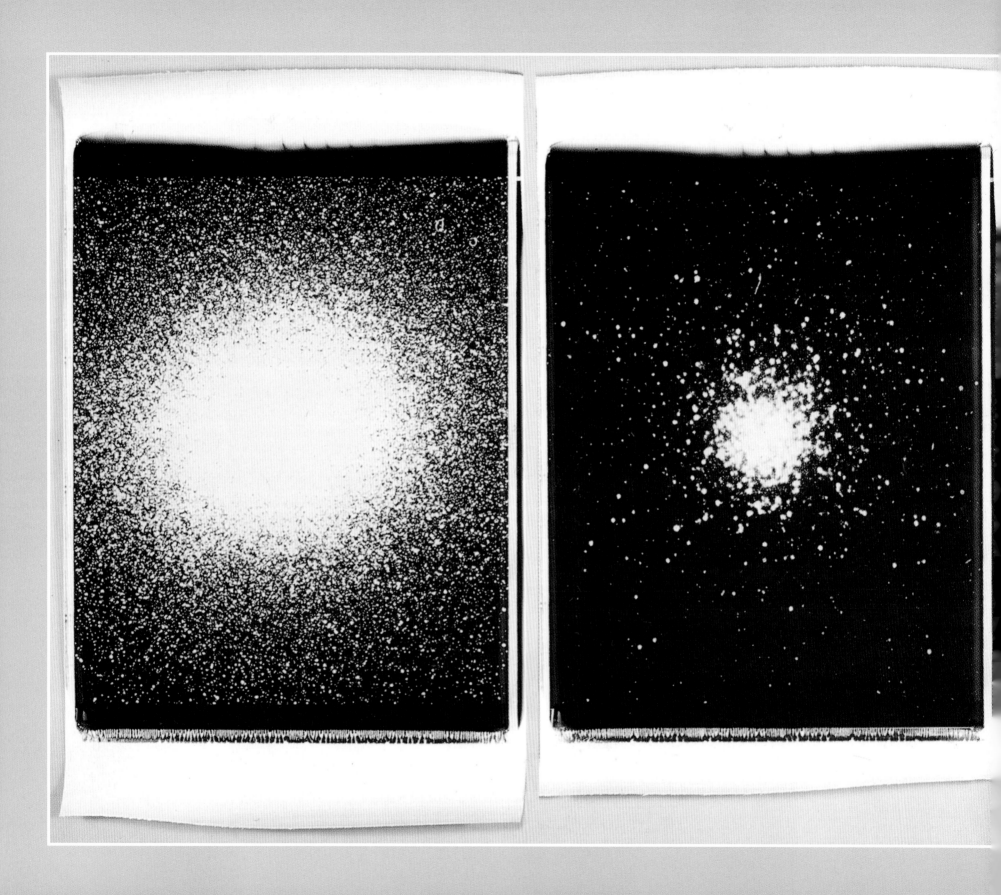

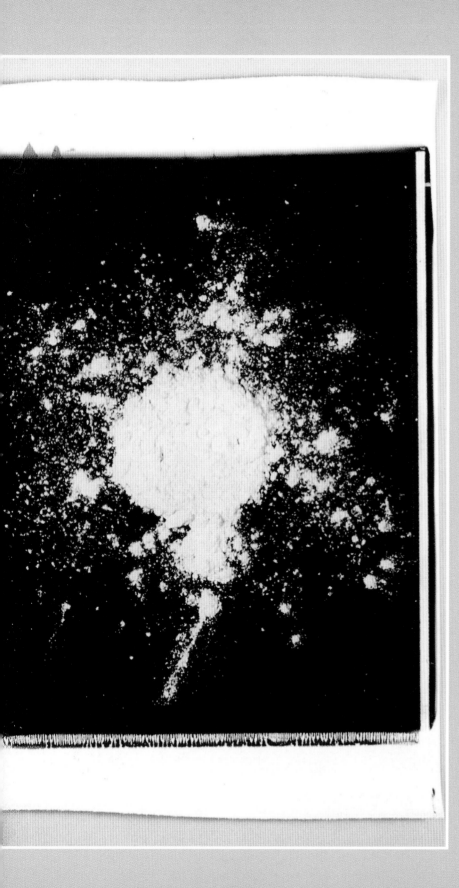

*G*od, if You wish for our love,
Fling us a handful of stars!

—Louis Untermeyer, *Caliban in the Coal Mines*

Davide Mosconi
NIGHT SKIES, NO. 12, 1990–91
Polaroid triptych, each image 24 x 20 inches
Courtesy the photographer

*L*ove, from whom the world begun,
Hath the secret of the sun.
Love can tell, and love alone,
Whence the million stars were strewn,
Why each atom knows its own.

—Robert Bridges

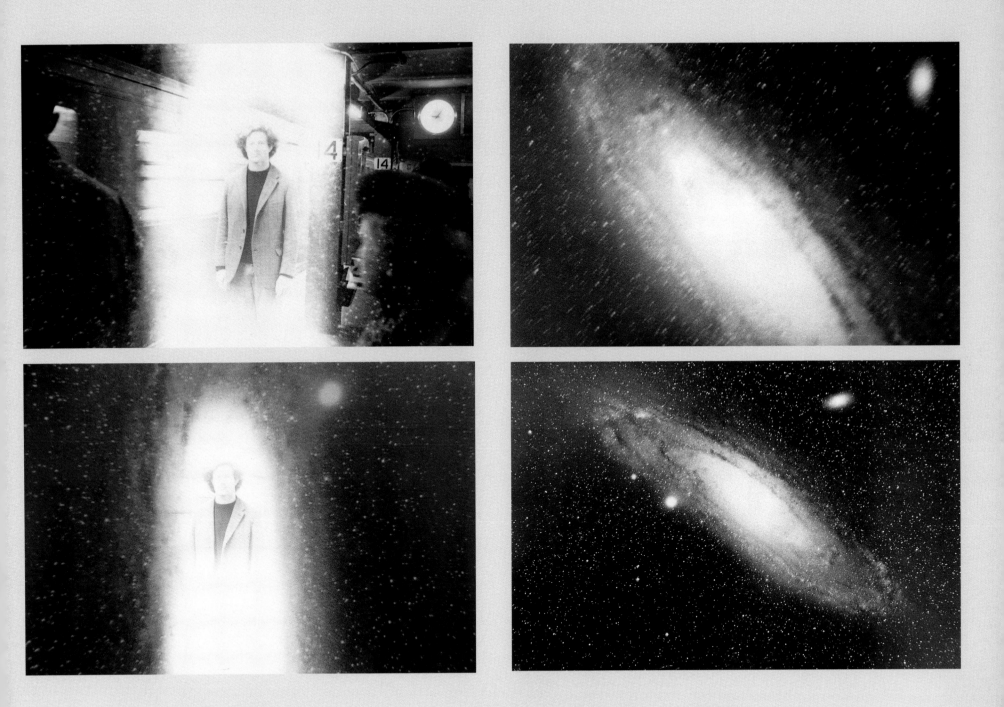

Duane Michals
THE HUMAN CONDITION, 1969
Sequence of six photographs
Courtesy the photographer

SELECTED BIBLIOGRAPHY

Bronowski, Jacob. *The Ascent of Man*. Boston: Little, Brown, 1973.

Darius, Jon. *Beyond Vision: One Hundred Historic Scientific Photographs*. New York: Oxford University Press, 1984.

Ford, Brian J. *Images of Science: A History of Scientific Illustration*. New York: Oxford University Press, 1993.

Gallant, Roy A. *National Geographic Picture Atlas of Our Universe*. Washington, DC: National Geographic Society, 1980.

Goldsmith, Donald. *The Astronomers*. New York: St. Martin's Press, 1991.

Hawking, Stephen W. *A Brief History of Time, from the Big Bang to Black Holes*. New York: Bantam, 1988.

Krupp, E.C. *Beyond the Blue Horizon: Myths and Legends of the Sun, Moon, Stars, and Planets*. New York: Oxford University Press, 1992.

Maran, Stephen P., ed. *The Astronomy and Astrophysics Encyclopedia*. New York: Van Nostrand, 1992.

Olson, R.M. *Fire and Ice: A History of Comets in Art*. New York, 1985.

Pasachoff, Jay M., and Donald H. Menzel. *A Field Guide to the Stars and Planets*. 3rd edition. (The Peterson Field Guide Series.) Boston: Houghton Mifflin, 1997.

Robin, Harry. *The Scientific Image, from Cave to Computer*. New York: Harry N. Abrams, 1992.

Ronan, Colin A. *The Universe Explained*. New York: Henry Holt, 1994.

Sagan, Carl. *Cosmos*. New York: Random House, 1980.

Schick, Ron, and Julia Van Haaften. *The View from Space: American Astronaut Photography, 1962-1972*. New York: Clarkson N. Potter, 1988.

Singh, Madanjeet, ed. *The Sun: Symbol of Power and Life*. New York: UNESCO & Harry N. Abrams, 1993.

Trefil, James S. *Space, Time, Infinity*. New York: Pantheon, 1985.

Whitfield, Peter. *The Mapping of the Heavens*. San Francisco: Pomegranate (in association with the British Library), 1995.